Wildlife Adventures
with a Camera

Harry N. Abrams, Inc., Publishers, New York

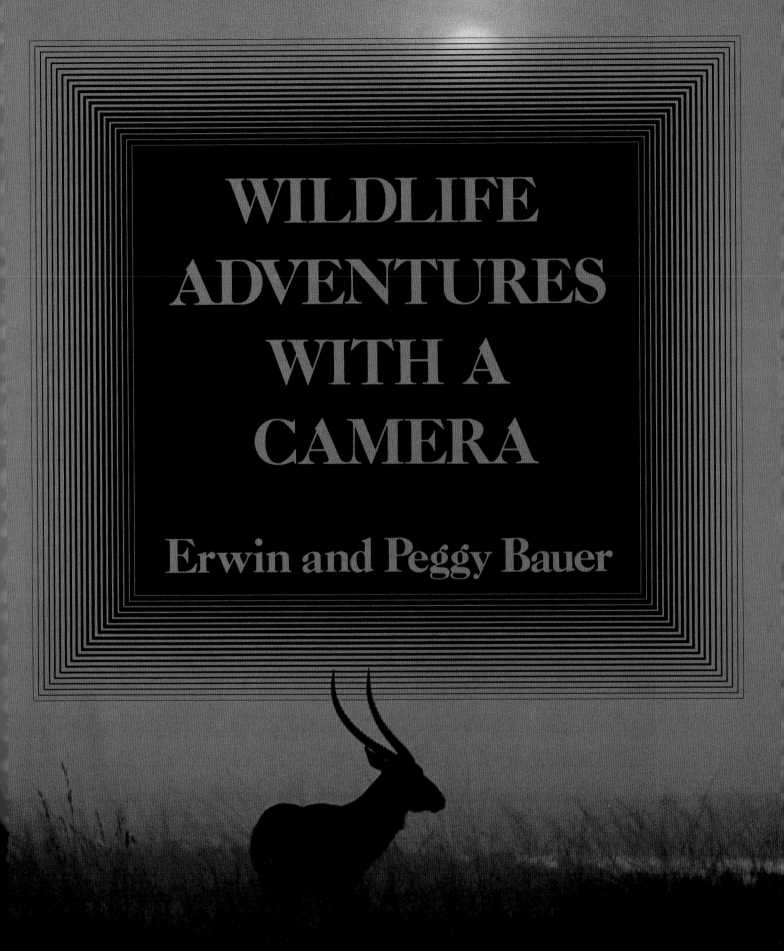

WILDLIFE
ADVENTURES
WITH A
CAMERA

Erwin and Peggy Bauer

PROJECT DIRECTOR: MARGARET L. KAPLAN
EDITOR: NORA BEESON
DESIGNER: CAROL ROBSON
MAPS : KATHY ZIMMERMAN

Library of Congress Cataloging in Publication Data
Bauer, Erwin A.
 Wildlife adventures with a camera.
 Includes index
 1. Photography of animals. 2. animals — Pictorial works.
 I. Bauer, Peggy. II. Title.
TR727.B265 1984 778.9'32 83-15464
ISBN 0-8109-1755-6

TITLE PAGE
A male waterbuck stands in late afternoon
silhouette in Uganda's Ruwenzori National
Park. Acrid smoke from distant grass fires
gives that strange salmon glow. The photo
was made during peaceful times, when
Uganda's parks were still among the most
attractive on earth.

CONTENTS PAGE
Zebras in Etosha National Park, Namibia.

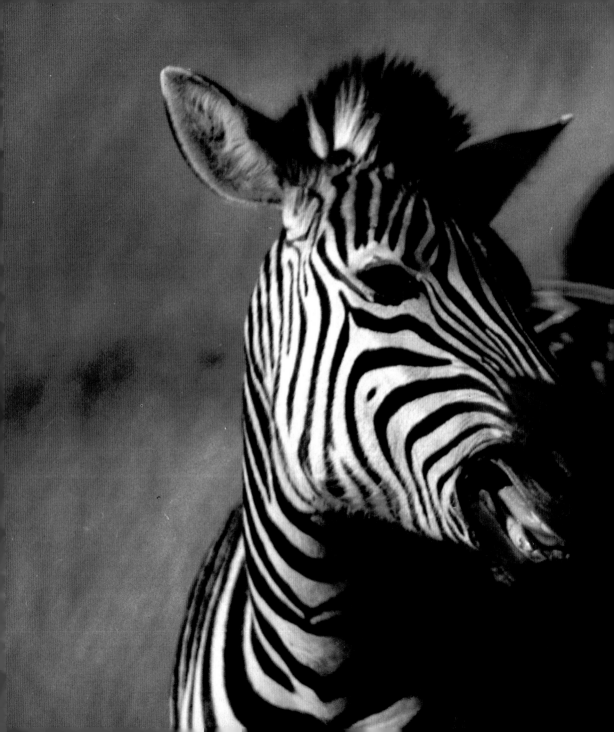

CONTENTS

PAGE IO LEFT
Some of the landscapes in Yellowstone National Park steam, tremble, and erupt. Hot springs bubble out of Roaring Mountain and flow down the inferno into a valley that herds of elk frequent every September.

PAGE IO LEFT
The polar bear sow and single cub sit with their backs to Hudson Bay. A large male bruin has appeared on the scene, causing apprehension. The cub instinctively huddles against its mother. In another moment, as the male moves closer, the two in the photo quickly depart for a safer site.

PAGE IO CENTER
During fall and winter in the Alberta national parks, bighorn sheep descend from their high altitude summer range to lower elevations, often within sight of highways. Rutting may take place within the view of passing traffic. For this portrait of a Banff roadside ram, we focused on the snowflakes on its face.

PAGE IO CENTER
A single, large bull moose grunts that he is available during the rut. Despite their immense size, moose are normally not aggressive toward photographers. But during this season, it is sensible to maintain a good interval between camera and target. A bull defeated by a rival could take out his frustration on anyone or anything.

PAGE II LEFT
This antelope buck, establishing its territory in late summer, seemed hyperactive—scent-marking and ripping sod with its black horns. It wasn't until the buck bedded down, grass still draping its head, that we could get a picture of it.

PAGE II TOP
The jaguar in the photo ventured too close to a remote ranch in lowland Colombia and was driven by a pack of ranch hounds to take refuge by swimming in vast Ciénaga de Zapatosa. We followed the large cat long enough in a dugout canoe to make the unusual photograph. Jaguars may be the most aquatic of the world's cats.

PAGE II RIGHT
A pair of trumpeter swans swims ethereally into the sunlight during a still, early morning on the Madison River. They share the river with otters, brown trout, ducks and geese, moose and elk, and bald eagles and ospreys.

PAGE II RIGHT
Wherever they survive in the world, gray wolves are difficult to approach, or even to see. More often than not we have heard them howling at night while camping in Denali National Park. These two young ones are probably litter mates and their antics are just sibling rivalry.

PREFACE

Wildlife photography is a relatively new profession. It is true that some outdoor enthusiasts, naturalists usually, have been taking pictures of mammals and birds ever since cameras became portable enough to carry outside of studios. Some of their fading, yellowed wildlife studies, buried deep in archives, are remarkable, given the immense limitations of early cameras and technology.

Jim Corbett, the legendary stalker of man-eating tigers and leopards in the hill country of northern India, eventually put his rifles aside and ended his career just photographing tigers. He was almost certainly the first person to succeed in doing so. Carl Ackeley made excellent still photos of African big game before he was fatally injured by one of his subjects, an elephant. He did not have the advantage of safe distance that modern telephoto lenses afford. George Shiras was a pioneer in photographing North American big game with a flash at night, including the Wyoming moose (*Alces shirasi*) named after him. No doubt many others were photographing wildlife early in this century, but unfortunately their efforts will remain unknown because at the time few really cared about animal pictures.

It wasn't until post-World War II and eventual development of the 35mm single lens reflex camera and modern telephoto lenses that many became interested in (if not addicted to) wildlife still photography. It was a fascinating pastime, even a challenging sport possible anywhere. Here was a great way to go hunting, even trophy hunting, but with many advantages. There were no licenses to buy, no closed seasons or bag limits to observe. A cameraman could shoot endangered as well as common species. It was a hobby to be pursued as passionately, as vigorously, or as passively, as anyone chose. Wildlife photography was and is an ideal way to celebrate the wonderful natural world.

After World War II, markets for selling wildlife pictures were created and gradually expanded. *Life* and *Look* joined *National Geographic* in using occasional wildlife features. Then came the environmental movement and the fine environmental magazines: *Audubon*, *National Wildlife*, *International Wildlife*, *Animal Kingdom*, *Sierra*, *Wilderness*, *Natural History*, and numerous others. Most general interest periodicals, many house organs and consumer publications use at least some wildlife material, and beautifully illustrated wildlife books have become popular in this age of growing conservation awareness. So the profession of wildlife photography—of keen woodsmen-naturalists who are also skilled photo technicians—is now well established. Astonishingly good work has been produced.

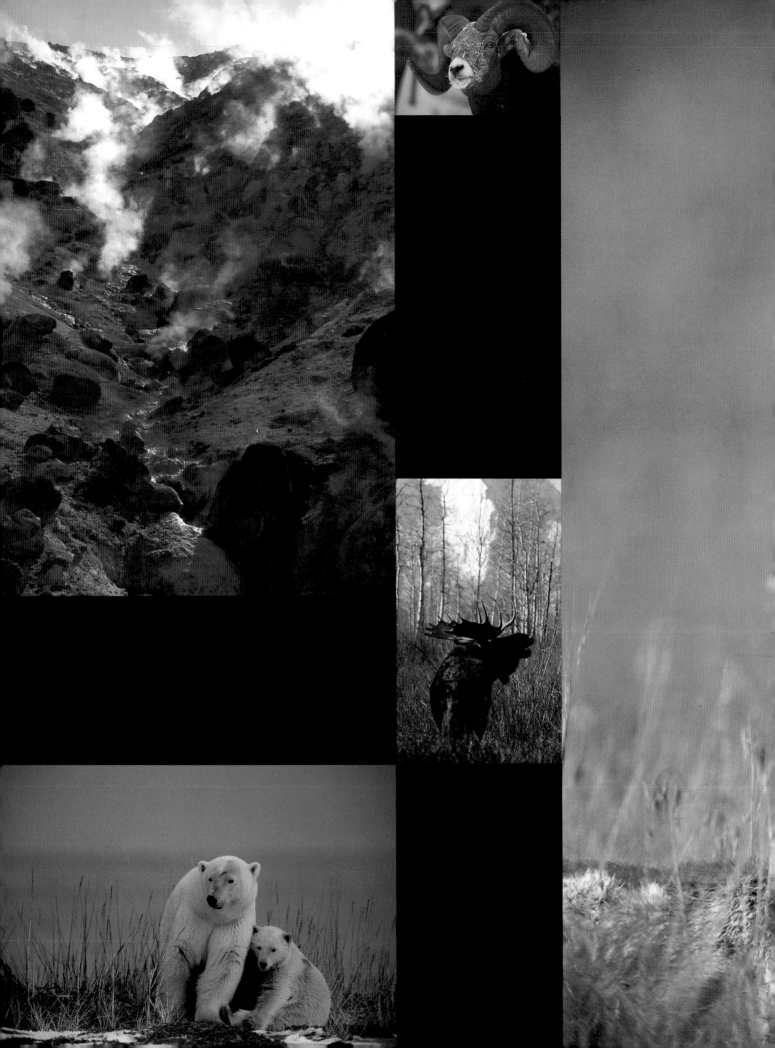

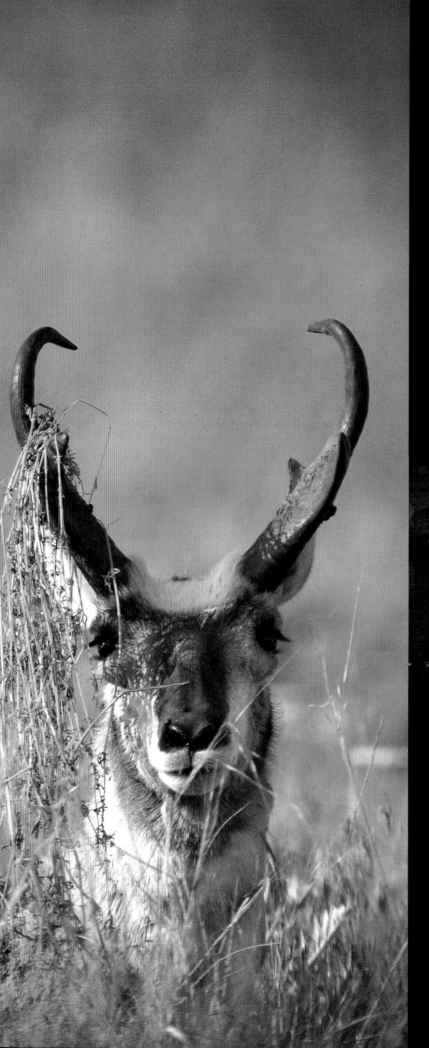
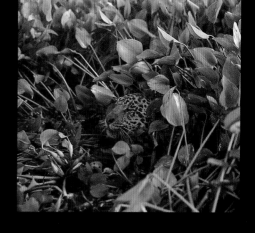
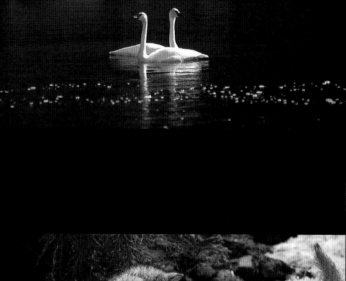
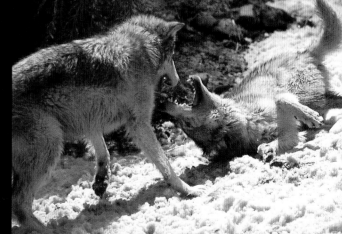

We have been photographing wild creatures for four decades, the last twenty years almost without interruption. It is an exciting life, which has taken us to the most distant, exquisite places, to the last remaining wildernesses. Between journeys we have been able to live in wildlife country of northwestern Wyoming, which is one of the last paradises. We can shoot many wild creatures with the incomparable beauty of the Teton Mountains as a background right through the back door.

But there is trouble in our paradise and just about everywhere else. It is true that since Yellowstone was named the first national park more than a century ago, 124 other countries have established national parks or similar protected sanctuaries. At this writing, the total number of such areas is about 2,600 and covers an estimated 5 percent of the earth's land surface. That is a pitifully small amount of wilderness for humankind to save, but even that much is far from secure. A few of the scenes in this book no longer look the same, and some of the places we describe are under attack as conservation areas.

Wheat farms are now encroaching on the north boundary of Kenya's Masai-Mara, perhaps the finest wildlife park in all eastern Africa. Tropical forests of South and Central America are being eliminated before our eyes, with almost none set aside intact for the future. India is having a desperate time maintaining the integrity of almost all of its national parks, and the pressure may soon become too great to keep them. The revolution in Iran, we learn, has wiped from the map an entire system of natural areas and parks, probably forever. The same has happened during the Russian occupation of Afghanistan. Very little wilderness at all survives in Europe or Japan. The developing struggle for natural resources will mean the end of Antarctica as a wildlife place.

Despite the devastating development of the world's wilderness and the disappearance of so much wildlife, a splendid scattering of national parks and refuges will survive as long as they are cost beneficial. In other words, Serengeti will live so long as people keep paying enough to visit there. So our earnest advice is both sound and simple: pack your cameras carefully, take plenty of film (which is in short supply wherever on earth you are likely to need it most), and hit the highways toward those last paradises. You will see clearly why we were motivated—no, driven—to prepare this book. Researching our journals and our recollections has been almost as pleasant as the actual traveling.

I

The Rocky Mountains

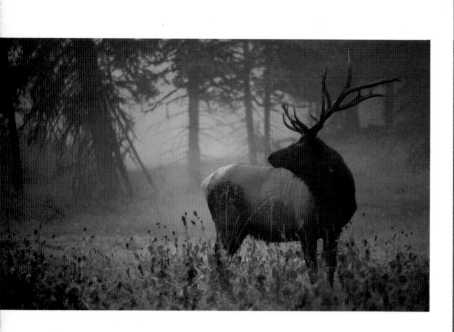
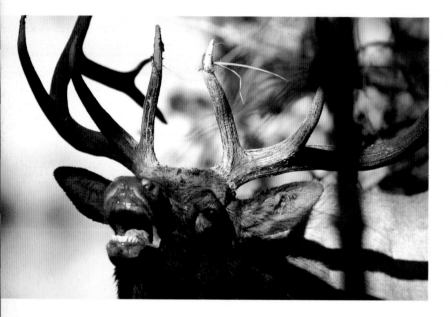
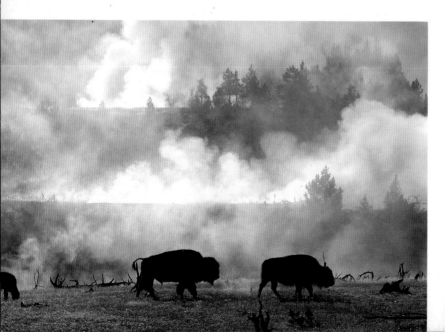

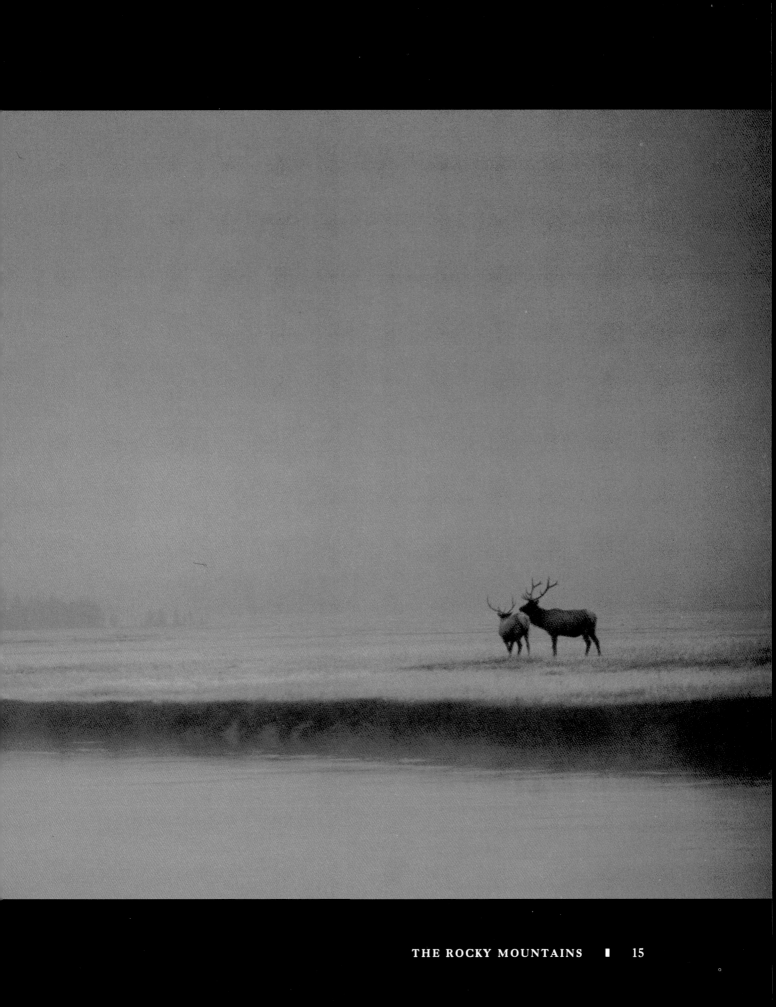

PAGE 14 TOP

An autumn day was breaking in Yellowstone Park and the exposure meter indicated not quite enough light to film with 64-speed film; but using a monopod to steady the camera at 1/30 second produced this image of a bull elk at the edge of a misty forest.

PAGE 14 CENTER

Late afternoon at Gibbon Meadow, Yellowstone, we watched this bull elk laze under a warm October sun. A rival bull appears nearby. All at once our bull is on its feet and annoyed. It looked like this, bugling, through a 400mm lens.

PAGE 14 BOTTOM

It is autumn and steam from boiling hot springs overflows Yellowstone's Firehole River valley. Bison are migrating into the area, where they will spend the winter. The entire Firehole Basin is also a traditional wintering area for elk and mule deer.

PAGE 15

Again we are stalking Gibbon Meadow in Yellowstone before daybreak. A ground fog smothers the land, so we sit down beside the Gibbon River, hoping the fog will dissolve. Then two bull elk walk out onto the scene and we shoot despite the gloom. The result is evocative of early autumn in this sublime park.

It is still night when we hear a shrill, eerie whistle coming from the grassy meadowlands along the Gibbon River. In the pale glow of the moon's last quarter we can distinguish the outlines of other tents pitched nearby in the Norris campground of Yellowstone National Park. September is blending into October, and herds of elk have gathered in many of the high meadows for the annual rutting season; our fellow campers are also on hand to watch the show. The whistle, which we hear again, comes from a herd bull guarding his harem of cows. It is hard to describe this sound, which is somewhere between a steamboat calliope and a parade-ground bugle.

We try to sleep a while longer, but it isn't any use. So we get up, scrape frost from a small camp stove, pump it, and begin brewing a pot of coffee. When it is finished, we huddle in the dark cab of our pickup, eating too many cinnamon rolls with the coffee. Not far away, other campers are lighting a breakfast campfire. A cold fall day is breaking on the Yellowstone plateau.

Our simple breakfast finished, we pull on knee-high trapper's boots, slip into the backpacks that hold our cameras, and walk away from the campground toward the bugling elk. A gray hoar frost clings to the deep grass. Just beyond the camp's perimeter we intersect an animal trail leading across the meadow. It is easy to see because the trail maker has brushed away frost crystals, leaving a dark wake. That trail is fresh, and we first assume it was made by an elk. But it is too wide, and on closer inspection we realize that it was made, perhaps only minutes before, by a grizzly bear.

Now we pause and study carefully the dim landscape all around. It is not a good time or place to stumble upon a bear. But all we see are the outlines of elk barely discernible where the Gibbon River flows through a boggy area. Still uneasy and continually glancing around us, we move toward the herd. Not directly and not too quickly. We would be able to find them even if we couldn't see them, because the bull bugles at regular intervals. And each time a rival bull answers the challenge.

Our timing is good. Just as the sun is poised to appear above the horizon, we are in position within medium telephoto lens range of the harem bull. It is a splendid animal with massive antlers. It sees us, notes our presence, and nothing more. Its total concentration is fixed on the other bull, which suddenly arrives on the scene from a stand of lodgepole pine. It pauses, lashes at the ground with its antlers digging up turf, and bugles. At the same time, the first bull plunges into the Gibbon River and wades across. Its body is steaming and its eyes are red; its breath is a white plume on the cold morning air. As we follow it through camera viewfinders, the furious animal rushes directly

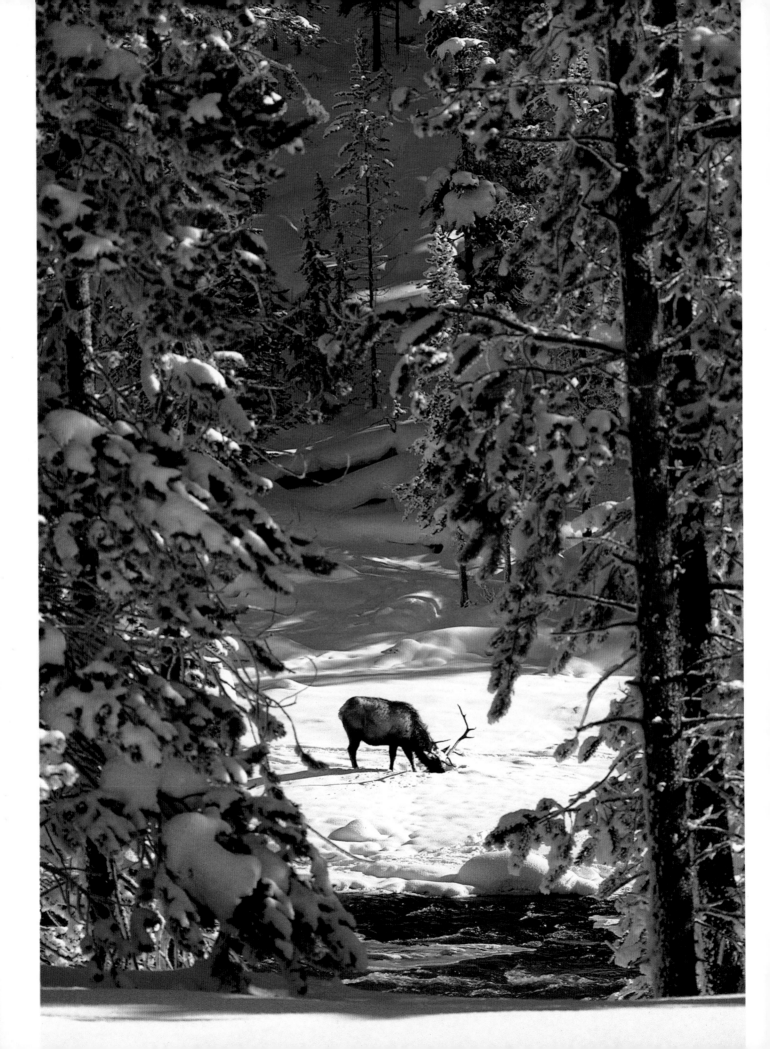

LEFT

Midwinter transforms central Yellowstone Park into a stark snowy environment where large animals survive only along a few rivers which do not freeze. These elk spent the entire season where heat and steam of Beryl Spring exposed enough vegetation for grazing along the Gibbon River.

RIGHT

The weasel in white winter pelage illustrates the wisdom of always carrying a camera, correctly set and ready to use, when hiking Rocky Mountain trails. It appeared suddenly from a ground squirrel den, posed briefly, and then vanished. Glacier National Park.

BOTTOM

This scene near Apollinaris Spring, Yellowstone, is familiar in autumn. Two elk bulls meet soon after dawn in a meadow dueling place. The prize to the winner is a harem of cows unseen in the background forest. Sometimes these bouts end in serious injury, but usually the loser simply gives up and retreats. This confrontation lasted ten minutes.

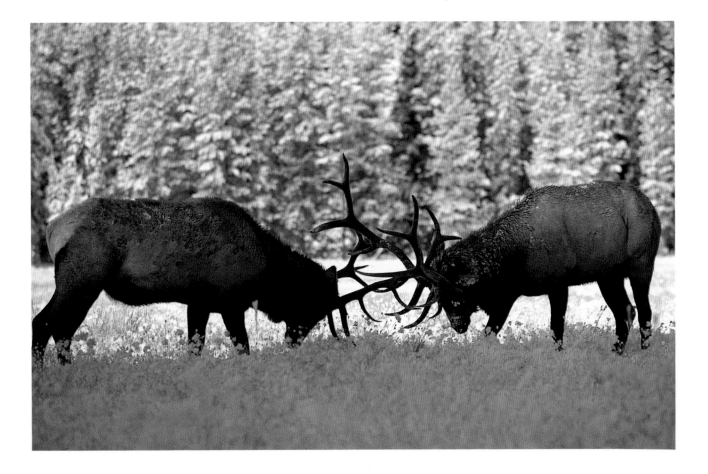

toward the interloper with head down, lunges toward it, antlers crashing to-gether. For a few moments, it is a savage, slashing encounter, but it ends less dramatically than it began. The second bull disengages and backs away. The harem bull does not follow but, with head raised, bugles instead. Not one of the cows, the prizes for the winner, has stopped grazing even briefly to watch the contest. But we have all the action on film.

In many ways we live on the edge of paradise, in Jackson Hole, Wyoming. Yellowstone Park (with those Gibbon River elk) is an hour's drive away, and Grand Teton National Park begins just beyond the back door. One elk migra-tion trail from the Teton high country to the National Elk Refuge passes near our property. Especially during the winter, moose are common visitors around the house. They rub against the wooden posts that support our porch deck, and press wet noses against our bedroom window. A colony of Uinta ground squirrels cavorts in summertime where moose stand almost buried in snow-drifts of winter. A weasel living in the woodpile keeps the ground squirrel population under control. Ruffed grouse roost in quaking aspens beside our driveway. We can and do shoot a lot of wildlife photos without ever leaving the premises. So neighbors wonder why we ever forsake home to sweat in Panama's humidity or to cruise the wild, sickening Drake Passage to Antarc-tica. The answer is simple: curiosity and compulsion to see and photograph as many of the world's places and wild creatures as possible.

But it is also true that where we live—in the Rocky Mountains of America —is a Promised Land for wildlife photographers that is almost impossible to match. From Mexico, where the southern Rockies rise, to British Columbia, wild creatures are still numerous and they live on landscapes that are invari-ably grand. Except for Alaska, this is also the region of America where, so far, both the human population and human impact are smallest in the entire United States.

It is best to divide the Rocky Mountains into two parts: the American Southwest and the northern Rockies. The generally drier Southwest contains some of the most awesome landscapes and canyons in the world, but wildlife is not as abundant as throughout the northern areas. Still, any cameraman in search of imposing scenes should remember the following national parks: Zion, Bryce Canyon, Capitol Reef, Canyonlands, and Arches in Utah; Carls-bad Caverns in New Mexico; Grand Canyon in Arizona; and Mesa Verde in Colorado. Add these national monuments to the list: Organ Pipe Cactus and Saguaro, Arizona; and White Sands and the Gila Wilderness, New Mexico. Whenever possible, in winter we head for Bosque del Apache National Wild-

life Refuge in New Mexico. It is among the most photographable places for waterfowl and sandhill cranes in the country. Spring is a perfect time to be in Utah. But when summer's heat begins to bake that stark, red rock country, it is time to turn homeward toward the northern Rockies.

There are great advantages to working close to home. One morning in May, we locked our pickup in a deserted trailhead parking lot not far away. A dense fog covered the Teton mountain slope above us, but it seemed to be dissolving. We quickly stowed our camera equipment, lunch, portable stools, a sheet of camouflage cloth, and plastic stakes into two backpacks. Then we trekked slowly up a steep and switchbacking trail. Twenty minutes later we reached a ridge and found the inconspicuous marker we had placed there the previous day. At a point out of sight was a mossy trunk of a fallen Douglas fir. It was the drumming log of a ruffed grouse, which we had originally located by zeroing in on the sound of the bird's wings beating the air. During the past three springtimes, one, or more likely several, male grouse had used this same site to drum—a ritual to attract female grouse to the spot to mate.

As quickly as possible we erected our cloth blind about twenty feet from the log and sat down behind it to wait. One camera with a 400mm telephoto lens was mounted on a tripod, and the other with a shorter lens was hand-held. Patches of winter snow lingered around the blind, and a shaft of sunshine spotlighted the exact place on the log where the grouse would stand to drum. Almost magically, as if on some cue, the grouse arrived from deep shadow to stand and perform in the sun. It hesitated for an instant, then spread its wings and began the performance. The beat began slowly, then increased in speed and volume, then ceased abruptly. And we began to shoot, exposing film as though we would never have the chance again. The bird alternately strutted and then, with fanned tail braced against its log stage, drummed its wings. The sound resembled an outboard motor put-putting on a lake far away. The wing beating ended as suddenly as it had begun when the grouse walked away, maybe because no female grouse responded.

The incident may seem to have been a great stroke of luck, but it was really just one advantage of photographing near home. Of course all wildlife photography is uncertain and requires a few lucky breaks, but this was well planned. After some diligent searching, we had located that active drumming log. Over a period of years, we had calculated that this particular May day was the average peak of the grouse drumming season at about 7,500 feet altitude. It would probably be much earlier elsewhere, at lower and warmer elevations. We also knew that this grouse was not too shy of people, because many tourists hike

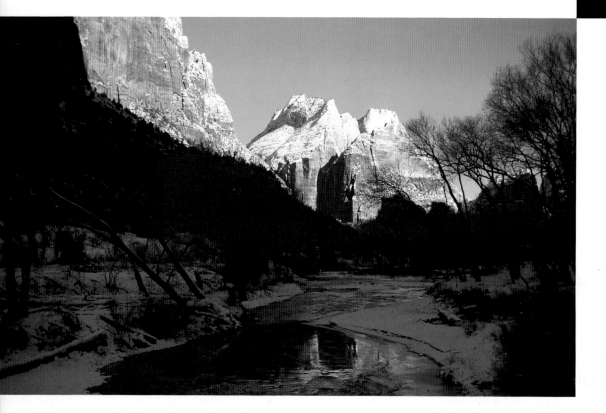

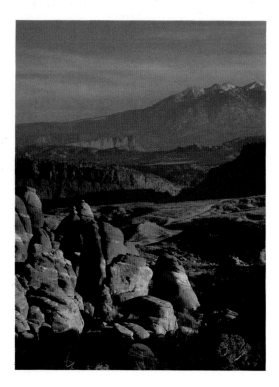
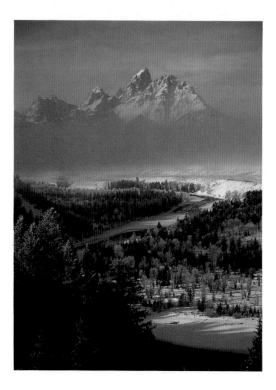

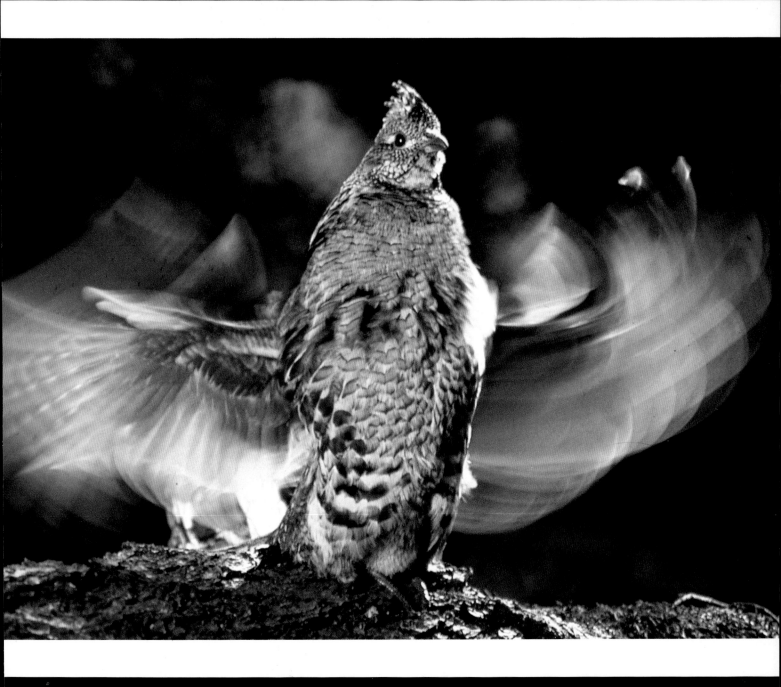

PAGE 22 TOP
The Virgin River flows through the heart of Zion National Park, Utah, and in places mirrors the Great White Throne and other multicolored monoliths towering all around. Spring is the ideal season to camp and trek the Zion backcountry.

PAGE 22 LEFT
Arches is one of five national parks in Utah. It is not a productive place to photograph wildlife, but the countless natural sandstone arches, and the tortured landscape, more than compensate.

PAGE 22 RIGHT
Midwinter gripped Grand Teton National Park when we shot this picture from an overlook along the main park road. The Snake River flows through Jackson Hole just below, and the Cathedral Group of the Tetons looms in the background. It is among America's finest mountain vistas.

PAGE 23
The photo of a male ruffed grouse drumming is a result of careful planning. First we located the drumming log. Past experience taught us the peak of the drumming, or courtship, season (mid-May) and best time of day (morning). We waited for a favorable weather prediction and set up a simple portable blind nearby.

PAGE 26 TOP
This mountain goat lived near Logan Pass in Glacier National Park. The picture clearly shows the lofty environment of the species as well as the effective photo technique of contrasting a light subject against a dark background.

PAGE 26 BOTTOM
There is a beaver-built pond within sight of busy Jackson Lake Lodge, Grand Teton National Park, which thousands of tourists see each summer. But few realize that it contains brook trout. One raw day in November, we discovered a family of otters "fishing" under the thin ice just forming. While we photographed for more than an hour, they caught and ate eight trout.

PAGE 27 TOP
The small herd of bison is wintering in a ghostly scene of Yellowstone's Lower Geyser Basin. They huddle where underground thermal activity slightly warms the ground and keeps snow from piling up. But frost forms on the coats of the animals. Those that survive the "hunger moon" will be thin and weak in the spring.

PAGE 27 LEFT
Because mule deer spend summers at higher elevations, they are not commonly seen by summer visitors in Yellowstone. But once the park empties of traffic in October, they suddenly appear and concentrate for the rut on lower slopes.

PAGE 27 CENTER
This bull elk was the loser in a duel with a larger bull in the Madison Meadow, Yellowstone National Park.

PAGE 27 RIGHT
Closeup photography is possible when winter grips the Firehole River valley in Yellowstone Park. A makeshift bipod of ski poles was used as a firm camera base. We focused sharply on the elk calf's wet nose and the light in the eye.

the nearby trails all summer long. Our blind was simple enough to erect quickly, without noise or commotion, and the weather prediction was for sunny skies, an important ingredient early in the morning in such forest locations. We made several more morning trips to the drumming log, with and without success. Once we mounted a flash unit over the log to compensate for lack of sunlight. Our filming there ended suddenly when a black bear destroyed our blind and our portable stools, which we had left in place overnight.

Over the years, we have developed an outfit that approaches the ideal for mountain photography. Almost as important as the cameras are the mountain hiking boots, well waterproofed and with Vibram soles suitable for rough trails and modest climbing. A lightweight, external frame backpack, with wide hip belt and multiple separate compartments, carries (in addition to the photo gear divided into separate compartments) a light foul-weather suit that rolls into a fist-size package, high calorie, high energy snacks, gloves, insect repellent, a cup, water purification tablets, a knit cap, and an extra vest or wool sweater. The pack is kept always handy and ready to go at a moment's notice. From the Rockies, we have carried the pack several times around the world, only slightly altering the contents to meet a special situation.

It is possible to drive through national parks of the northern Rockies and spot wildlife targets far away. Then we stop, pick up the backpacks, and head out. It is even possible to be trapped in a column of heavy summer-vacation traffic on a narrow mountain road and, suddenly, to spot something that all the other travelers are missing. One day on Glacier National Park's Going-to-the-Sun Highway, moving at a snail's pace, we happened to glance up into the shale cliffs of Logan Pass. There, beside a clump of mountain bear grass, we noticed an unnatural patch of white. We pulled out of the traffic. Through binoculars, the white proved to be a nanny mountain goat with a kid, all but hidden from the road below. With backpacks and fifteen minutes of scrambling, we photographed the pair as they walked thin ledges and dined on alpine wildflowers.

Some excellent wildlife photo opportunities, plus high adventure, exist on many of the scenic and whitewater float trips on wilderness rivers of the West. The Snake River, which flows a swift, serpentine course through Grand Teton National Park, is a splendid wildlife run if launched at daybreak or just before. Float trippers will see bald eagles, and the odds are good for beavers and for moose crossing the current just ahead. But even on mornings when the creatures do not cooperate, the first shafts of sunlight on the Tetons are exquisite.

The Middle Fork of the Salmon River, which races and thunders through the Idaho Wilderness Area, is primarily a whitewater river. It is surely one of

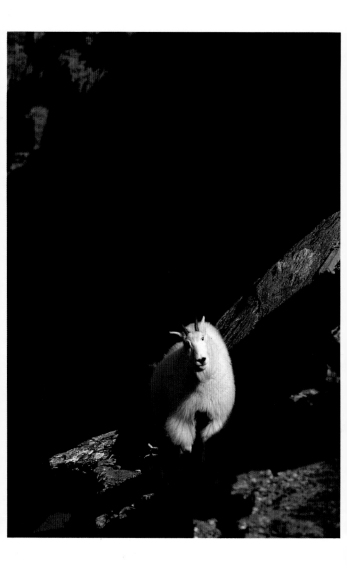
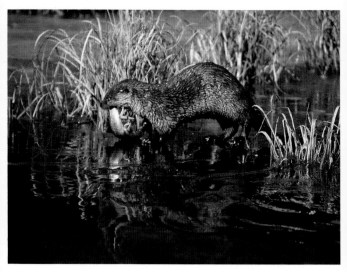

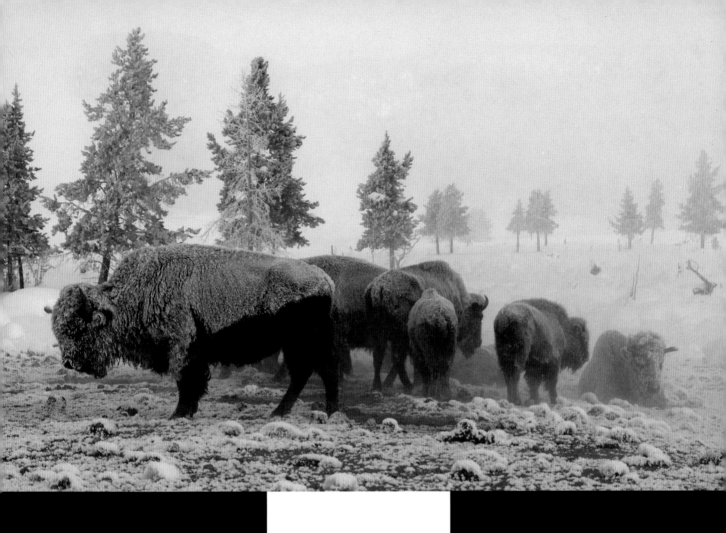

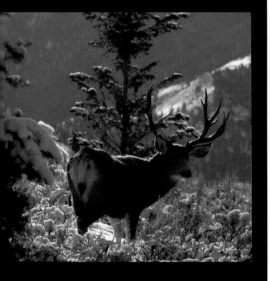

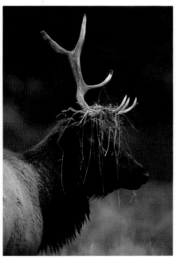

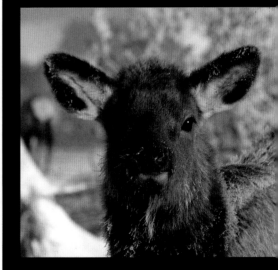

the world's wildest, most unspoiled rivers and to travel it by inflatable rubber raft is an adventure of a lifetime. The wildlife along the way is a rich dividend. Mule deer, chukar partridges, marmots, golden and bald eagles are common sights. Bands of bighorn sheep do not budge from drinking at water's edge as you pass a paddle-length away.

Given just one place to live and photograph wildlife, the choice would have to be Yellowstone. It is a cameraman's bonanza at any season. Winter might be the most stirring, the most fulfilling time of all to visit the world's first national park. Except for the single highway that connects Gardiner with Cooke City, Montana, all of Yellowstone is locked up by deep snows from (usually) mid-November until May. You travel by over-snow vehicles, on cross-country skis or snowshoes. We always begin our own trips from West Yellowstone, on the park's west boundary, by riding the snow coach to Old Faithful, where there are winter accommodations. From Old Faithful, we can ski in all directions on day or half-day trips, depending on the weather. We carry our summertime backpacks, but add cold weather survival gear in case of emergency.

The vicinity of Old Faithful becomes a fantastic blue and white wonderland soon after Thanksgiving, with massive snowfalls covering the landscape. Moisture from geysers and hot springs condenses on trees and gives them a grotesque shape. The combination of intense cold and snow drives most animals that do not hibernate down into the valleys of those few rivers that are prevented from freezing by the constant inflow of hot water. We find herds of elk, bison, and a few mule deer concentrated along the Firehole, Madison, and Gibbon rivers. They manage to eke out an existence nibbling on the vegetation that grows at water's edge, and coyotes stand by in case any do not survive.

Here is an extraordinary chance to photograph animals living in the grip of winter. Most of these elk and bison are familiar with tourists and photographers, but when we ski out along the Firehole, we are careful never to approach too near. Any animal's reserves of strength are already ebbing, and extra exertion to escape us could endanger it. Instead of carrying the extra weight of a tripod on our backs, we have devised a handy method of using ski poles as a bipod with telephoto lens. One can see much wildlife from the Gardiner–Cooke City road and even shoot some of it from the car window, but it is good insurance to carry along skis or snowshoes to reach better vantage points. To tell the truth, skis may be any cameraman's secret weapon once winter enfolds the northern Rocky Mountains.

The
Great Plains

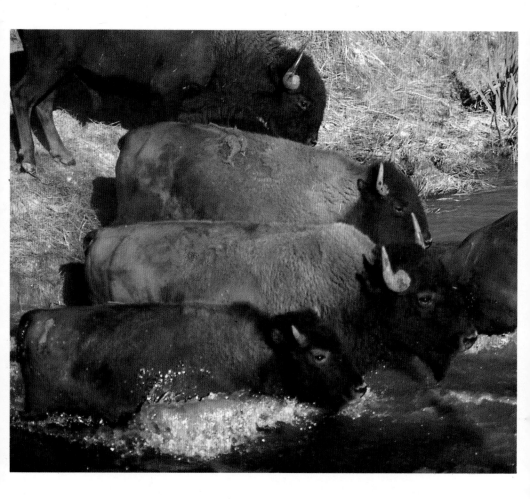

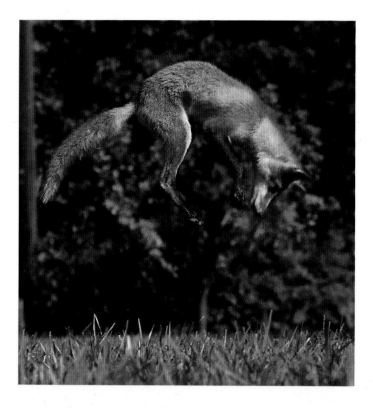

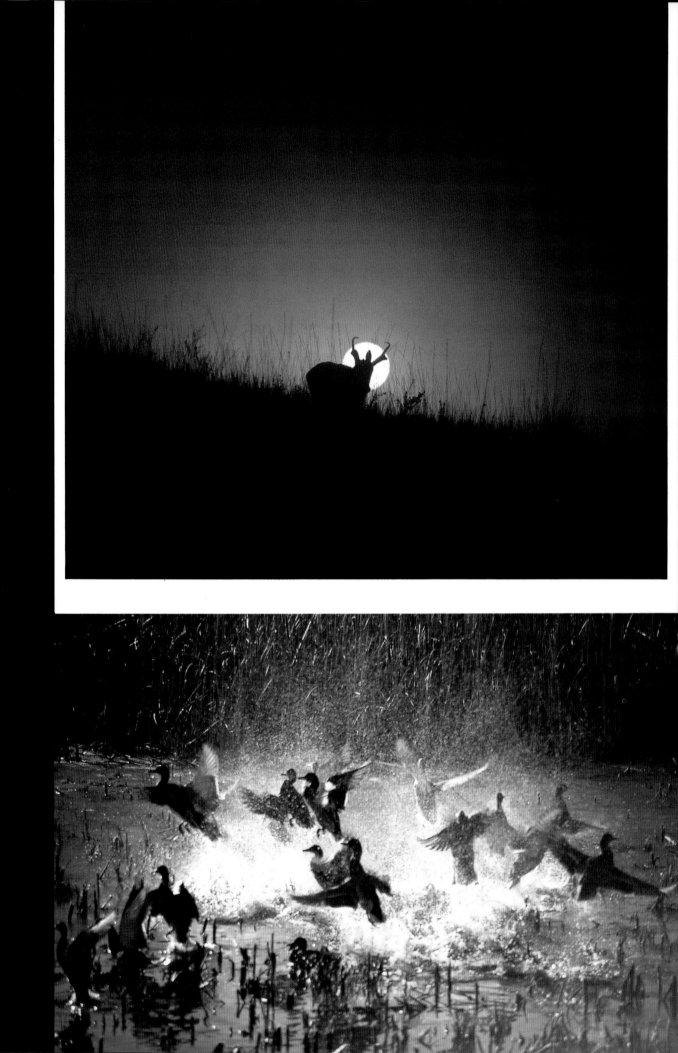

One of the essentials of successful wildlife photography has nothing to do with optics and shutter speeds. Instead, it concerns sleep—or rather arising early enough in the morning to be afield by daybreak. Its importance cannot be overstated for two reasons: first, the morning light is richer and deeper than at any time until dusk; second, with few exceptions, all animals are more active—better performers—than at any other time of the day. Devils Tower in eastern Wyoming offers a good example.

The monument is famous for the stump-shaped, striated rock column that rises abruptly 1,200 feet above the surrounding plain to one mile above sea level at the top. It is the tallest rock formation of its kind in the United States and an astounding sight at any time of day. We came to film the black-tailed prairie dog colony, or "town," at the base of the tower. We also harbored a faint hope, a very faint hope, of seeing a black-footed ferret. Until the recent rediscovery in Wyoming's Bighorn Basin, these ferrets had been considered extinct for many years, but there were reports of sightings at Devils Tower. We realized that daybreak was our only chance to see the rare creature which is almost entirely nocturnal.

Prairie dogs by the millions once populated much of the Great Plains from Texas northward far into the Canadian prairies. But following an appalling eradication effort unmatched in our history, they suffered a cataclysmic decline. Their numbers and range have been reduced by more than 95 percent. Today, both white-tailed and black-tailed prairie dogs survive only in isolated communities on scattered federal and state sanctuaries. The small rodents may not be as exciting to pursue as the grizzlies of Denali, or the rutting elk bulls of Yellowstone, but days spent in a prairie dog town in midsummer are more than worthwhile. You meet many other creatures, such as burrowing owls, and even rattlesnakes, as well as the dominant residents.

Most other visitors in the Devils Tower campground were still sleeping when we shouldered our equipment and walked the short distance toward dog town. We were already set up and scanning the colony when the sun, filtered through fog hanging over the Belle Fourche River, climbed over the horizon. Three white-tailed deer walked nervously along the edge of cottonwood trees, which bordered the colony, watching us all along the way. A coyote hurried across the almost bare earth, seemingly unaware of all the prey creatures lurking in the maze of burrows and passageways directly underfoot. No sooner had the predator passed when a small head appeared above an earthen mound, a burrow entrance. Then another and another head popped up. During the next few minutes, the town gradually came alive with prairie dogs beginning a new day of preening, posturing, quarreling, feeding, chasing, and barking.

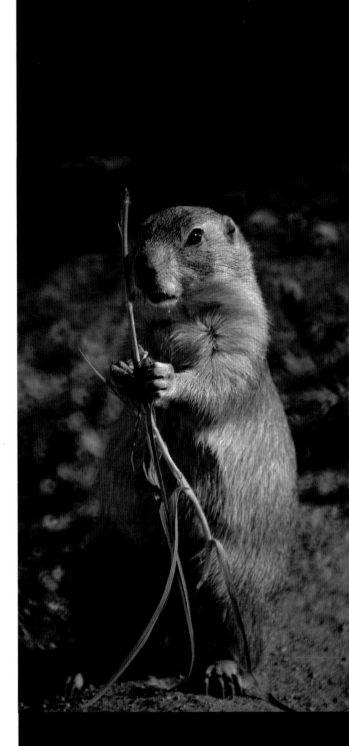

PAGE 30 TOP

Buffaloes roam freely over Montana's National Bison Range and it is an ideal place to see them living free. We followed this small herd all morning and finally photographed several bison fording Mission Creek. Bison are most active here during the early fall rut.

PAGE 30 BOTTOM

The red fox is another familiar character of middle America. This young one, baited with food to a suburban backyard, is hunting mice by pouncing upon them. Many other kinds of creatures can be photographed around feeding stations at home.

PAGE 31 TOP

In Wind Cave National Park we located this male antelope before sunrise on a very foggy morning. Then we followed it along a ridge until the sun appeared.

PAGE 31 BOTTOM

Mallard ducks flush from a prairie pond at sunset.

PAGE 33

Almost any active prairie-dog town can be an absorbing place to photograph. Something is always happening. This animal is about to dine on green salad, but an instant later another snatched it away.

So many things were going on in so many places that it was difficult to select a subject to shoot. On one mound three small pups appeared, pestered a parent, and were groomed. Much nearer, an adult disappeared into an underground passageway, but an instant later came flying out with another in pursuit. Earth was being excavated from some burrows. Then suddenly one dog snapped upright to attention, the town grew silent, and we could see the reason. Drifting in low over the ground, a golden eagle came winging directly toward the colony. All at once the ground was empty; the prairie dogs had scurried below to safety. The raptor flew away without a warm meal. A few minutes later, the residents reappeared and life in the colony resumed.

Watching through our viewfinders, we made an interesting observation. These small animals are imitators. Take the jump-yip display. From an upright sitting position, a prairie dog jumps into the air, throwing forelegs upward and head back, at the same time emitting a half-yip, half-whistle. Although we knew others would follow the first jump-yipper, we never did catch the action sharply focused on film. But it occurred to us that any active prairie dog town is an ideal field laboratory for a beginning cameraman to get acquainted with his equipment—and how to handle it faster.

Probably because the backgrounds are never as breathtaking as in mountains and along seacoasts, plains and savannas are often skipped by photographers. But wherever the soils are not intensively plowed or grazed by livestock, the Great Plains of North America contain much wildlife and immense beauty. The skies can change from azure to ominous in a short time. Also, our plains are far from unbroken by such photogenic features as badlands, meandering rivers, low foothills, and extensive wetlands, which seasonally attract great populations of migrating birds. Perhaps the best photographic chances of all come during the biannual migrations in the pond and pothole country.

One afternoon in late February, we crouched in crude blinds beside Nebraska's slush-coated Platte River. On slow, labored wingbeats, a flight of lesser sandhill cranes flew into a gusting wind and spitting snow to settle nearby on ground frozen solid. We could feel the rush of air just overhead as they descended, vanguard of an estimated quarter million cranes flying nonstop 600 miles from their Muleshoe National Wildlife Refuge wintering grounds in western Texas. During the next week or so, most of the world population of the species would gather in this 150-mile stretch of the Platte near Grand Island. Despite half-frozen fingers, crunching through shore ice, and trying to keep powder snow outside the cameras, we spent long daylight hours on the

river. We photographed the lesser sandhills dancing, feeding, loafing, pair-bonding, and flying away from the water to disappear for the day. Except for the penetrating cold and nagging problems with a camera motor drive, it was a bird "show" difficult to surpass in America beyond the plains.

Photographing waterfowl and other migrating birds has its own set of problems. A cameraman must be on hand when and where the birds are moving or are massed—not just when it is convenient. Being around water often means being around mosquitoes. At times we have found them to be more terrible than climbing a sheer cliff in pursuit of a wild goat. Because ducks and geese are hunted during open seasons all along the flyways, the already wary water-fowl are much harder to approach within reasonable camera distance than other subjects. It is a fascinating game, one which makes a hunter's passion for being in a blind at sunrise completely understandable. You attract water-fowl into camera range with the same devices gun hunters use: decoys, calls, and camouflage.

Excellent potential for wild waterfowl photography exists on most national wildlife refuges of the Great Plains. Following is a list of the main areas: Des Lacs, Upper Souris, Audubon, J. Clark Salyer, Sully's Hill, Arrowwood, and Tewaukon in North Dakota; Sand Lake, Waubay, Lake Andes, and Lacreek in South Dakota; Fort Niobrara, Valentine, and Crescent Lake in Nebraska; Kirwin, Quivira, and Flint Hills in Kansas; DeSoto and Union Slough in Iowa; Squaw Creek, Swan Lake, and Minto in Missouri; Bowdoin, Benton Lake, and Medicine Lake in Montana. Many of these contain other wildlife, even big game, fairly available to photograph. Twin (north and south) units of Theodore Roosevelt National Park, North Dakota, have long been over-looked by photographers, probably because of their remote location. But we found scenery in the badlands portions to be unique and wild. Deer, bison, and prairie dog towns are present.

A traveler touring west over South Dakota's Great Plains eventually reaches the Black Hills region, in which there are two of the finest wildlife refuges: Wind Cave National Park and Custer State Park. Wind Cave is tiny as United States parks go, but here is still another large prairie dog colony, surrounded by grazing herds of bison, antelope, and peripatetic badgers. For us, the underground caverns are of secondary interest to the wildlife above ground.

Custer is one of the largest state parks in the country and probably is also the best one from a wildlife photographer's standpoint. The heart of the park is French Creek Wilderness Area, which is encircled by an 18-mile wildlife

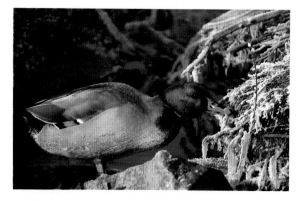

ABOVE

Hoar frost crystals encrust the vegetation surrounding a Dakota pond, in contrast to the bright green head of a mallard drake. With corn, the duck was attracted to the spot near a cattail photo blind.

BOTTOM

Sooner or later every cameraman will meet a badger on the Great Plains. Most are shy and will hurry away from a human. But occasionally one will pause long enough to be photographed. We shot this one through our pickup window.

PAGE 37 TOP

Late every winter lesser sandhill cranes gather en masse along Nebraska's Platte River. It is exciting to photograph them at any time, but never more than at dawn just before the birds leave the water on their daily feeding flights.

PAGE 37 LEFT

A fixed photo blind was all but ignored by this pintail drake which swam to very close range. We had been careful to camouflage the blind with natural materials. Waterfowl can be lured into an area near a blind if it is baited with waste grain.

PAGE 37 RIGHT

While hiking in low sagebrush hills one morning we came across a strange object on the ground. As we looked closer, the object became a very small antelope fawn which did not move or even blink when the camera shutter snapped. But we did not linger there. The fawn had not been abandoned. A moment later we saw its mother watching us anxiously from a distance.

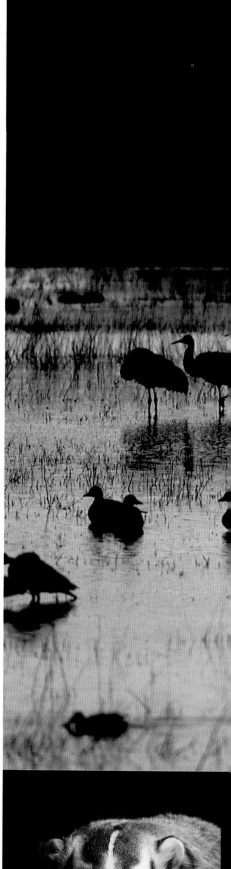

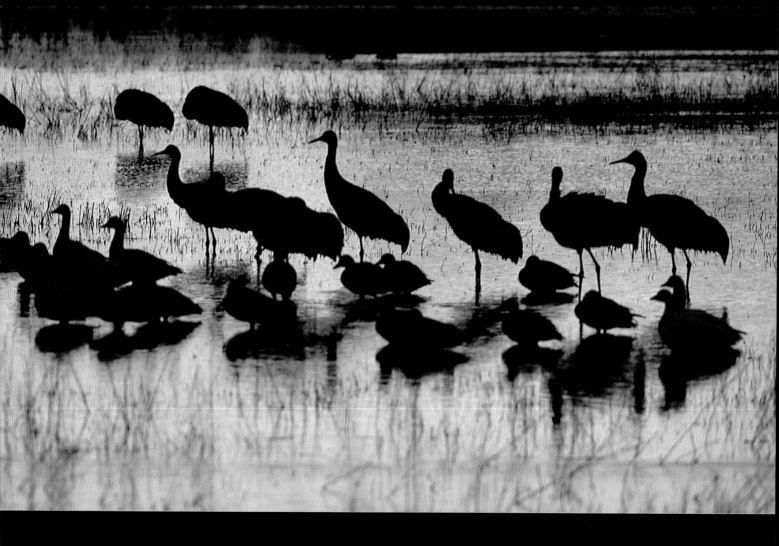

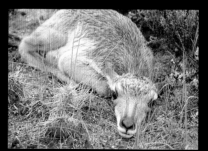

loop road. Often we have started this circuit without ever finishing it because we met too many antelope, bison, mule and white-tailed deer along the way. Spring is a very good time to explore Custer Park because new green grass covers the foothills where both the antelope and bison will be dropping their fawns and calves. Late August can be unpleasantly hot, but exciting, because bull bison are sparring and smashing in clouds of dust to breed with cows. But in either spring or late summer, the scene is exactly the same as a covered wagon traveler or cavalryman would have observed when riding westward more than a century ago. Strange as it may seem, bighorn sheep also exist in Custer State Park, although it isn't always easy to find them. But mountain goats (which long ago escaped from captivity and have multiplied) are not difficult to photograph around Mount Rushmore and on Harney Peak just outside Custer Park.

Westward from the Black Hills, rising onto higher and higher plains deeper into Montana, we reach the National Bison Range, another American treasure. The bluffs and grasslands here comprise one of the first of several refuges established just as bison were teetering on the edge of oblivion early in this century. President Theodore Roosevelt designated the Bison Range in 1908, when only about 300 of the species survived on earth. Today, some 300 freely roam the Bison Range alone, along with all the other large mammals of the northern Rockies, except grizzly bears. This is probably the place where a photographer can focus on more species of big game in a single day than anywhere else in the United States, including Yellowstone National Park.

We spent one warm and golden day toward the tag end of summer following a herd of bison. The year was 1980, but it could have been 1880 or any summertime at all in the distant past. At dawn, we found the animals bedded on a steep slope, but at sunup all arose and headed toward Mission Creek, grazing on cured, brown prairie grasses. Most were cows with some calves now four months old, lowing and grunting continuously as they moved. Two or three of these cows were in estrus, evident because three or four shaggy herd bulls singled them out and followed them closely in the milling group. Sudden fights broke out, violent shoving matches that raised plumes of dust all the way down to the creek. At water's edge, a brief truce lasted only as long as necessary to gulp down the clear, cool water. Then all waded across the river and the jockeying began anew. Some bison paused long enough to roll wet, dark bodies in tan dust on the far bank. Another began running and that triggered a brief stampede. In a few minutes all were out of sight. At the same time our cameras were empty. We dusted them off and headed back to camp for an afternoon siesta.

The
Pacific Coast

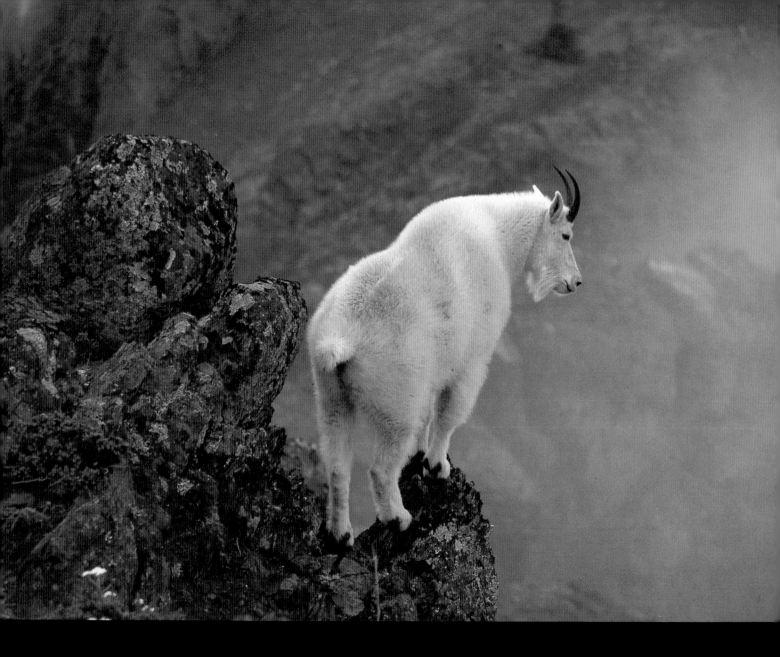

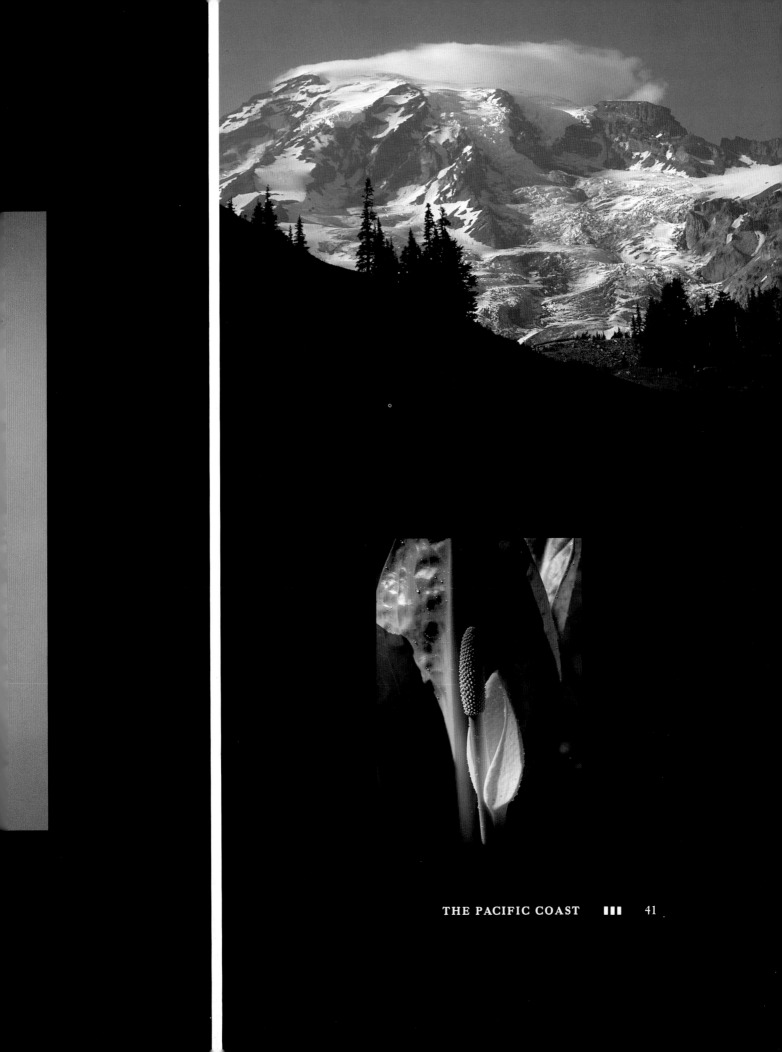

PAGE 40

We found this billy goat after a steep climb to Klahhane Ridge in Olympic National Park. Unafraid of us, it walked easily through mists along a rocky spine. No large native animal is so surefooted.

PAGE 41 TOP

No matter from what angle it is photographed, Mount Rainier is a radiant sight on a sunny day, when the peak may be visible for a hundred miles. Hiking the trails is high adventure, during which a cameraman might find mule deer or elk in the foreground of his mountain scenes.

PAGE 41 BOTTOM

A springtime photographer in the Northwest cannot miss seeing yellow skunk cabbages, which grow widely in boggy places, even in standing woodland pools. Where skunk cabbage grows in quantity, black bears can usually be found because they relish eating the entire plant, including the roots.

There is a certain trailhead in Olympic National Park, Washington, which is not too easy to find. Drive several miles southward past Heart of the Hills ranger station and watch for a widening on the right where cars have pulled off the pavement to park. Nearby, a faint path originates in dense, green vegetation and proceeds up a steep mountain slope. We found the trailhead early on an August morning and there filled our backpack compartments with cameras, film, lunch, a topographic map, and a poncho apiece. Our goal was to hike the two or three miles to Klahhane Ridge, where a herd of mountain goats is known to spend the summer and fall. We almost canceled the hike because ominous, low clouds spilled down on us from Hurricane Ridge to the west. But we decided to try it anyway. At the time, we had little experience with the strange goat-antelope of the Pacific coastal ranges, which is the most surefooted of all the large mammals of North America. The white, bearded goats thrive on knife-thin ridges and on the faces of dizzying cliffs, where even bighorn sheep will not venture.

The trail to Klahhane was not meant for leisure hiking. It is steep from the outset and the gradient never relaxes. As always, our legs were in very good shape, but after an hour of steadily trudging upward, we paused and removed the backpacks. Our lungs were on fire from climbing too rapidly. We were wet with a combination of sweat and the moist cloud that seemed to hang over us. But once underway again, we soon emerged above the cloud into a brighter alpine world.

Now near timberline, the trail switchbacked through meadows knee-deep in wildflowers. Then suddenly, coming around a sharp bend, we stopped face to face with a goat, which blocked the trail. It seemed completely unsurprised at meeting us on the mountainside and didn't budge one inch. As we fumbled into backpacks for cameras sealed in waterproof containers, a second goat—this one a small snowy white kid—stood up from its bed in the wildflowers and joined its mother in the center of the trail. It was one of those rare encounters and photo opportunities that happen much too infrequently.

We spent another hour following and photographing the pair as they grazed in that meadow high on the Olympic Peninsula, above the clouds. Neither had any fear of us and we had no need for the telephoto lenses we carried. We focused from a few feet, from many angles, backlighted and in over-the-shoulder light. Eventually the goats tired of the encounter and both disappeared into a deep ravine, where they bedded side by side. Exhilarated, we continued with fresh vigor up the trail to Klahhane Ridge, but dark clouds spilled over again, denser than before. When we finally reached the ridge, it seemed to be a slate-colored island suspended in a dank, misty void.

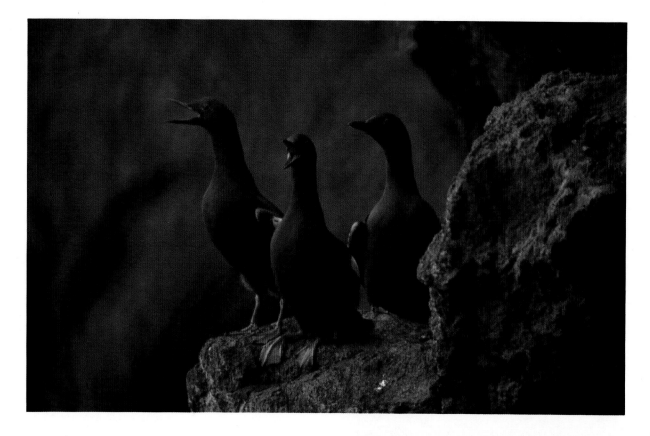

ABOVE
Some good photographs are the result of accident or pure luck. We were climbing cautiously around a cliff for a better camera angle of the Oregon coastline below us when we noticed just ahead the scarlet feet of three pigeon guillemots perched in deep shade.

RIGHT
Some of the most scenic hiking trails in Olympic National Park, Washington, begin on Hurricane Ridge. These pathways are good places to meet black-tailed deer at any time of the year. The photo of twin immature bucks was made early on a summer morning.

PAGE 45
Our favorite American littoral is the Oregon coast, which is astonishingly beautiful and better preserved from development than any other state seashore.

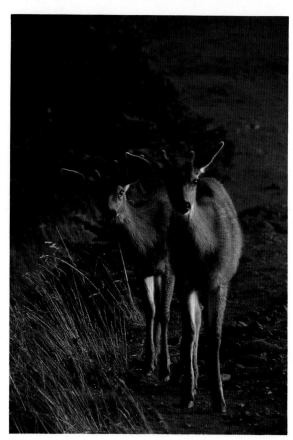

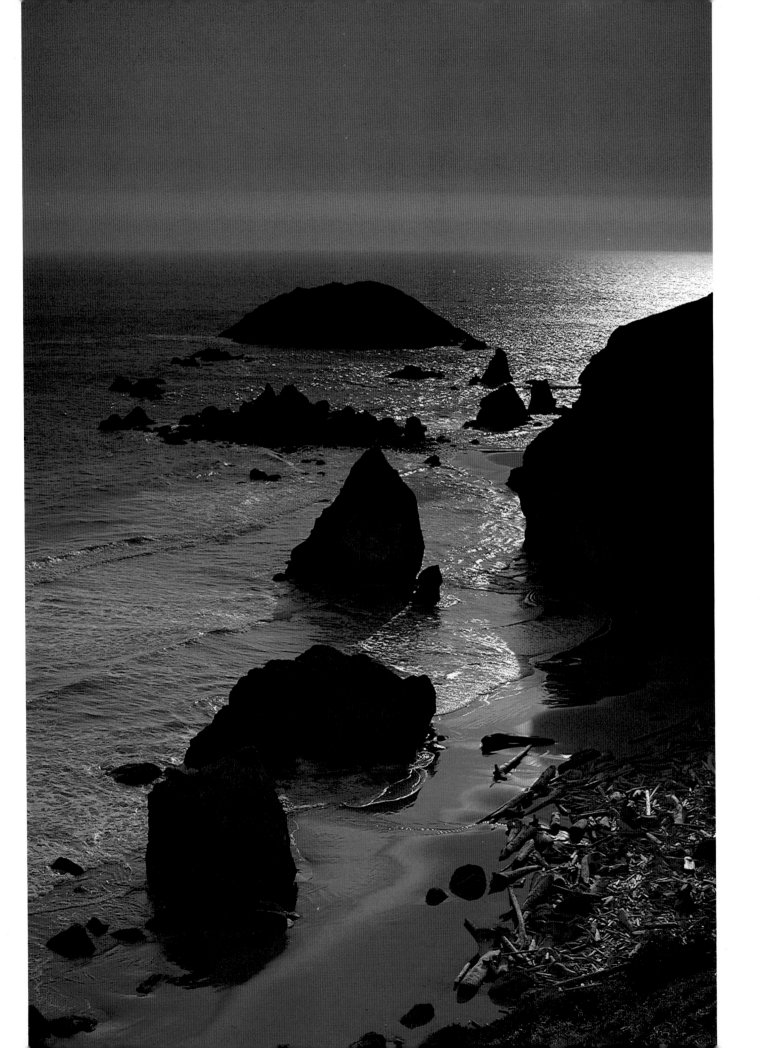

Moving slowly along the crest of the ridge, we talked about returning to the trailhead and of trying again another day. In places the ridge fell away to eternity on both sides of a pathway now almost invisible. We stopped abruptly when we heard a rock dislodged and crash away out of hearing. The same instant one ... two ... then a third white ghost materialized from the void ahead of us. We had nearly stumbled on three huge billy goats. For a few uncertain moments we stood facing and staring at one another. Then one of the goats nudged another in the rump with black stiletto horns. One by one, all three bedded down. We backed away several paces and also sat down. Leaning against sharp rocks, we wolfed down cold, delicious sandwiches. We had to laugh out loud because only wildlife photographers could enjoy lunch in such a strange and eerie situation, high in clouds, and thirty feet away from three male mountain goats chewing their cud.

Early in the afternoon, the overcast lifted just enough to permit some minimum photography. Obligingly, the goats strolled along the rim of the ridge, sometimes almost posing for us against the cloud background. In time, they tired of the game and plunged nimbly down a loose, nearly vertical rock slide and out of our sight. But we felt we had superb goat pictures on film and we almost floated back down the steep, killer trail. It had been a difficult day, but a very rewarding one. We slept much too late in warm sleeping bags the following morning, but no matter because it was raining steadily.

Olympic is not among the most heavily used of our national parks, although it is certainly among the most scenic. But there is one notable drawback, especially from a photographer's viewpoint. Mount Olympus in the heart of the park is drenched with the heaviest rainfall (200 inches annually) in the continental United States. Clouds carried onshore by sea winds have created one of the world's few temperate rain forests at lower and mid-elevations of the western and central Olympic Mountains. But unlikely as it seems, the Olympic Peninsula coast (on the Strait of Juan de Fuca) barely forty miles northeast of Mount Olympus is our driest coastal region outside of southern California.

A backpacking cameraman equipped for the predictably damp weather can revel in Olympic Park. Hikers along the remote wilderness Pacific beaches will find photogenic cliffs, sea stacks, seabirds, tidepools writhing with marine life, and beachcombing treasures cast ashore by a ceaseless surf. Roosevelt elk frequent the few park roads and lowland meadows in winter. Summer is the ideal time to hike through westward-sloping rain forests, especially along the Hoh River. Here you stalk through towering stands of western hemlock,

Sitka spruce, western red cedar, and bigleaf maple, draped with club moss and lichens. The open spaces along the trail may be the best of all places to find black-tailed deer. We had them poking around our campsite on the Hoh River.

The popular national parks of California—Yosemite, Sequoia, Redwood, and Lassen—are better for photographing the matchless scenery, the wildflowers, and the giant trees than wildlife. But we have encountered approachable mule deer in late summer at both Sequoia and Yosemite, perhaps in backgrounds as gorgeous as the species is ever found. Point Reyes National Seashore is a happy hunting ground for a footloose photographer with no specific targets. Channel Islands National Park (which unfortunately we do not yet know very well) is the premier place to film marine mammals and a large cast of nesting seabirds. Lovely Mono Lake, east of Yosemite, is a national treasure being sacrificed to fill swimming pools and soak lawns in southern California, but it is still a worthwhile (although seriously diminished) place to watch nesting birds in springtime.

Many excellent, if not the best, marshes in which to photograph migratory waterfowl are in the Pacific coast states. In autumn, the Klamath Basin Refuges on the California–Oregon border may contain one of the greatest goose and duck concentrations on earth. Birds from as far away as extreme northern Alaska and even Siberia funnel through here during migrations. It is possible at times to fill a viewfinder with some of the 250,000 snow geese in temporary residence.

On a sunny day in September 1971, we waded ashore on an island named Lisianski, after the Russian sea captain who first discovered the beach beyond a maze of treacherous coral reefs. Lisianski is the farthest west (six degrees east of the International Date Line) island of what must be ranked among the world's premier wildlife sanctuaries, the Hawaiian Islands National Wildlife Refuge. This is a loose chain of tiny islands and atolls extending for almost 1,100 miles westward from the main Hawaiian Islands. The land area of the refuge is only 2,000 acres, but the refuge boundary protects 200,000 acres of lagoons and some of the least disturbed, least exploited reefs left on earth, with an estimated 100 million seabirds, which depend on the islands for nesting. Currently, the state of Hawaii would like these waters put under its jurisdiction rather than that of the federal government. Were this to come about, fishing would begin on a commercial scale with possible grave consequences for the wildlife of the refuge.

Trouble has visited these islands in the past. Plume hunters, guano diggers, Japanese poachers, and the introduction of domestic hares completely elimi-

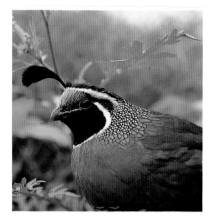

The California or valley quail is an abundant, spritely, gregarious bird not easy to capture on film except when it comes to refuel, daily, at a regularly stocked feeding station.

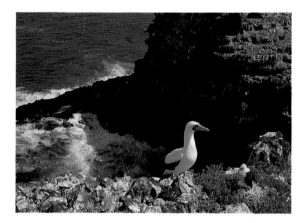

Necker is one of a necklace of tiny islands, which extends northwestward for almost 1,100 miles from the main Hawaiian Islands to Midway. Because of a pounding surf and tremendous mid-Pacific swells, few humans have ever climbed ashore on Necker. The masked booby is one of several species of oceanic birds that nest on this isolated land-fall.

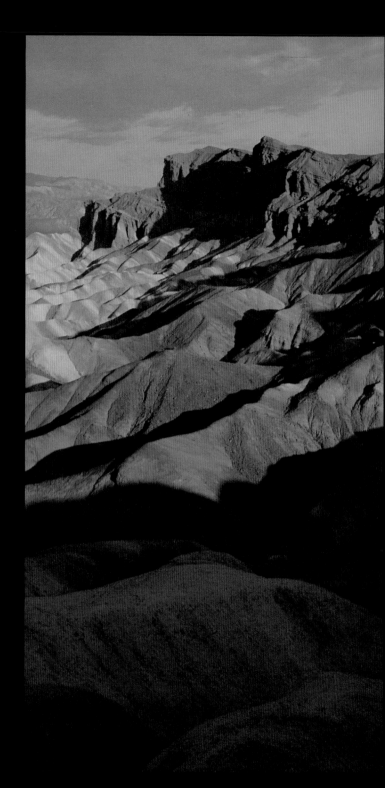

Death Valley National Monument, California, is largely unrelenting desert, some of it below sea level. Rare desert pupfish live in a few shallow warm springs. The panoramas are magnificent, but a photographer must concentrate his work soon after daybreak or just before dusk, otherwise the pictures are pale and bleached. Desert bighorn sheep can be filmed around water sources during the brutally hot summer months.

nated at least three endemic species—a flightless rail, a honeycreeper, and a millerbird—while almost dooming others. Theodore Roosevelt created the refuge in 1909 to prevent further destruction.

In a 25-foot surfboat from the U.S. Coast Guard cutter *Buttonwood*, we threaded our way cautiously through coral heads toward solid ground on Lisianski Island. Clouds of noddy and sooty terns swarmed out to meet us; boobies and great frigatebirds with bat-shaped wings flew above the terns; and ruddy turnstones walked among several monk seals, which dozed and baked on the beaches. The din of the seabirds was shrill and unreal as we waded onto the 382-acre speck of real estate in the center of the Pacific.

Hiking completely around Lisianski's beach is a mere three and one half miles. But over the soft, powdery surface in the heat of autumn, at twenty-six degrees north latitude, it seemed much longer. But what a remarkable, hot hike it was! Our companions, wildlife biologists Gene Kridler and John Sincock, marine mammalogist Ken Norris, carried enough gear to live-capture, hold, weigh, and tag as many monk seals and green sea turtles as they could catch. The busy biologists counted 119 seals, which are deceptively lethargic and may not bother to move when approached. But they tagged only the smaller animals because all have terrible teeth and resent being handled— the larger, the more resentful. Monk seals are gravely endangered and are the only species of seal surviving anywhere in tropical waters. They exist only on Lisianski and on a few other Leeward or northwestern Hawaiian Islands. While our friends toiled on a project aimed at saving the seals, we exposed an extravagant amount of film. Back aboard the *Buttonwood* that evening, we were gloriously dehydrated, but just as gloriously thrilled about the day's "shoot."

Our voyage aboard the *Buttonwood* (which began at Midway Island, roughly midway in the Pacific) to patrol the refuge and census the birds touched on all the islands where landing is at all possible: Pearl and Hermes Reef, Laysan, Necker, Nihoa, Gardner Pinnacles, French Frigate Shoals, finally terminating at Honolulu. Even on a calm ocean, which favored us, the massive swells made scrambling and clawing ashore up the cliffs of Nihoa and Gardner Pinnacles a perilous undertaking. We waited to reach the top of a swell and then leaped for a foothold. Despite the myriad of seabirds we found, plus such rarities as the Nihoa finch, it was an immense relief to be back safely in the surfboat and off the island.

Laysan, where we camped onshore for a week, was an easier matter of picking a way through guardian coral reefs toward a sloping beach. There we unloaded everything we would need, including food and every drop of water,

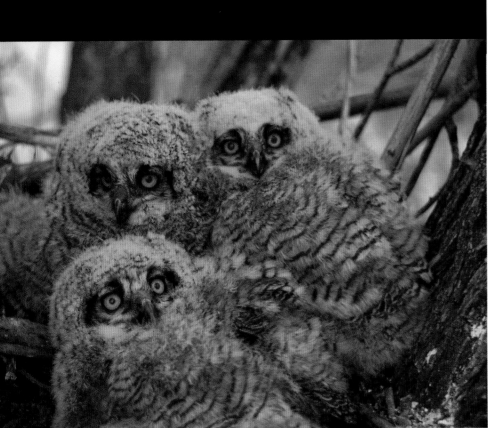

We camped one night beneath a large cotton-
wood tree on the Malheur National Wildlife
Refuge, Oregon, but sleep did not come
easily because of the nightlong activity over-
head. Next morning we found the reason: a
nest of great horned owlets. The rustlings we
heard were parents feeding their young ones.

Arrowleaf balsamroot glows against the dark
background of the Idaho Wilderness Area.

FAR RIGHT
The bald eagle, our national symbol, has not
fared well in recent times, although it still
exists in good numbers in the Northwest,
especially (and seasonally) around Puget
Sound and along the Skagit River. But the
best place to photograph eagles south of
Alaska is in Glacier National Park, Mon-
tana, during November.

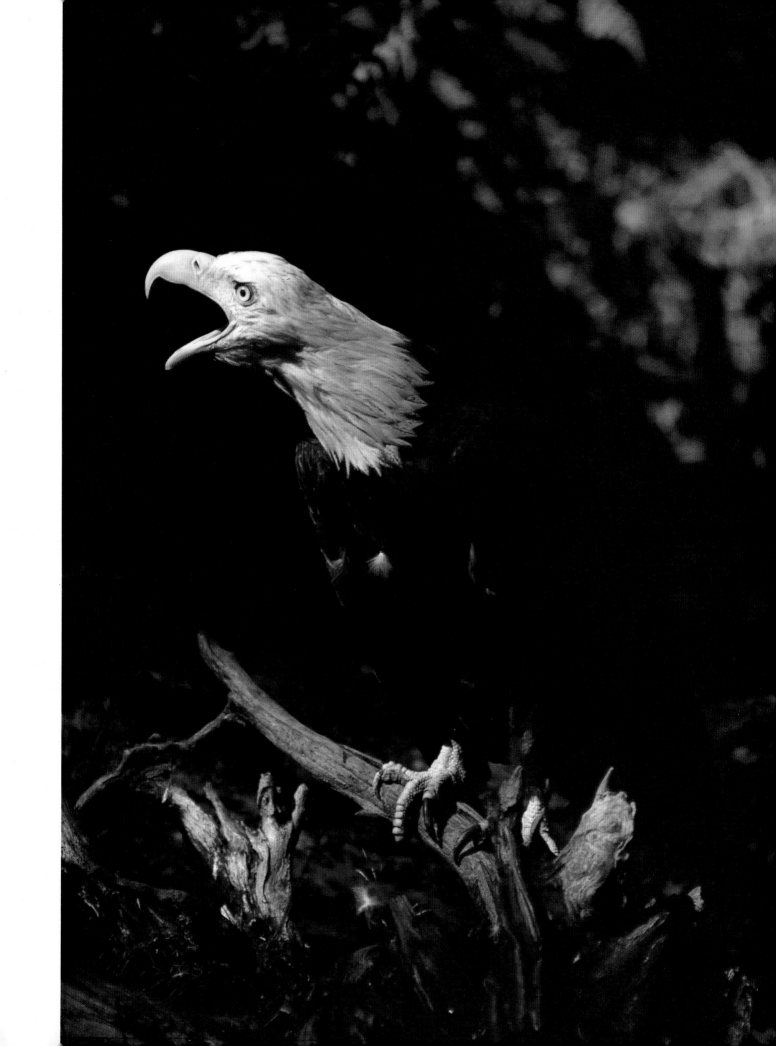

until the *Buttonwood* was able to retrieve us. We had to figure that a storm or high seas could delay the pickup for days. When the *Buttonwood* cruised out of sight, we were stranded on a genuine desert island. We had camped in unusual situations often before, but this was unique. Parents fed a reptilian frigate chick just twelve feet from our screened tent flaps. Immature boobies soon discovered the tent ridgepoles to be perfect perching (and defecating) sites worth quarreling over. Endemic yellow Laysan finches ate bread crumbs from our table and eventually from our hands. After dark, a wedgetail shearwater peered through the mosquito netting at the curious figures inside, cleaning lenses in lantern light. Another tried to dig a nesting burrow beneath the canvas floor. All night long, the unearthly moaning chorus of wedgetail and Christmas Island shearwaters, and of Bonin Island petrels, rose and fell with the shifting wind. We were living among the birds.

One week proved too little time to spend on Laysan. Beside a lagoon several times as salty as the surrounding sea, exposed to a relentless sun, we aimed cameras at bristle-thighed curlews, wandering tattlers, and turnstones. But mostly we were interested in the Laysan teal, which swam there daily to skim the surface for brine flies. These small chocolate-colored ducks are seriously endangered and live nowhere else in the wild. Once the world population was down to only seven individuals, but it had risen to about 120 when we visited.

From hot ocean beaches to icefields atop the Cascade Mountains and the High Sierra, the Pacific regions of America offer unlimited opportunities for any wildlife watcher or photographer.

IV

Texas

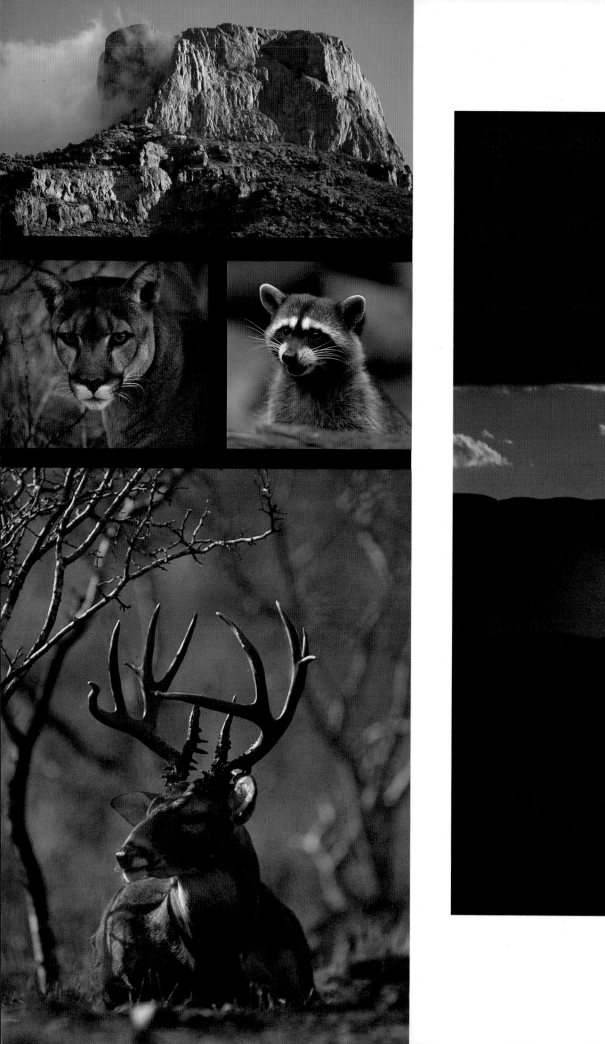

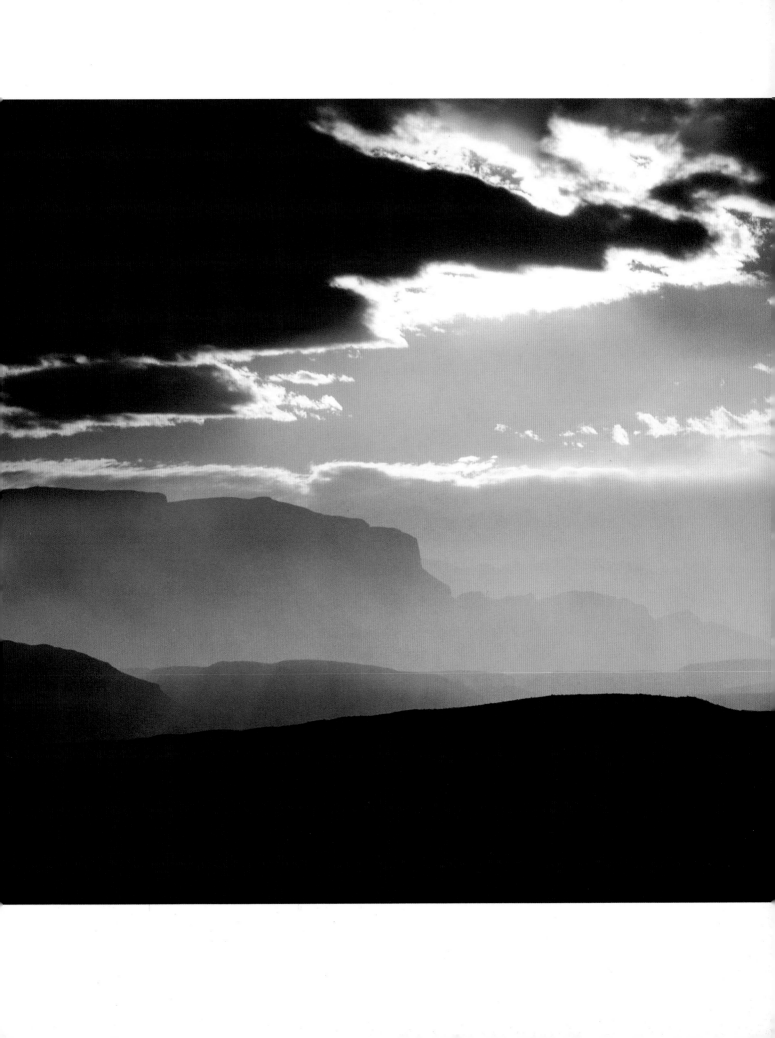

PAGE 54 TOP
Casa Grande is a major landmark of the Chisos Mountains, the heart of Big Bend National Park. The forests of dense scrub oak surrounding the peak are habitat for Carmen Mountain white-tailed deer, which are very small and very shy.

PAGE 54 LEFT
In Texas, the cougar, or mountain lion, is a phantom. A photographer can leave his footprints all over the Big Bend of the Rio Grande country, find plenty of cat signs, but never really spot the cat. And if he does, it will probably be in deep shade of an even deeper canyon.

PAGE 54 RIGHT
It isn't necessary to look for raccoons in Texas. In many public campgrounds they will look for you, searching for your cache of food. This one came seeking its breakfast around our tent at Aransas National Wildlife Refuge.

PAGE 54 BOTTOM
We almost passed by this fine white-tailed buck resting motionless, its antlers blending neatly into stems of dry brush. We were driving along a south Texas cattle trail when we saw it. The deer sat still for several exposures, perhaps believing it was concealed, before the pressure to escape became too great.

PAGE 55
A storm front moving from Mexico over Big Bend country can be an ominous sight. Rain and then a wet snow followed this one. But many of these storms are brief, clearing the atmosphere, and the bright days immediately following are ideal for photography. In late winter many desert plants bloom after the rains.

PAGE 58 TOP
In repose near a nest or in flight, the roseate spoonbill is our most brilliantly plumaged wading bird. It adds great beauty to a typical Texas rookery, where green of the foliage and white of the egrets are the basic colors.

PAGE 58 LEFT
Our blind is on one edge of a wading-bird rookery near the Gulf Coast. A tripod-mounted telephoto lens is aimed at a roseate spoonbill nest. Then this egret head appears out of the brush only a few feet away, and we shoot the portrait with a shorter lens, which is always handy.

PAGE 58 RIGHT
Only pitifully small segments of the original Big Thicket of east Texas survive today, most of these in a fragmented national preserve. Still, much wildlife dwells in the dark hardwood forests, and carnivorous pitcher plants, such as this one, grow in moist soil along the woody margins.

PAGE 59
We have spent a hot thirsty day simmering in a blind on Sidney Island. Suddenly, egrets are soaring over the island, and some perch just above our blind, framed against the setting sun.

It is still well before daylight when we turn southward through McMullen County, south Texas. The lonely road is empty of traffic. Murry Burnham is driving slowly because a dense ground fog, typical of December, cloaks that brittle, brushy countryside. Morning is a pale lemon glow in the east when he turns off the pavement and follows a narrow, twisting cattle trail, which peters out beside a stock tank where an ancient, creaky windmill is pumping a trickle of water.

Burnham produces a pair of white-tailed deer antlers tied together by a rawhide thong, and he drapes these around his neck. From the bed of the pickup, he hefts a mounted deer, which is really the skin of a doe stretched over a papier mache form light enough to be carried over a shoulder. With both the antlers and the deer, plus a light rucksack, our guide walks quickly but very softly down one of the *senderos*—barely cleared cowpaths—which lead away from the windmill. We follow, carrying cameras through extremely dense ground cover. When we have reached a grassy clearing, Murry stands his counterfeit deer in the center of it. Next, he sprinkles the rump of the decoy with fluid, which has a strong animal odor. It is "doe in estrus lure," more precisely, female deer urine. Now we crawl deep into the brush surrounding the decoy and sit as comfortably as possible, cameras on our laps.

For a time we remain motionless and listen to sounds of night blending into day. As soon as an exposure meter indicates that there is enough light to film, we nudge Murry, and he picks up the antlers. What follows is a remarkable performance. First, he cracks and rattles the antlers together to imitate two white-tailed bucks sparring. Keep in mind that this is the rut, the breeding season, when male deer fight for supremacy and for does. He also scrapes the antlers on the ground and against dry blackbrush. Pausing for a few moments, he is about to begin again when we notice motion just opposite our decoy. The white tips of antlers appear just above the thicket. In the next instant, a splendid male deer with high, heavy antlers, eyes bright and neck swollen, bounds out into the clearing directly toward the decoy. If it knows we are watching, it gives little sign of it, not even when the motor drives of two cameras begin clicking.

For several minutes, the elegant buck circles and sniffs the mounted doe, completely puzzled but intrigued by it. Once or twice, the deer stares directly at us, and its white flag-tail is raised in mild alarm, but until the deer finally realizes it has been duped, we have exposed two rolls of film. The widespread, very abundant white-tailed deer of North America is difficult to film in the wild. And that is doubly true when the photographer is also trophy hunting, trying to shoot only large and mature bucks. These males do not reach ripe

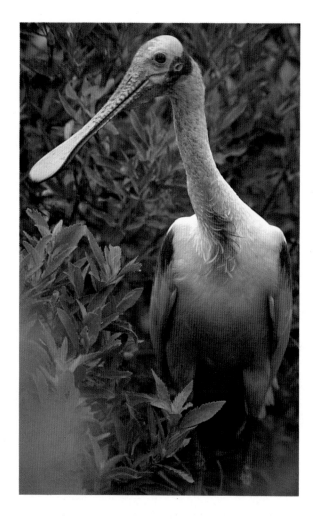

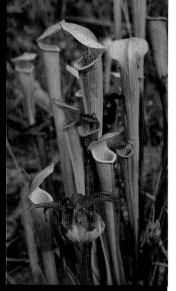

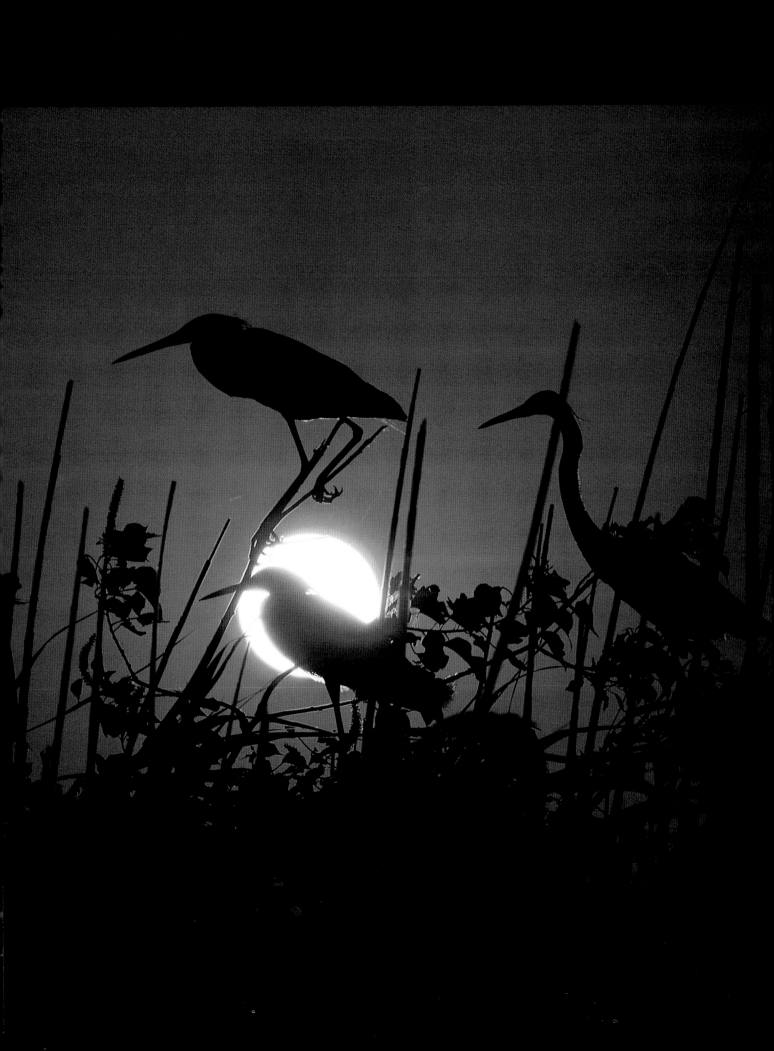

old age by being foolish. To shoot them successfully, consistently, means using trickery and other techniques such as baiting, blinds, decoys, rattling, or some combination of these.

Working with Murry Burnham of Texas has been a graduate course in calling and attracting wildlife. A native of Marble Falls, Texas, he is a woodsman of extraordinary skill. By using a variety of mouth calls that he invented, artificial scents, camouflage clothing, and even by scraping a turkey wing bone over the lid of a cedar box, he is able to call everything from caracaras to cougars, turkeys, and owls to ringtail cats. Using only a small cigar-sized, plastic mouth call, he is absolutely phenomenal when coaxing such wary animals as coyotes and bobcats into close enough range for cameras.

Texas has long been our laboratory for testing and discovering new wildlife photography skills, and it provides unlimited opportunity for any cameraman. Like a favorite uncle, Texas has a wide embrace. Most Texans do not realize that almost 5,000 vascular plants grow in the state, including 2,000 different wildflowers and several rare cacti that do not exist anywhere else. Add 600 species of birds—the largest number of any state in the union—mountains, deserts, lakes formed by earthquakes, high and low prairies, marshlands, piney woods, and the great barrier island, which is Padre Island National Seashore. It is a state of immense diversity, which no cameraman could cover completely, even if devoting an entire life to it.

Our own favorite part of Texas is the southwest corner. It is the driest, least populated, and most remote from the Houston–Dallas kind of Texas. Seldom have we seen a greater variety of wildlife, present and passing, than during one late autumn morning in a hunting blind near Encinal. Southwest Texas also contains the arid and haunting Trans-Pecos, a corner of the Chihuahua Desert, Big Bend National Park, and Guadalupe Mountains National Park.

The hiking trail that follows McKittrick Canyon for a few miles before beginning to switchback upward into the heart of the Guadalupes is a treasure to discover. If you start walking soon after daybreak, or delay until the end of the afternoon, the other hikers you are most likely to meet among the red-scaled madrone trees are mule deer, many mule deer. They are not shy, although all seem to vanish during the middle of the day. The trails of Guadalupe Mountains National Park also lead to anyone's best chance to glimpse a mountain lion.

The trails of the Chisos Mountains, heart of Big Bend National Park, are also ideal places to meet deer in a magnificent environment. These are not

ordinary deer, but Carmen Mountain deer, a race of miniature white-tails, which lurk in the oak thickets around the Chisos public campground. Once during the week between Christmas and New Year's Day, when a light snow had dusted Casa Grande and her sister peaks, we discovered that Carmen bucks respond to rattling antlers as readily as the twice-as-large bucks of southern Texas brush country.

We have met more serious wildlife photographers, amateur and professional, while vagabonding in Texas than anywhere else. One popular area is Aransas National Wildlife Refuge on the Gulf Coast near Rockport. It is best known for the wintering whooping cranes, although filming these is a forlorn hope. But the refuge does have white-tailed deer, wild turkeys, javelinas, and even alligators. Not far distant is Sinton and the Welder Wildlife Refuge, unique in that it is a private sanctuary and wildlife scientific station with some access to the public. A patient and serious bird photographer can be endlessly absorbed at the Santa Ana National Wildlife Refuge near McAllen. Baited blinds attract everything from Mexican green jays and orioles to chachalacas.

Sue Bailey is the warden and caretaker of an uncommon bird island, Sidney, in the lower Sabine River, which forms the eastern boundary of Texas. Employed by the National Audubon Society, trustee of the island, she has a sweaty, smelly, sometimes perilous responsibility. Thousands of wading birds, egrets, herons, roseate spoonbills, ibises, nest en masse here early every summer. For a few months, the small island seethes with life and it is a temptation for passing boaters and fishermen to go ashore. Sue must see that this does not happen, that nesting goes on undisturbed. Fortunately, Audubon selected a determined, capable woman.

We spent a day crouched in a photo blind on Sidney, while Sue carried out both her patrol and her annual nesting bird census. Normally, the total humidity, intermittent rain, and stench would not make for a comfortable vigil, but with the unceasing action all around, we barely noticed anything but the graceful, squalling birds. Life in a busy wading bird rookery is the closest thing to choas in the wildlife world.

A white-plastered roseate spoonbill nest of loose sticks was one of several within easy photographic distance of our blind. It contained three pale pinkish reptilian chicks, which did not get along well together. At regular intervals, one of the parents arrived to feed the triplets, but two seemed to monopolize the meals; the smallest, we guessed, would not survive.

A steady din hung over Sidney Island, and the volume increased whenever a flight of parents returned to feed the begging chicks. In the center of such a

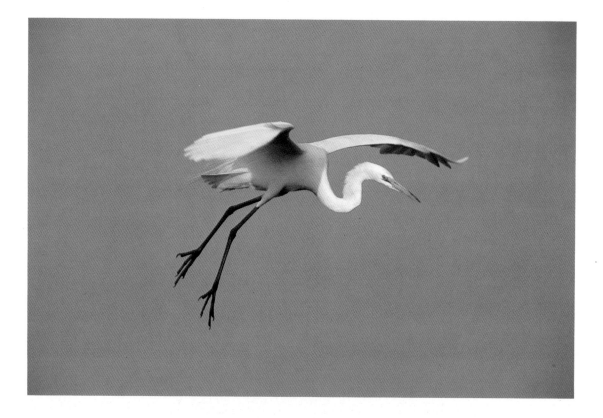

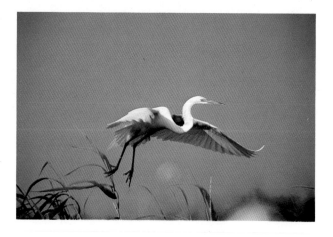

Life in an active wader rookery is a constant stream of noisy arrivals and departures of parents fetching food for nestlings. It is fascinating and challenging to photograph these incoming common egrets. A smooth-working ball socket tripod, fast shutter speed, and sharp focus are necessary to "stop" the descending birds.

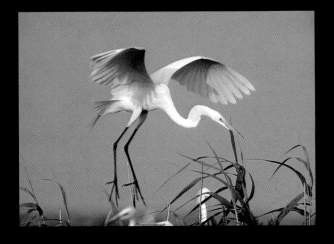
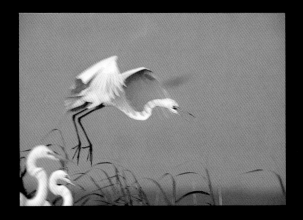
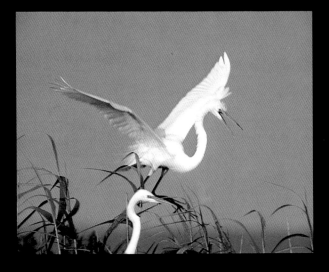
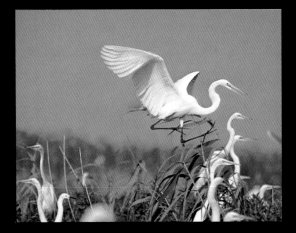
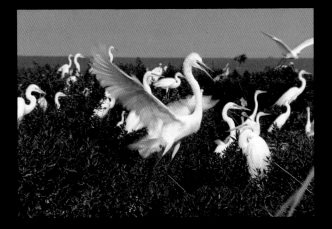
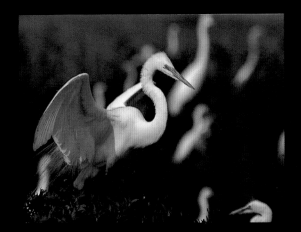

spectacle, there is a terrible compulsion simply to aim a camera at the mass and keep shooting, trying to capture the entire scene. But from bitter past experience we knew it wouldn't really work, and so we concentrated on individual birds and individual vignettes—on snowy and common egrets, on a glossy ibis, and on preening cattle egrets in chestnut-tinged breeding plumage.

Alaska

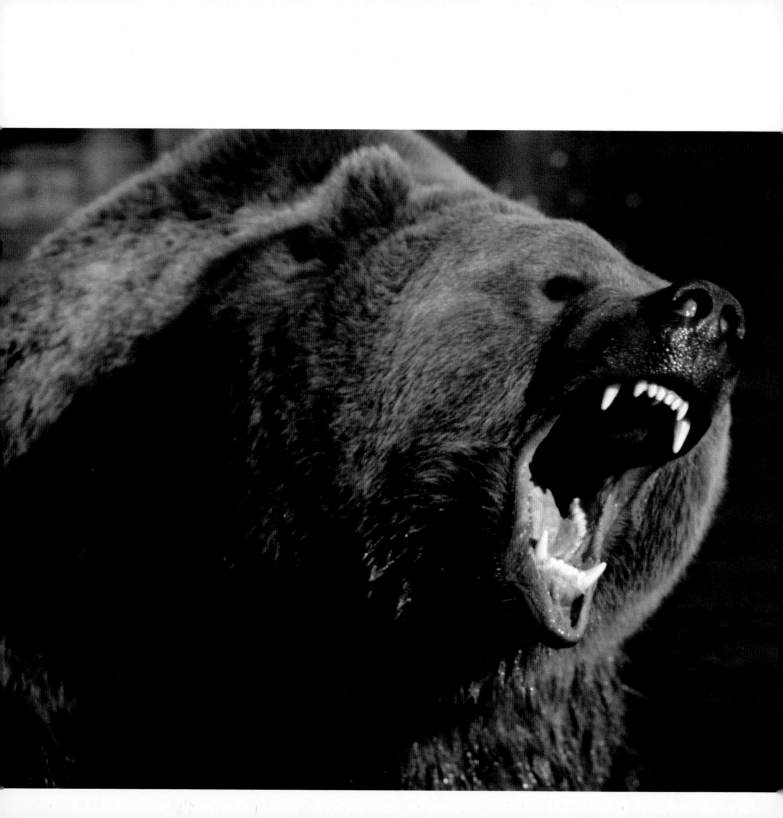

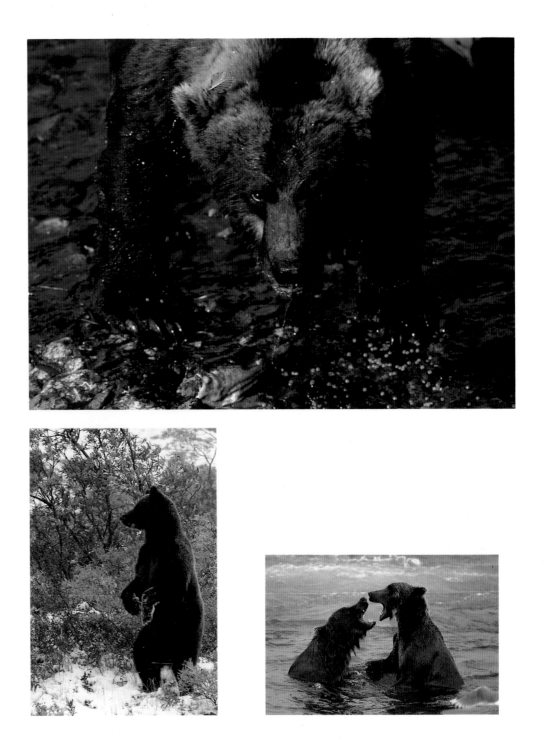

PAGE 66

The Peninsula brown bears, which may reach almost half a ton in weight, are formidable and potentially dangerous animals. Inexperienced (or even veteran) cameramen are wise always to give them a wide berth. This one, shot with a long telephoto lens, is warning another bear. We have never been threatened by any of the many brown bears we have photographed.

PAGE 67 TOP

Brown bears have various eating techniques: holding down a squirming salmon, first biting out the ripe red eggs, or stripping the skin first. Some females share a salmon with their cubs, but just as often the sows do *not* share. Cubs must learn to capture their own. McNeil River.

PAGE 67 LEFT

Luck can sometimes play a role in wildlife photography. This young male grizzly bear, encountered beside the Denali Park road, was shot with a telephoto lens through our pickup truck window. A moment later, the bruin began to dig in the soft earth for Arctic ground squirrels, which had burrows there.

PAGE 67 RIGHT

The most active photo subjects of many species are often young males. These brown bears may be disputing a fishing territory in the McNeil River, establishing "rank," getting exercise, or all of these. A fast shutter and correct exposure "stopped" this action on an overcast afternoon.

It is just after daybreak when we are awakened by the crunch of gravel underfoot just beside us on the desolate beach. Groggy at first, but sitting suddenly upright in warm sleeping bags, we unzip the tent flaps and immediately see the cruncher. A brown bear, which may weigh 900 pounds, is standing less than fifty feet away. For an instant, the bruin stares uncertainly toward us through small eyes, puzzled, testing and sniffing the cold, soggy morning. But its vision is flawed, and the great shaggy animal must rise onto hind legs for a better look at the cluster of red and yellow nylon expedition tents pitched among tussocks of tall Arctic grass. Even viewed through mosquito netting, the bear is an awesome, unnerving sight. Without a sound, it drops to all fours and shuffles away across a vast tidal flat without a backward glance. We breathe normally again.

It is late July. The place is far out on the lonely and remote Alaska Peninsula, where the McNeil River empties into a tidal lagoon of Shelikof Strait. We are camped here because this is the peak of an annual dog salmon spawning migration from the sea into sweet water. Hundreds, probably thousands, of generations of brown bears have always gathered here to gorge on the salmon at a chasm—a natural fish trap really—called McNeil Falls. We have flown by small floatplane to this McNeil sanctuary specifically to photograph the event.

The unexpected visit of that bear in camp is reveille for eight campers. We dress quickly, pull on rubber hip boots, and wolf down breakfast in a shack built of bleached driftwood—the only permanent structure of any kind within 100 miles in any direction. When our meal is finished, all food is hidden away in a trapper's cache, erected high out of bears' reach on peeled log poles. We shoulder backpacks full of photographic gear and strike out for the falls, an hour's hike from the campsite. Biologist Larry Aumiller, carrying a shotgun filled with rifled slugs (which so far he has never had to use) instead of cameras, leads the single file march.

It is not a gentle hike. First we wade across a lagoon, which is passable only during low or ebb tides. Beyond that, where brown bears have been digging on the flats for clams, huge paw prints are etched everywhere in the soft mud. Abruptly the trail turns from open mudflats onto a steep bluff where in places the sub-Arctic grass is shoulder high. Visibility all around is nearly zero. Twice we pause and shout to clear the trail ahead of bears, which we can hear snorting. We break into a cold sweat when a shaggy sow with twin cubs stares sullenly from too nearby for too long. But she retreats, and we climb past that point quickly. Suddenly we come to a knoll overlooking one of the greatest wildlife spectacles on earth.

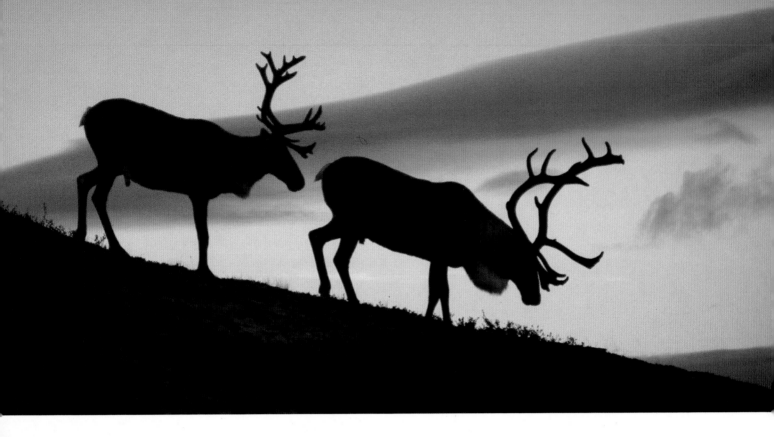

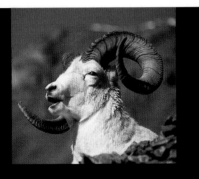

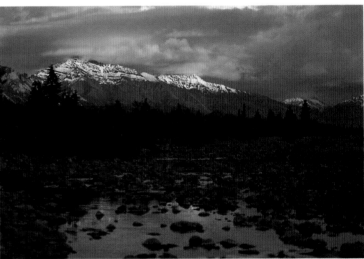

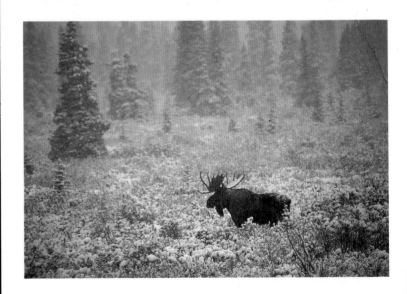

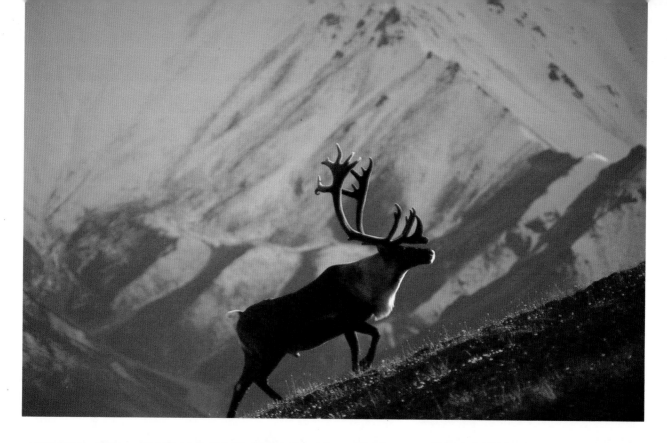

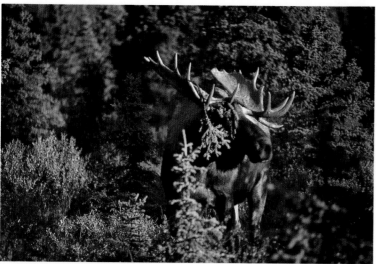

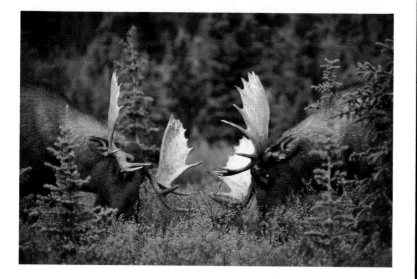

PAGE 70 AND 71 TOP

During early summer, it is often possible to photograph thousands of barren ground caribou in mass migration across Denali National Park. But these lone bulls were shot in late August, with antlers fully developed, and the rutting season not far away.

PAGE 70 CENTER LEFT

The all-white (or Dall) sheep of Denali National Park are easy to photograph for anyone with strong legs willing to climb to lofty ridges where the sheep live. At times we have scrambled almost near enough to touch them. This splendid ram was bedded on the edge of a cliff.

PAGE 70 BOTTOM LEFT

A heavy morning frost glittering on foxtail grass is a good reason to always carry a macro lens.

PAGE 70 CENTER RIGHT

One year we camped for four weeks beside the Teklanika River on a photographic assignment. This is the brooding pastel scene we often saw at dawn in September from our campsite.

PAGE 70 BOTTOM RIGHT

The moose, the largest deer on earth, is common all over Alaska, but nowhere is it more easily approached and photographed than in Denali Park. When the rut has begun and the velvet is gone from the super-bull, it is spoiling for a fight.

PAGE 71 CENTER LEFT

After shedding the velvet sheath, blood has colored this bull's antlers temporarily red.

PAGE 71 BOTTOM LEFT

The young bulls square off in a head-to-head duel over a cow moose in estrus.

PAGE 71 CENTER RIGHT

Wildflowers carpet some portions of wild Alaska so densely as to resemble an oriental tapestry. Among hundreds of native species commonly seen is the yellow paintbrush, photographed near Yakutat.

PAGE 71 BOTTOM RIGHT

Especially toward the tag end of summer, the Alaskan landscape is punctuated with the bright colors of late-blooming wildflowers and wild berries. These bunchberries grow near Auke Bay, southeastern Alaska.

Below us thunder McNeil Falls, and a necklace of foaming green cascades choked with hook-jawed salmon in pinkish spawning colors. Glaucous winged gulls scream and dive above the fish. We count sixteen brown bears stalking, splashing, quarreling, and feeding on the salmon. Even during a lifetime of hunting with a camera, it is an absolutely extraordinary scene.

From all directions bears are constantly arriving and leaving on centuries-old trails, surly old males as well as smaller females with cubs. One shaggy, shedding, ancient male, Aumiller tells us, has been seen here for twenty-six years. He calls it Megabear. The older, larger bears preempt the best fishing spots and defend them first with body language or, if necessary, by a sudden savage attack against an intruding bear. Some bruins are expert fishermen and catch one salmon after another almost nonchalantly; others never seem to get the knack of it. But for several weeks, as long as salmon spawn, the area below the falls is an arena of drama and conflict. We concentrate filming on the young males because they tend to be most combative, most active, and the best camera subjects. Alternately through 200mm and 400mm lenses, we shoot and shoot and shoot until a steady rain drives us back down the trail toward camp.

It is difficult to describe Alaska, perhaps because from a cameraman's viewpoint it is so overwhelming. Both the highest (Mount McKinley) and the lowest (the Aleutian Trench) points on the continent are here. The wildlife that lives within The Great Land's 365 million acres is beyond description, and the McNeil River State Sanctuary is only one tiny niche, one opportunity of hundreds. It also happens to be one of the most difficult of access. After obtaining a permit in an annual drawing or lottery, you go by chartered float-plane, taking along all you may need from toothbrush and sturdy tent to canned food and an extravagant supply of film. McNeil is total, raw wilderness. Katmai National Park, not far from McNeil as a small aircraft flies, also has resident brown bears, which can be viewed from greater comfort (a lodge and a less primitive campground).

Denali (once McKinley) National Park in central Alaska is an easier place to reach; you can go by car or train. Except perhaps for Yellowstone, no park in America matches Denali for photographing the big game species. Also, an astronomical number of seabirds nest every summer on the cliffs, and herds of fur seals mate on the rocky shoreline of the Pribilof Islands. Once remote and seldom visited, there is now regular air service for anyone anxious to explore that strange and misty archipelago in the Bering Sea.

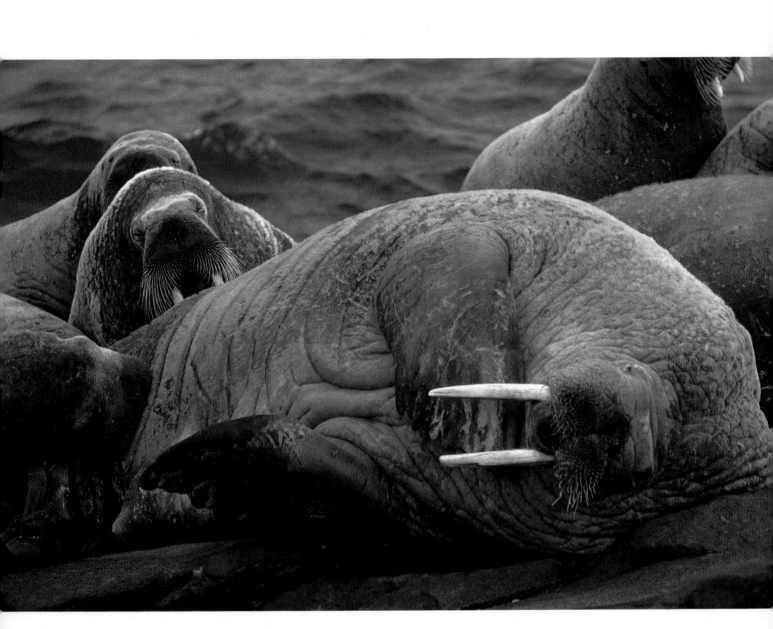

The total biomass would be difficult to calculate, but on Round Island every summer about 10,000 bull walruses haul out to stock up and bask in occasional weak sunlight of northern Bristol Bay. It is the best place on earth to photograph so many of these great marine animals at once. The only access is by risky floatplane.

PAGE 75 TOP
During each Alaskan summer, a large proportion of the world's fur seals settles on the slick rocky shores of the remote Pribilof Islands to bear young and then immediately to mate again. This is a young sub-breeding male.

PAGE 75 LEFT
Of all the pinnipeds of Alaska, none are harder to photograph than the harbor seals, which are common in all coastal waters. They had been hunted hard for many years; although fully protected today, the species remains extremely shy.

PAGE 75 RIGHT
As late summer blends into fall, the surfaces of small ponds freeze each night. One morning we photographed this pattern of air bubbles in ice crust on a mini-pond near the Toklat River, Denali.

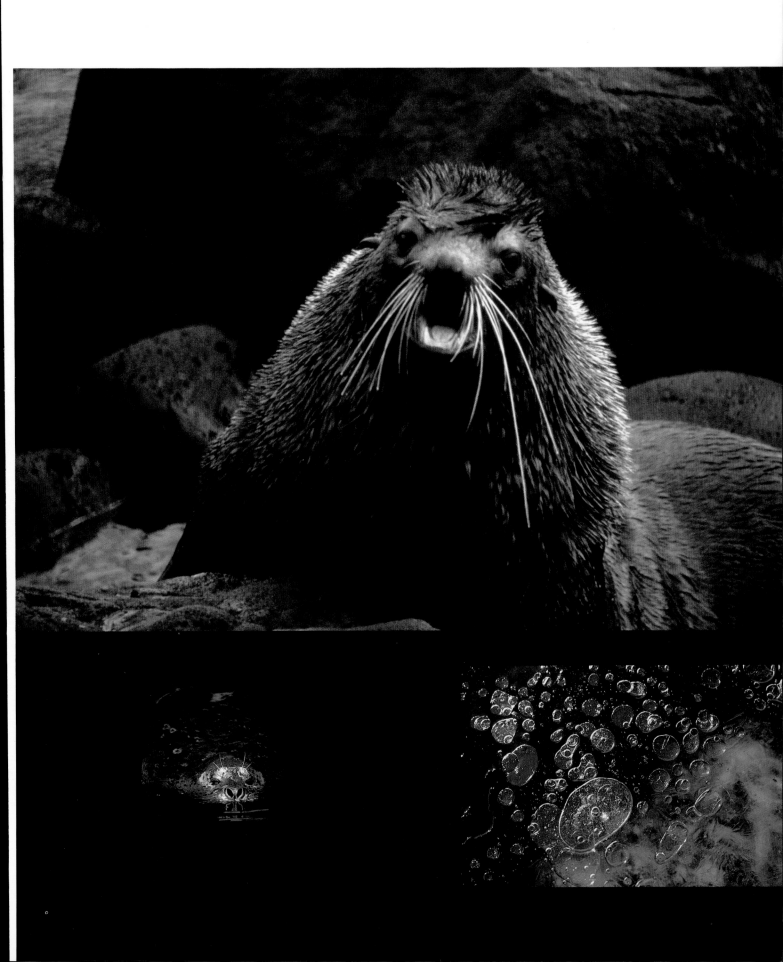

Every summer, Round Island is a hauling-out spot from June through August for at least a thousand walrus bulls. The Chilkat valley near Haines is the gathering place for a most astounding reunion of bald eagles. Gravely threatened and very rare elsewhere in the United States, they mass here late each autumn. From Afognak Wilderness Lodge on Afognak Island, our wildlife neighbors were salmon, seabirds, brown bears, black-tailed deer, Steller's sea lions, and sea otters. The list of all Alaska's unique wild places could fill a large volume.

Despite the magnificence of the land and its animals, there is a depressing element to photographing in Alaska. The weather tends to be poor, overcast at best, and at times even grim, and the sun is elusive. Rain is not. So a serious and sun-worshipping cameraman must psych himself to expect (and prepare for) the worst. Even on the warmest July days, which can turn surprisingly hot, winter lurks just below the ground as permafrost. Too often we have sweated one minute and shivered the next. We choose warm clothing that can be worn as multiple layers, to be added or removed instantly as needed. Foul-weather outer garments, say ponchos, are as important as more film than we estimate we will need; so are waterproof plastic bags for every item of photo equipment. Rubber hip or knee boots come in handy for slogging over tundra and across creeks. Because proper exposure becomes more critical the poorer the light, a spot sensor exposure meter is an extra item worth its weight in Alaskan gold nuggets. But in all the world there is nothing more exquisite and exhilerating than those rare and golden sunny days over the matchless Alaskan wilderness.

VI

The Southeastern United States

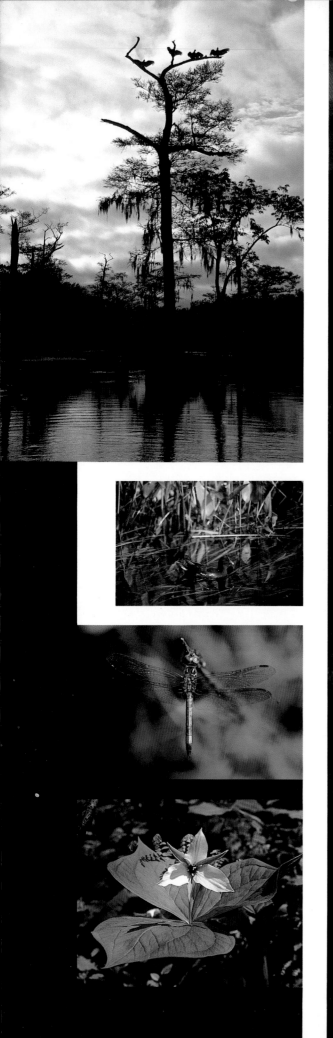
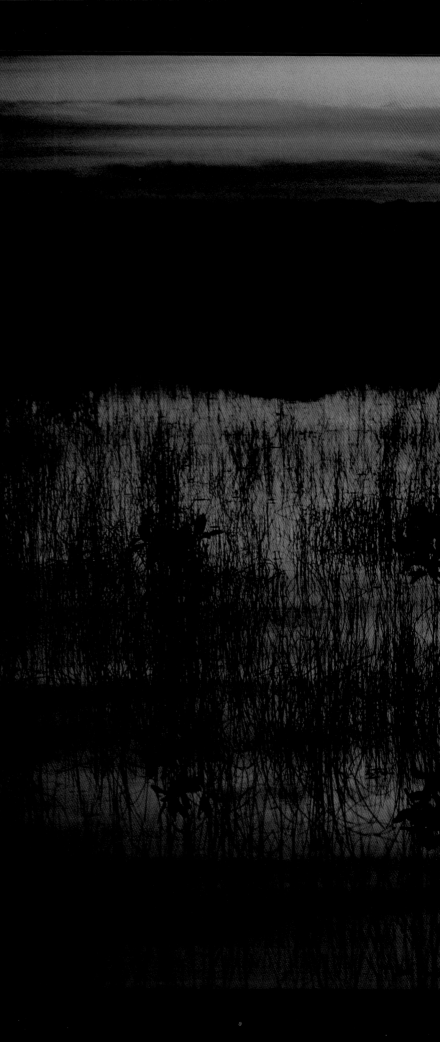

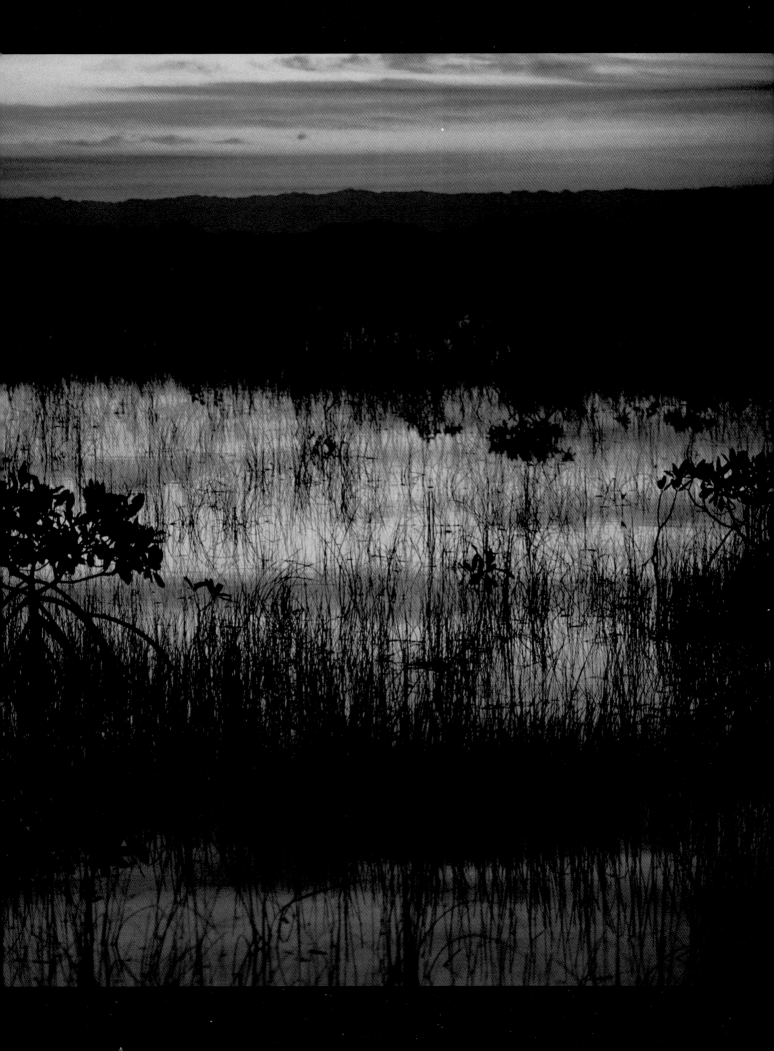

PAGE 78 TOP

Old cypress trees draped with Spanish moss border the Wakulla River, which may be the most beautiful waterway in northern Florida. It gushes from the earth in a single sweet-water spring, which is its origin. This is an early morning scene downriver.

PAGE 78 CENTER

We photographed the common gallinule, or moorhen, from a boat drifting slowly down the Wakulla River. Accustomed to a steady procession of boats all day long, the birds are not disturbed by cameramen.

PAGE 78 CENTER

We do not seek insects to photograph because of the special techniques and equipment necessary to do a specialist's job. But it was impossible to pass up the Louisiana dragonfly, which perched on our tripod before transferring to a nearby twig.

PAGE 78 BOTTOM

The trillium is a common woodland wild-flower, which blooms widely over south-eastern United States in spring. It is an appealing subject for a nature photographer anxious to celebrate the end of winter.

PAGE 79

This mangrove is growing in Everglades National Park, not far from Flamingo, where brackish-to-salty water has infiltrated the sawgrass "prairies."

It is difficult to estimate how many thousands of tourists stroll the Gumbo Limbo and Anhinga trails (especially the latter) of Everglades National Park each season. The number must be high because the main park entrance is not far from the megalopolis of Miami, Florida. But if you begin the Anhinga hike just at daybreak during the winter months, you are likely to have the less than one mile-long trail to yourself.

We visited the Everglades during an extended drought in February (consequently low water level). But that was an advantage for photography along the Anhinga Trail because it concentrated even more than the normal amount of wildlife in the dark freshwater pools. At the first pool, common gallinules were engaged in noisy, active courtship, one pair dangerously close to an alligator that was poised motionless as bedrock near the pond's fringe. Only the reptile's eyes and nostrils protruded above water level and these must have been all but indistinguishable to birds busy making love. A little farther on, an anhinga (or water turkey, or snake bird, if you live in Florida) perched on a low bush, wings fully spread to the sides to dry. It did not fly when we set up a tripod to film it against the sunrise. It was a good morning to spot the wet, corrugated backs of alligators, and when we paused for a closer look at one ten-footer lying beside the trail, we also saw a green heron and a bittern, both posed stiffly in damp grass nearby. Palm warblers flitted around our heads.

Eventually the ground path ends and the trail becomes a wooden walkway winding a few feet above the glades. Over the years, wildlife has become used to the sound of humans walking heavily overhead and it does not flee. Today we would rate this among the best, most convenient wildlife walks in the world. Keep in mind the adjective convenient. Usually the first creatures a hiker sees are the alligators and myriad of turtles. But stop to stare down into the clear swamp water and you also see garfish, bream, and largemouth black bass. Great blue herons frequent the farthest ponds along the Anhinga Trail, and there may be no better place to watch purple gallinules walking over clusters of lily pads.

But anhingas are the main attractions of the Anhinga Trail. From late winter through early spring, several pairs nest in low trees just across a pond and in good telephoto lens range of the main boardwalk. It is not unusual to find a whole battery of camera people, professional and amateur, lined up at a vantage point with long lenses focused on parents feeding their ungainly chicks. Wildlife photographers tend to be solitary rather than gregarious workers, but something about this site inspires them to be congenial and talk shop.

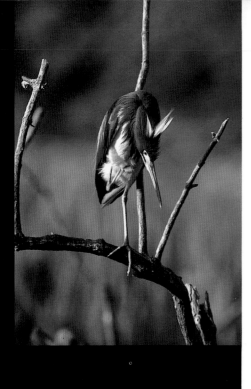

LEFT

It is easy to mistake this motionless Louisiana, or tricolored, heron, perched on one leg, as a part of the dead snag. But the wind blowing feathers betrayed it. The bird had a nest in a rookery nearby at Avery Island, Louisiana.

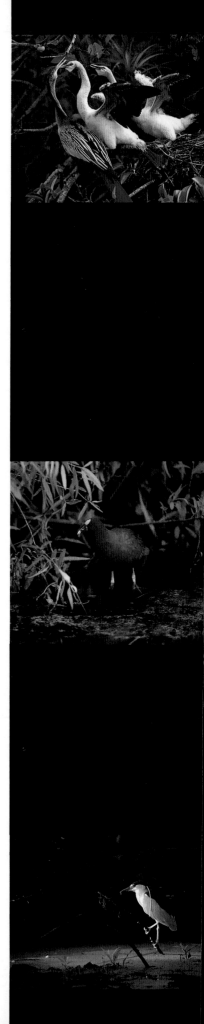

RIGHT

An anhinga parent has returned to the nest to feed two young still unable to fly. The sibling rivalry for food is intense. It is remarkable that visitors could watch, and photographers could record, this family life from eggs hatching until full flight from a viewpoint on the Anhinga Trail, Everglades National Park.

PAGE 83

Day is just breaking in Everglades National Park. An anhinga spreads wings to dry beside the slough that parallels Anhinga Trail.

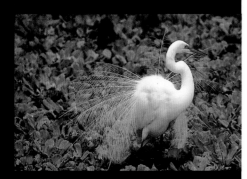

LEFT

An egret in exquisite breeding plumage wades in Lettuce Pond, Corkscrew Swamp.

RIGHT

There are many inducements to walk (or bicycle) on the Shark Valley Trail of northern Everglades Park soon after sunup. Later, throngs of tourists will be walking or riding the tram on the first mile or so of the seven-mile route. An early riser has the best chance to photograph the purple gallinule, which skulks and nests in the dense green vegetation.

LEFT

This pied-billed grebe at Eco Pond, Everglades, was a reluctant photo subject. It popped to the surface frequently in the same area, although never long enough to catch in focus with a long telephoto lens. Persistence finally prevailed. We focused where we *thought* it would emerge and won this picture.

RIGHT

In early morning, a black-crowned night heron is spotlighted by the first rays of the sun. Just as our boat comes alongside in the Wakulla current, it catches a sunfish. The bird then moves into denser cover to swallow the palm-sized catch; it is not an easy task and takes several minutes.

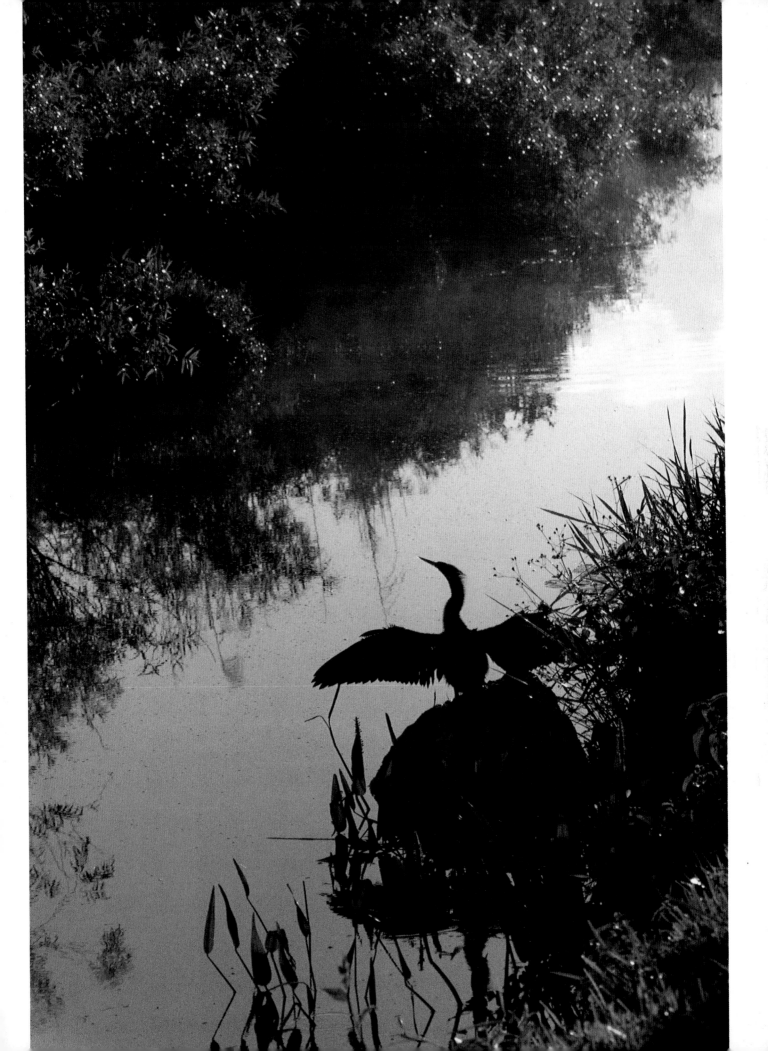

Everglades Park is an outstanding and handy place for wildlife photography. One way to go exploring is by canoe along the marked canoe trails; one especially productive waterway begins at West Lake near Flamingo and ends at Alligator Creek on Florida Bay. Once a family of otters cavorted close beside our canoe while we fumbled for cameras sealed in Ziploc plastic bags because it had been drizzling. But they fled just as we were ready to shoot. We had to be satisfied with filming raccoons, which were very numerous. Remember that from spring onward, the canoe trails also wind through country infested with mosquitoes.

Eco (for Ecology) Pond is a short walk from the Flamingo campground and would be remarkable in any national park anywhere. Well acquainted with people from long experience, the bird life is far from shy. During a single morning we filmed smooth-billed anis, a red-shouldered hawk, pied-billed grebe, snowy and common egrets, a green and a Louisiana heron, white ibises, and roseate spoonbills. Sometimes we had only to aim the camera in another direction to film another species.

One more corner of Everglades Park is outstanding for wildlife photography. On the northern edge is a seven-mile return trail at Shark Valley, which can be hiked or bicycled on a solid dry surface just above water level (except during flood periods). Regularly scheduled trams also make the circuit every day. But any cameraman should walk or peddle a bike, carrying his gear with him.

We have spent many days hiking other trails and other boardwalks over southeastern wetlands, and many of the most memorable have been in Corkscrew Swamp, a treasure of a sanctuary in southwest Florida owned by the National Audubon Society. The heart of Corkscrew is a stand of virgin bald cypress trees bearded with Spanish moss. During winters when water levels are favorable, hoards of wood storks nest in the cypress crowns, and this is a spectacle to cause any wildlife photographer to change his travel plans.

Even with storks feeding young just overhead, and with the fledglings flexing their wings crazily in preparation for the first launch, it is easy for the mind and lens to wander. We almost missed the V-wake in the black water, which was an alligator dragging away a wood stork chick that had fallen from its nest. A much larger alligator was stalking the first. Later, a raccoon ambled silently along the boardwalk, and the unnatural "growth" high on a cypress limb turned out to be a barred owl.

Drive northward from Corkscrew and eventually, near the state line, you reach Wakulla Springs. It is one of the countless Florida "attractions," where

tourists are amused by a boat ride, a glass-bottomed boat, hybrid orchids, or a mermaid show. This one is billed as a "jungle boat trip." But Wakulla is decidedly different. Rarely have we seen as much native wildlife as while floating quietly down a short stretch of the wild, unspoiled Wakulla River, which originates in one huge, clearwater spring. Our drift in the wide flat-bottomed johnboat began just below the spring, and the local boatman maneuvered us down a single open channel. Elsewhere aquatic vegetation was salad-thick in the river. We mounted a tripod in the bow of the boat. Again the most evident creatures were the alligators. A red-shouldered hawk, perched in shadow, did not fly even when we passed at arm's length. A black-crowned night heron stood motionless on a deadfall in a shaft of yellow sunlight at river's edge. We eased an anchor overboard from the stern to hold the boat fast in the current. Almost on cue, the bird seemed to uncoil and in that second it captured a punkinseed sunfish as big as the palm of a hand. While it tried to swallow that bill-full, which must have required five minutes, we exposed film.

Cormorants, anhingas, egrets, gallinules, and even mockingbirds watched our boat drift by. But we were most surprised by the tameness of several limpkins, which are shy birds and almost never easy camera subjects. But we photographed an adult with twin chicks, barely an oar's length from our floating photo platform.

There is another incentive to photograph at Wakulla. A magnificent old lodge, a page out of Florida's plantation past where time still passes in slow motion, offers excellent accommodations within sight of the gentle, silent river. It was a welcome change of pace for two photographers who spend a good many nights outdoors and under canvas.

From Wakulla we continued to a great, mysterious swamp, which is largely within the Okefenokee National Wildlife Refuge, Georgia. If our description of this wilderness seems pale, blame it on the fact that we had first visited Everglades, Corkscrew, and Wakulla. Okefenokee is among our finest primitive areas. For sheer beauty of the environment, Okefenokee exceeds all of these. But the wildlife is brooding and more difficult to see within easy range. Sandhill cranes dance during courtship on wet prairies, and there is a high black bear population, but do not bank on seeing any. However, alligators exist almost everywhere in the water of the 650-square-mile sanctuary.

There are four main places to begin exploration of Okefenokee, the land of trembling earth: Okefenokee Swamp Park on the north (with the largest alligator anyone is ever likely to see in the wild); Stephen Foster State Park on the west; and Kingfisher Landing and Suwannee Canal Recreation Area on

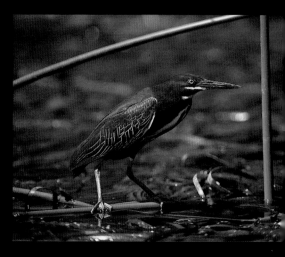

ABOVE

A fine nature trail, which is partly an elevated boardwalk, crosses freshwater sloughs of central Florida's Highland Hammock State Park. We saw the tell-tale wake of an alligator swimming, tracked it through the viewfinder, and were ready when it surfaced for an instant.

TOP RIGHT

The often secretive green heron is another bird of the upper Wakulla River. It remained motionless, frozen in half-stride, as we drifted to point-blank range.

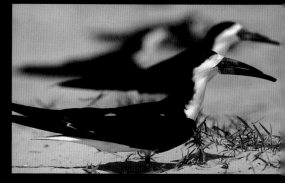

CENTER RIGHT

A portable blind was necessary to photograph the black skimmers at a beach nesting site within the city limits of Biloxi, Mississippi. Four-lane auto traffic constantly whizzes past the site, which is far from any category of wilderness. These are the only birds on earth with longer lower mandibles than upper. It is a unique experience to film any species of wildlife with the blue haze of auto exhausts hanging in the atmosphere.

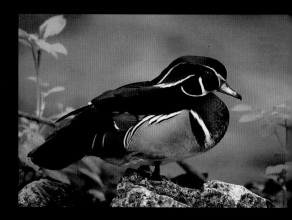

BOTTOM RIGHT

The male wood duck, or summer duck, is the most exquisite of American waterfowl. It is found on southern rivers and in flooded forests where the species nests in tree-trunk cavities. This one was filmed from a blind near its regular resting and preening spot.

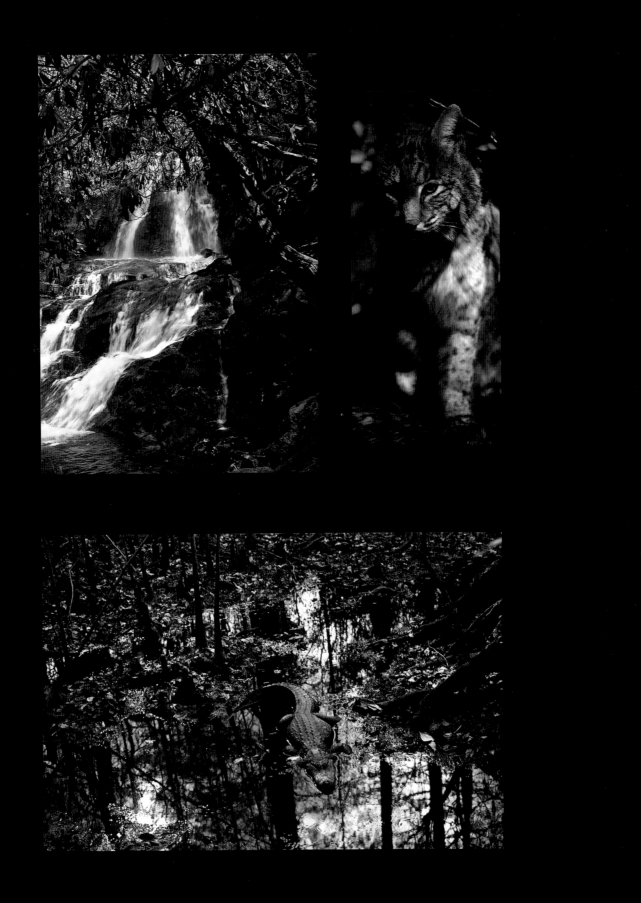

the east side. The use of some kind of watercraft is almost a necessity for photography, although a number of short boardwalk trails twist into the swamp. Perhaps the most stunning pictures of Okefenokee will be of the compelling scenery, the mirrored waters, the bearded trees, the sunsets, and the native flora, rather than of the wildlife.

That is also true of Great Smoky Mountain National Park much farther north in cooler Tennessee, although at times filming black bears may be much easier than a cameraman would wish. The secret to finding the local bruins, a photographer friend claims, is to hike the Appalachian Trail, which bisects the park. If you don't soon find bears, they probably will find you.

The Great Smokies have an immense beauty. In autumn, a hundred species of hardwood leaves burn with bright color before they wither and fall. Winter is white and often bitterly cold, but is attractive nonetheless, especially following storms. In summer, the high "balds," which are unique terrain features of the Smokies, are overgrown with catawba, rhododendron, and mountain laurel. But from May through September, cars are bumper to bumper on the roads.

April is the cameraman's month in the short, but loveliest, spring season in the Smokies. New wildflowers appear along pathways every day throughout the month, which is a botanical extravaganza at lower elevations. But a photographer interested in wildlife alone had better travel to Cade's Cove and then slowly drive the one-way road. White-tailed deer will be emerging from forests onto newly green meadows. But more exciting are the wild turkey toms, which gobble and strut early and late every day.

A number of unusual wildlife spectacles of southeastern United States exist surprisingly close to civilization. American skimmers are the only birds with lower mandibles longer than the uppers. They are easy to photograph nesting each spring on a sand beach of Biloxi, Mississippi; the beach happens to adjoin a four-lane highway carrying a steady stream of high-speed traffic. Avery Island, Louisiana, is well beyond the sound of superhighways, but here hundreds of common, cattle, and snowy egrets nest next to a salt mine and to the red brick factory where Tabasco sauce has been made for the last century; depending on the direction of the wind, a faint acrid odor wafts over the teeming rookery.

PAGE 87 TOP LEFT
Throughout Great Smoky Mountain National Park, hiking trails lead to waterfalls, wildflower meadows, and quiet scenes of Appalachian beauty, as Laurel Falls here.

PAGE 87 TOP RIGHT
The eastern bobcat is a common resident all around the fringes of the Okefenokee Swamp in southern Georgia. But it is seldom seen and then only briefly. This one frequented the area around Stephen Foster State Park.

PAGE 87 BOTTOM
Not long ago the American alligator was in trouble, and conservationists worried about its uncertain future. But a crackdown on poaching, plus other protective measures, has resulted in an alligator "boom" over much of the Southeast. Now it is possible to find them living inconspicuously wherever there is suitable habitat.

VII

Baja California

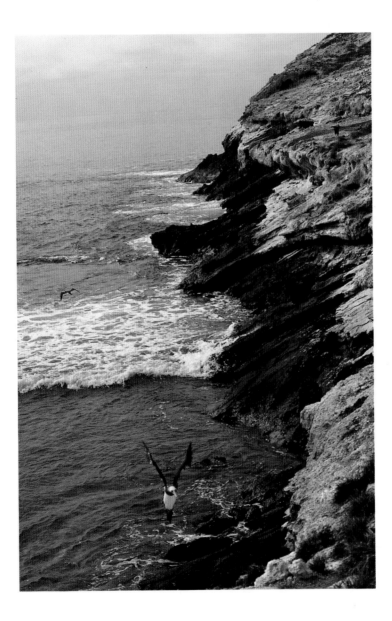
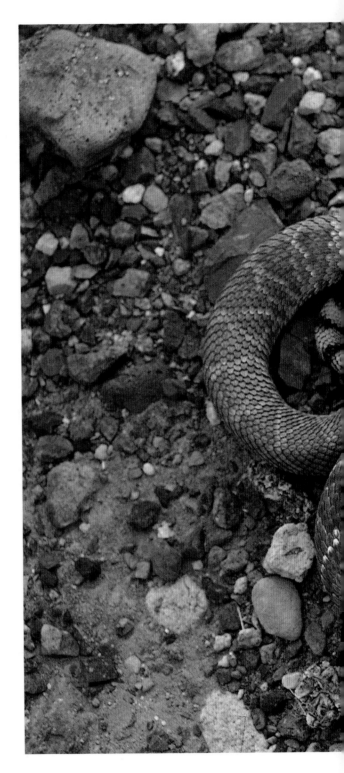

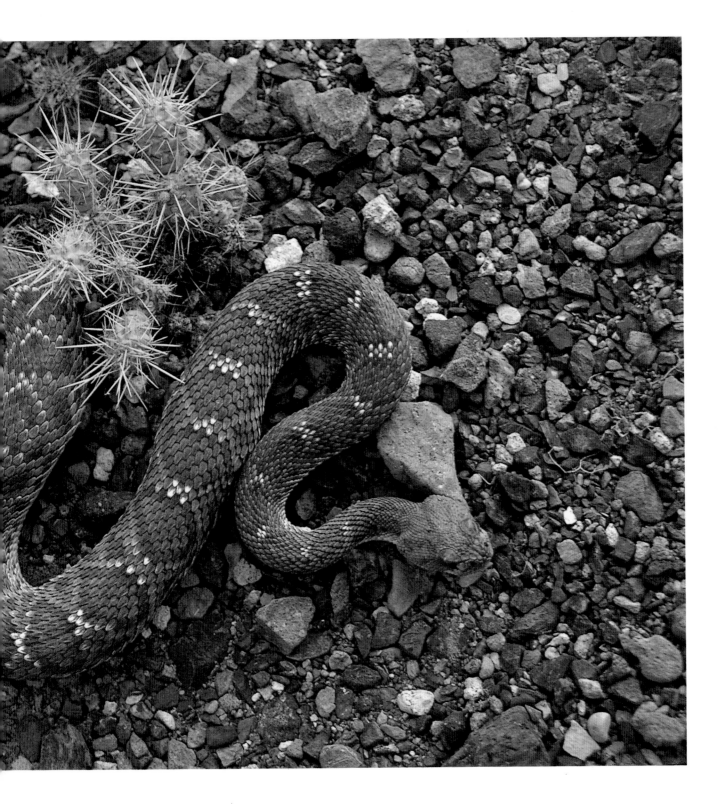

PAGE 90
A masked booby returns to its nest on remote Isabela Island from fishing in the fertile Pacific Ocean. The white crust on the steep shore is guano, droppings deposited by generations of nesting seabirds.

PAGE 91
Strange separate species, or variations of common species, evolve and are able to survive on remote islands around the world. A good example is this endemic rattlesnake of Isla San Lorenzo, which has a barred pattern rather than rattles on its tail. We found three during a half day's exploration of the hot arid island.

S everal times every day as the satellite Landsat 4 circles in orbit far above the earth, its robot cameras send back a revealing and rarely changing message: off the west coast of Mexico lies a sliver of real estate unlike any other in North America. It is never obscured by smog and only rarely by clouds. Even from that lofty elevation, the pictures show a great mountain range, awesome canyons, and spectacular seashores outlined by wild, white surf. As viewed from directly overhead, Baja California appears to be some lost and lonely Eden.

It really is a paradise from many perspectives, especially that of a photographer: a finger-shaped peninsula, 800 miles long by an average forty miles wide, which originates at the southwestern United States border and points southeastward into the Pacific Ocean. Isolating this peninsula from mainland Mexico is the Gulf of California. Deep and deep blue, punctuated with hundreds of uninhabited volcanic islands, it is among the purest seas left on the face of the earth.

Today most of Baja California, and especially the southern third, is comparatively little altered by man since the time of its "discovery" in the 1500s. Except for the northern border region, its 55,000 square miles are sparsely populated. And no wonder, because certain central regions may receive no rainfall at all from year to year.

Desert bighorn sheep haunt high ridges of the Sierra de la Giganta. Such a dry wilderness supports 110 different species of cacti, of which eighty are endemic, and the grotesque boojum tree, which grows nowhere else. Baja is the home of such strange creatures as a kangaroo mouse, which never drinks water in its life, a fish-eating bat, a rattleless rattlesnake, and hundreds of thousands of seabirds, some of which nest in underground burrows, or beneath or atop cactus plants.

We have made several trips the length of Baja, the first when most of the peninsula was still roadless in 1955. It was dusty, thirsty, seat-of-the-pants high adventure in a battered jeep, which already had enough miles on the odometer to have encircled the globe three times. We camped at night by unrolling sleeping bags on the ground wherever the black velvet nightfall found us, and we built campfires of dead cactus trunks. There were few other travelers. Despite the sheer determination it required to complete the journey, we saw enough brooding landscapes and had enough tantalizing glimpses of wildlife to vow to return. This we did by pickup truck when a transpeninsular highway was built, and most recently aboard the *Lindblad Explorer*, a unique ninety-passenger motor vessel designed for adventure cruising to

We approached Isabela Island as the sun was breaking through a squall on the eastern horizon. Squadrons of brown pelicans perched on the shore.

PAGE 95 TOP
The black vulture is a familiar bird of Baja, waiting hunched on the edge of a fishing camp or soaring overhead on heat thermals. This one probably has so gorged on a fish washed ashore that it had trouble getting airborne.

BELOW LEFT
A single sea lion basks on the edge of sunlight as we cruise around Isla del Espiritu Santo, near La Paz, Baja California. We shot with a short focal-length lens and a fast shutter speed to compensate for motion of the boat.

BELOW RIGHT
The exposed shore of San Pedro Martir is undercut by powerful wave action, which has created picturesque grottoes, many occupied by sea lions. By circling the island in a small craft, we came upon this tableau during the first light of a warm morning.

PAGE 95 BOTTOM
An endemic barrel cactus of Isla Santa Catalina blooms only briefly during the Baja springtime.

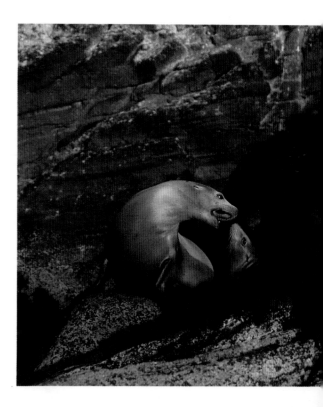

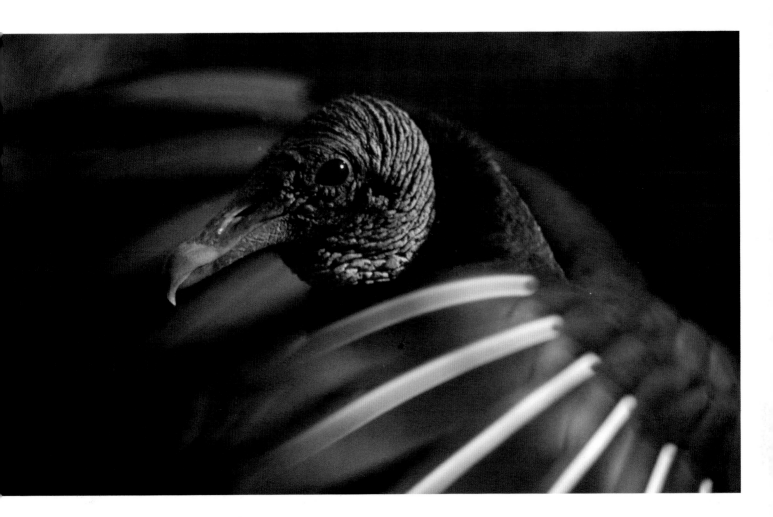

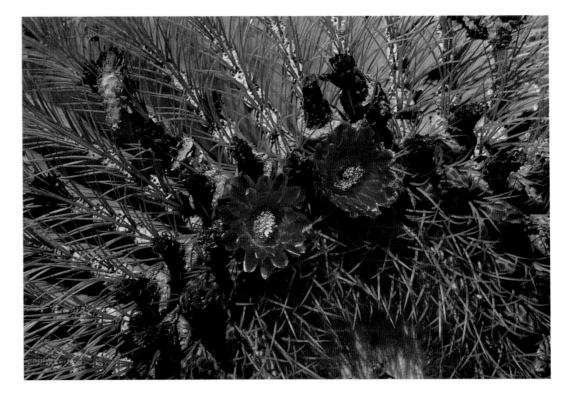

exotic destinations—the ends of the earth—rather than for luxury. Annually, for example, the *Explorer* carries travelers to both Antarctica and deeper into the Arctic than any other passenger vessel has ever ventured.

Cruising thus is the best way for a wildlife photographer to explore Baja California and is the only possible way to set foot on many of the offshore islands that hold—or actually hide from camera view—the greatest wildlife treasures. Our journey began in May at Acapulco and aimed toward Cabo San Lucas, Baja's land's end. Almost immediately we sighted a scattering of whale sharks, the largest fishes to swim the oceans. Spotted and six feet across the broad blunt head, some of these were thirty-five feet long. A school of hammerhead sharks seemed to be tracking them.

After sailing northward during warm nights, the *Explorer* anchored off Isla San Pedro Martir just before dawn. Its jagged, volcanic profile was an eerie scene in that sulfur light. From inflatable rubber rafts lowered over the sides we waded ashore in lukewarm water carrying backpacks heavy with cameras and optics.

At sunrise, the island seemed even stranger and more stark than when sighted still in shadow. It is about one mile in diameter, nearly conical, with extremely steep slopes climbing toward a single peak approximately 1,500 feet high. Except for the giant cardon cactus comprising a climax forest of that species, hardly another plant grew on the island, which was totally crusted white by generations of nesting and perching seabirds. We found western gulls nesting closest to the slippery, rocky shore. In cracks and crevices just above them, red-billed tropicbirds were incubating eggs or tending very young chicks.

In the past, this island was mined for the guano, and the crude stone shelters of workers survive about 250 feet above sea level. Two pairs of blue-footed boobies courted by sky-pointing and whistling softly atop one of the shelters, as if on a stage. In an area just beneath the crown of the island, more boobies were nesting among the numerous scattered nests of brown pelicans. We sat down among the nesters for a long time, quietly studying the avian scene. When the birds were completely comfortable with us, we carefully set up tripods to begin filming.

Later we circled San Pedro Martir by raft and found that some sections of it were badly undercut by the sea, forming caves. About 400 southern sea lions had taken up residence here and they lay copper-colored in the sunshine. The animals looked up suspiciously at our approach, began honking, plunged into the water, and swam part way out to meet us.

Baja has been called the land of the blue-footed booby because the species nests in large numbers on many islands. It is difficult to visualize the plain gray chick as the elegant, blue-footed adult it will be in a few months' time.

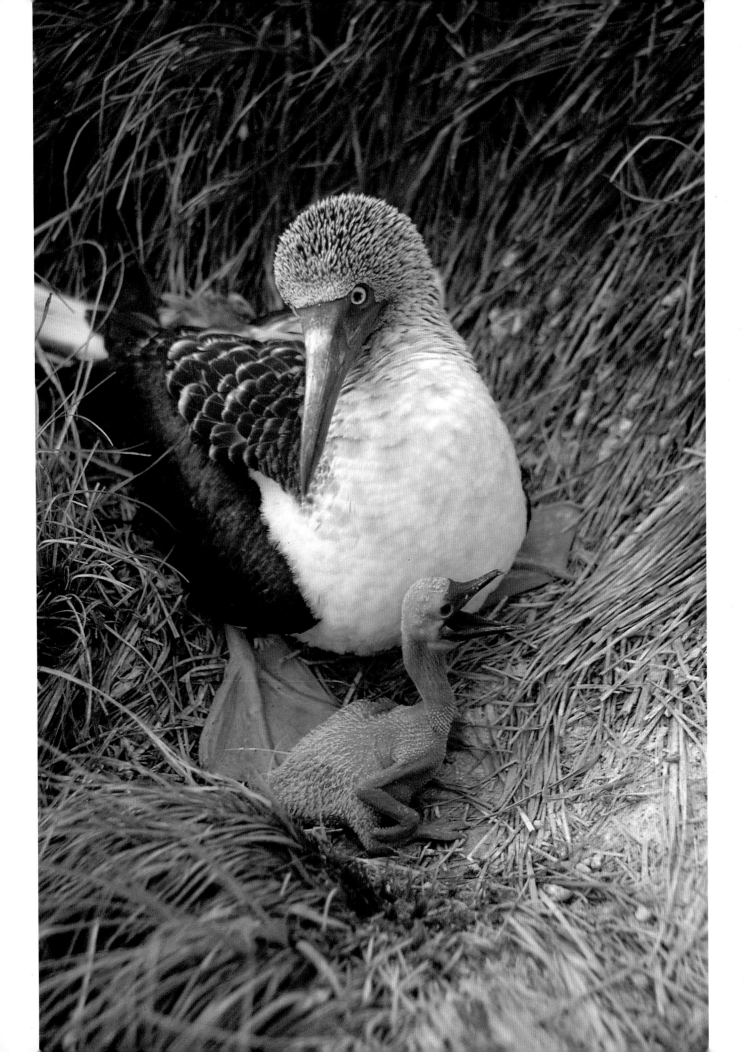

Over a period of years, every wildlife photographer has known good luck and bad, fair weather and foul. This expedition was better than average all around. We proceeded northward over a sea sometimes as smooth as a vast oil slick. On Isla Estanque we found a few fish-eating bats secluded in dark rock crevices a short hike from the landing spot. On the north end of Isla Angel de la Guarda, we waded quickly ashore, hurrying past beachmaster sea lion bulls that challenged us, and climbed toward a large osprey nest. It was a treacherous, and maybe a foolish, gamble because the nest appeared empty, although two adult birds circled above us, screaming. Only when a few feet distant did we see two chicks, fully fledged, and almost ready to fly. They were crouching deep within a nest of tangled twigs, sea grass, and rope. We were surprised to note that some earlier peripatetic birdbander had already placed aluminum identification rings on the legs. While the young osprey hissed at us, we shot closeup photos before retreating back down the cliff. We were not yet far away when a parent landed at the nest, a fish in its talons.

The glorious days passed much too quickly. On Isla San Lorenzo we found the endemic rattlesnake that has black and white stripes rather than rattles on its tail. But it still vibrated the bare tail as rattlers do while being photographed. On nearby Isla Tortuga we discovered what seemed to be an extraordinary concentration of rattlesnakes—these being an island race of the western diamondback—which were neither shy nor aggressive when we approached. Between Tortuga and San Lorenzo islands, all hands came on deck to watch a pod of false killer whales passing and, minutes later, a pod of finback whales, which probably spend their entire lives here.

Raza may be the most fantastic of all the Baja islands, particularly if approached in the pale predawn. From an anchorage close by, the island seems to be belching birds into the sky. At first it is impossible to identify them, but most are royal and elegant terns, and Heermann's gulls, as we confirmed after going ashore and negotiating a thin track over shifting rocks. On a bare flat depression in the center of the island, we found 40,000 terns (our educated estimate). The birds were compressed as tightly as possible in a single breeding concentration, a seething turmoil of noise and nesting and feeding fluffy, recently hatched young. Overhead and all around the perimeter of the mass of white feathers and orange bills, gulls patrolled to pounce on any tern chick that wandered away or was left unguarded for just an instant. Survival of the fittest (and luckiest) was taking place before our lenses.

From Isla Raza the *Explorer* hurried southward, rounded Cabo San Lucas, and turned north paralleling the Pacific coast toward the trip's end at Los

Angeles. We paused, but never long enough, at Cedros, San Benito, and Guadalupe islands. It was on this last island where the Guadalupe fur seals were twice regarded as extinct, but each time, in 1927 and again in 1952, a few were found again. A herd survives there today. We could not locate these seals, but we did spend a lively afternoon photographing elephant seals in a small bay of San Benito. For more than an hour we aimed telephoto lenses at immature males sparring—play-fighting—in the shallows. It was a memorable end to a voyage to an unlikely paradise of rocks and sand.

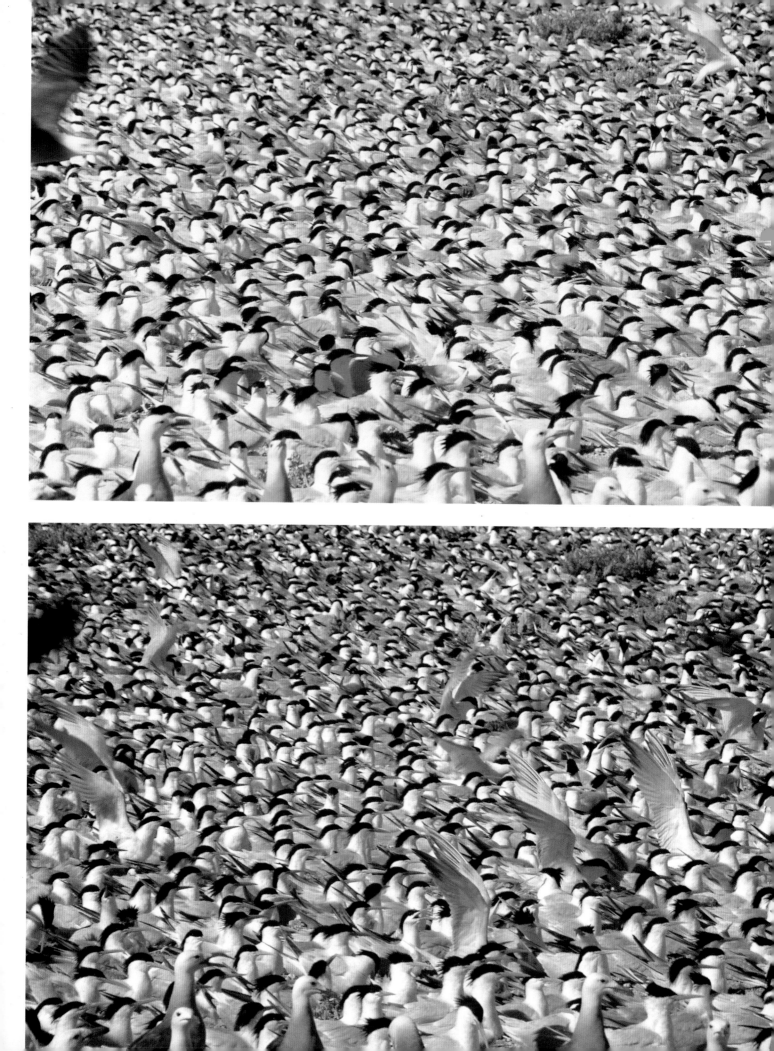

PAGE 100

An estimated 40,000 royal and elegant terns nest en masse in this central basin of Isla Raza. The colony is usually surrounded by Heermann's gulls, which prey on any unattended chicks.

PAGE 101 TOP

We climbed to a promontory on Isla Angel de la Guarda to photograph a large osprey nest. At the edge we were greeted by this young bird almost ready to fly. Another immature is hidden just behind this defiant one.

PAGE 101 LEFT

From a whole catalogue of strange Baja plants, the endemic boojum tree of the northern Baja mainland may be the strangest of all. It is a slightly eerie experience to walk through a boojum forest as day is beginning to break. The trees look upside down; hummingbirds buzz close to the blossoms on the ground, and doves mourn in the distance.

PAGE 101 RIGHT

A royal tern parent guards a chick on the edge of a breeding colony where it is vulnerable to predation by Heermann's gulls, which lurk all around.

PAGE 101 RIGHT

The cardon cactus grows to its maximum size on Isla Santa Catalina. The photograph was made in late afternoon, with side-lighting, and was deliberately underexposed.

VIII

Canada

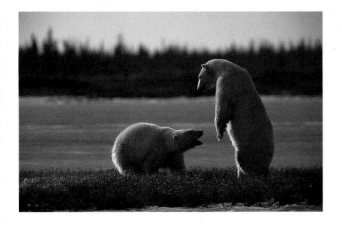

The arena is a frozen freshwater pond, where stunted spruce forests give way to tundra. Two male polar bears are play-fighting in the wan light of a November afternoon. Half-serious, the scuffling goes on for hours as we inch closer and closer with cameras. Such photography is a sweaty business (even in the deep cold), but this is a spectacle not often observed from such a short distance.

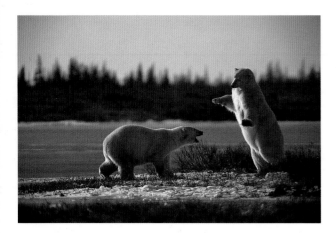

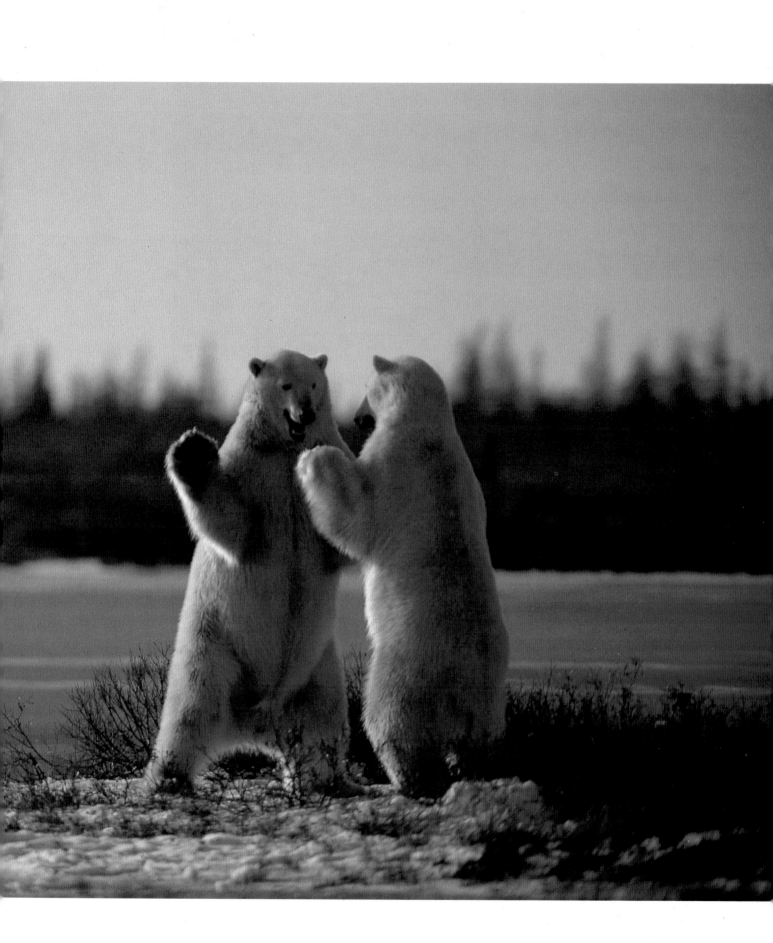

The small, desolate town of Churchill, Manitoba, with a permanent population of about 650, exists despite a predicament unique in the world. It is situated astride a centuries-old migration route of the largest and potentially most dangerous carnivores on earth. As soon as snow flies every fall, the citizens and city fathers must deal with a chilling invasion of the surrounding region, and even of the village itself, by several hundred polar bears.

Churchill was built where the great Churchill River empties into Hudson Bay, originally to serve in summer as an ice-free port for grain shipments from Canadian prairie provinces to Europe. It is accessible only by a transtundra railway and by thrice-weekly flights from Winnipeg. No auto roads connect Churchill with the "outside," and except for a too brief summer it is bleak and decidedly unattractive. But bird watchers and naturalists have discovered great beauty in the forsaken place. They travel to Churchill in growing numbers in June to see beluga whales and northern lights with blizzards of birds that arrive from points south to nest. But perhaps most visitors come in autumn to see the ice bears.

For a long time polar bears were regarded as lifelong, random wanderers of the shifting polar ice packs. A bear born in Canada, say, might someday show up in Siberia. But now we know that the world population of polar bears is composed of smaller, local groups living in separated maritime areas with fairly definite boundaries. One of these lives on Hudson Bay as long as it remains frozen. When the ice melts, the bears move temporarily onto the wilderness land just south or east of Churchill. After a summer of fasting (or near fasting) and indolence there, the ravenous animals are drawn back toward the coastline to await the refreezing of the bay. They are hungry for the seals that they will soon be able to stalk again out on the ice pack. It is during this annual march toward salt water that they pass through, or spend from two to five weeks in, the Churchill environs.

The annual bear trek has been a mixed blessing to Churchill residents because the animals once posed a problem. They have broken into homes, camps, and food caches. In 1968, a young boy was killed and others have been mauled in sudden encounters. Scores of nuisance bears have been trapped in backyards, playgrounds, and even near the Catholic Eskimo Museum. Churchill is no doubt the only town where armed motor patrols must accompany children trick-or-treating on Halloween night. Maybe it also has the only airport where landing aircraft must at times dodge white bears on the black tarmac, and where one animal broke into a hangar to eat a whole cargo of doughnuts. Every resident has at least one humorous or one hair-raising bear tale to tell. All of them carry bear pictures in their wallets to show visitors.

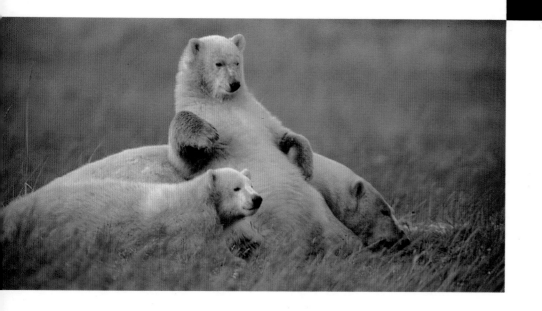

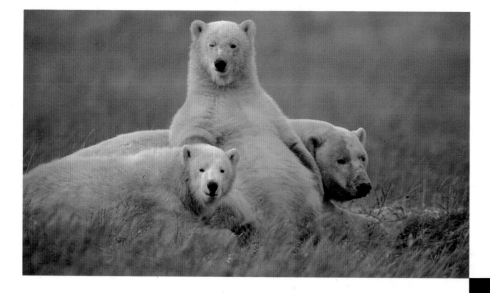

We were acquainted with this polar bear family for two years. These are triplet one-and-one-half-year-old cubs, and we made this family portrait in fall 1981. A year later, the family was still intact although the cubs had grown almost as large as their mother. Near Churchill, Manitoba.

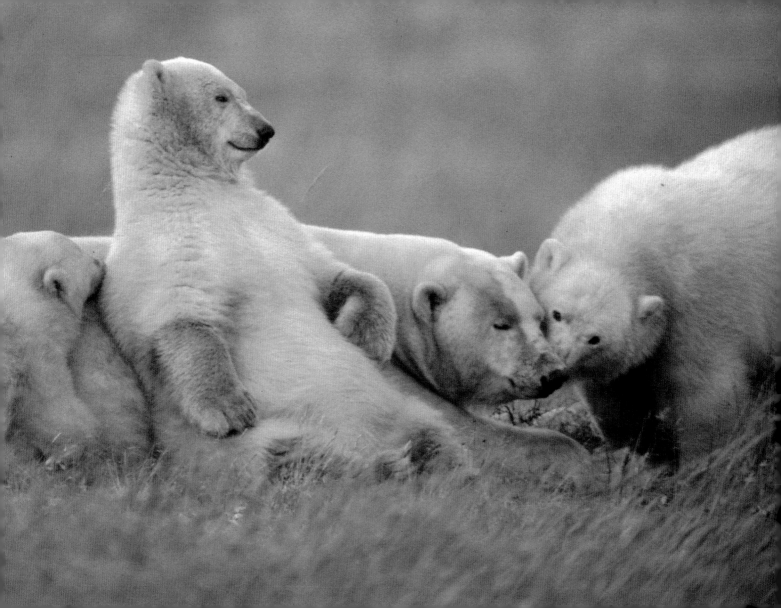

But despite the potential of ever impending danger, the polar bear problem seems solved today thanks to education and a cooperative public alarm and alert system. In 1965, it was necessary to destroy twenty bears in the interest of public safety. Now the statistic is down to near none. So today, Churchill in early November is the only place where anyone can easily see—often at very close range—one of the most magnificent of creatures living in the wild, without organizing an expensive expedition.

Photographing the bears is possible, but limited, by car or van along the few roads that emanate for short distances from the Arctic Inn in Churchill. Most visitors go in tracked, all-terrain motor coaches or tundra wagons. The last is a huge, double-decker bus-size vehicle with balloon tires, which can carry up to thirty passengers over tundra and frozen potholes to wherever there is a congregation of polar bears. But we had our own 4-wheel-drive Datsun pick-up shipped to Churchill by train, just for the extra convenience and freedom. Besides our photo gear, it contained all kinds of winter emergency and survival equipment and clothing, from shovels and cables to cross-country skis. We especially needed the clothing because photography here is a bitter business, usually in a terrible wind.

We found a few scattered bears simply by driving eastward out of town and closely paralleling the shore of Hudson Bay. Some bears were digging for garbage in the town dump, sometimes even singeing their hair on the burning trash. But this was a dreary, surreal scene, where many of the bruins had large green numbers painted on their flanks (by biologists for field identification). So we never lingered here. A few miles farther on, a bitter on-shore wind and surf piled mixed slush and seaweed against rocky bluffs, and usually we found bears loitering. Young bears wrestled and old bears slept in the dark litter, sometimes waking long enough to swim out in the near-freezing water. They seemed to be tense and impatient. The top of the bluff was an ideal place to set up a tripod and shoot, both because of the high angle and the safety factor. It is foolish to approach any polar bear very near on foot.

One sow along the beach with three cubs, each nearly as large as she, was an old friend. We had photographed that same female (which we recognized by a distinctive scar across her muzzle) a year earlier when the cubs were much smaller and more timid. This time one cub kept stalking and sniffing us whenever we began filming. It was unnerving and finally we were forced to retreat to our pickup. Incidentally, not all polar bears react the same way when they see you or a car; some vanish at first distant encounter, others come closer quickly. It is sensible to stay always alert.

During our entire trip, our favorite subjects were three medium-sized (say 700 or 750 pounds apiece) bears, almost surely males, which we usually found together somewhere beside a chain of frozen, freshwater ponds. Some days we discovered them sleeping on the open ice, but more often at least two were standing erect, swinging wildly with both forefeet. This play-fighting (for dominance, exercise, or to relieve boredom?) is the kind of live, lasting action that any wildlife photographer relishes but finds too seldom. It is amazing how any animal can sustain such vigorous action for so long—in fact, for days on end—while eating next to nothing. When one tired temporarily, the odd bear would take its place. The three bears were still scuffling the last evening before Hudson Bay finally froze solid in mid-November. The next morning we could not find a single bear left on land near Churchill. So we packed our pickup, loaded it onto the train during a savage snowstorm, and headed homeward.

It is impossible to recall all the splendid adventures we have had photographing wildlife in Canada, but some specific times and places stand out in our memory.

Early in World War II, the specter of an oil shortage in America resulted in building the now totally forgotten Canol Road and oil pipeline from Norman Wells on the Mackenzie River, Northwest Territory, to Whitehorse, Yukon. In retrospect, it was an astounding, but useless, engineering feat, which extended for 600 miles across the heretofore trackless wilderness. The difficult terrain is underlain with permafrost. Abandoned and impassable as soon as it was completed, the Canol Road had one lasting benefit: Using the timbers and other materials from its crumbling bridges and construction camps, our friend Sam Miller built a fine, cozy lodging on the N.W.T.—Yukon border for friends of the wilderness, photographers, and backpackers to share with him. The site overlooks a vast alpine tundra, which is really a patchwork of silver ponds. Vocal ducks float and raise broods on every saucer of water, half-whistling, half-yodeling in the eerie stillness. Miller named his place Oldsquaw Lodge after the whistlers. Incidentally, he is a biologist who came in from the cold after a career of studying polar bears.

We spent an indelible few weeks exploring daily, cameras in the packs on our backs, overfueled on high calorie Oldsquaw breakfasts. We studied grizzly bears and barren ground caribou in the distance. We counted such uncommon birds as the wandering tattler, Smith's longspur, harlequin duck, hoary redpoll, LeConte's sparrow, and Baird's sandpiper. We caught exquisitely colored Arctic grayling. But while we were vagabonding far afield, gray

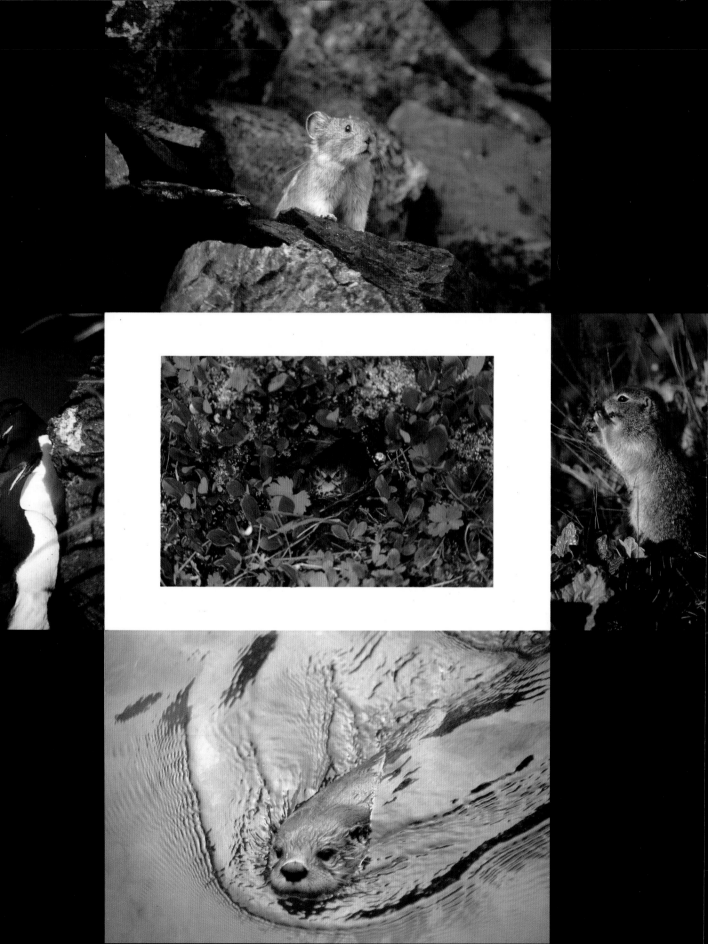

PAGE 112 TOP

Few creatures are more appealing than the pikas, which live in crevices and rock slides deposited by avalanches. Often it is possible to hear their plaintive squeaks long before you see them. This one watched us hiking on a high Yukon trail in search of Dall sheep.

PAGE 112 FAR CENTER

Hundreds of thousands of thick-billed murres nest on ledges of cliffs on many Canadian Arctic islands.

PAGE 112 MID-CENTER

The photo itself is not especially noteworthy, but the subject is. A water pipit is sitting on its nest beneath the surface of the Yukon tundra, only a few inches above permafrost. From a distance, we watched the bird fly to its well-hidden nest and later photographed it with a 400mm lens.

PAGE 112 RIGHT CENTER

In the entire Canadian sub-Arctic, few creatures are more obliging to photographers than sik-siks, or Arctic ground squirrels. This one in the Northwest Territory often fed from daylight to dark to accumulate enough body fat for the coming winter. In time, it paid no attention to our presence and filming. But while we were away, a grizzly bear dug up its den and probably ate the sik-sik.

PAGE 112 BOTTOM

While we were skiing beside an Alberta river, the otter presented a sudden opportunity for a photograph taken hastily. As happens so often, the otter submerged in the next instant.

PAGE 114 TOP

The population of mountain lions is still fairly high in western Canada, especially in the Rocky Mountain parks of Alberta and British Columbia. We have seen the tawny cats on three occasions, which is extremely lucky. The female with cubs was photographed near Banff National Park.

PAGE 114 BOTTOM

It is a rare sunny day toward the end of September in northern Manitoba, on the Cape Tatnam Wildlife Management Area. Migrating geese filled the sky above the tundra yesterday; today only two shorebirds are left on the slough.

PAGE 115 TOP

It is mid-November and the onset of the mule deer rut in Banff National Park. The buck in the center is strongly attracted to the doe in the foreground. Mating will take place even though a heavy snow has fallen and more is on the way.

PAGE 115 CENTER

It is a gloomy morning and snow threatens to penetrate to working parts of the camera, which can lead to serious troubles. There is not enough light for 64-speed color film, but we shot this mule deer anyway. It is an extremely expressive picture of a typically cold winter morning in southern Alberta.

PAGE 115 BOTTOM LEFT

Waterton Lakes is a little-known Canadian national park adjoining Glacier National Park in Montana. Its mountain landscapes are never more exquisite than just after a heavy winter snowfall.

PAGE 115 BOTTOM RIGHT

The scene just north of Lake Louise on the Banff–Jasper Icefield Highway is a favorite one of calendar photographers. We noticed a bull moose browsing on willow tips along the lakeshore.

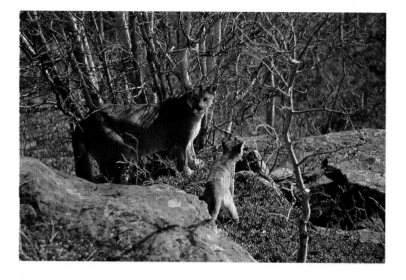
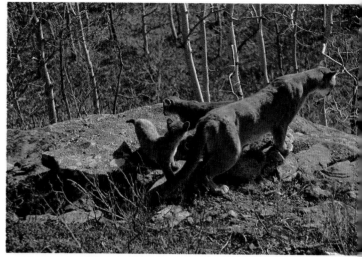
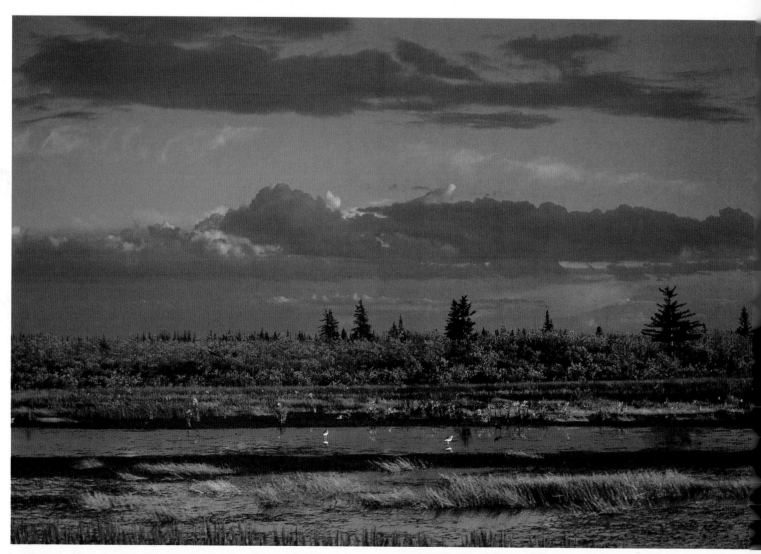

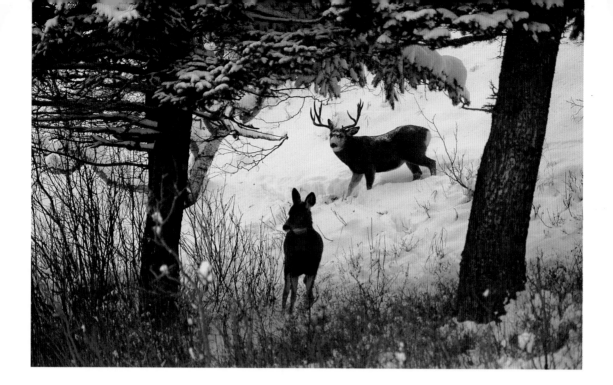

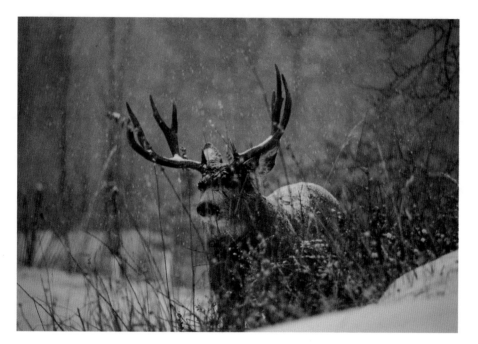

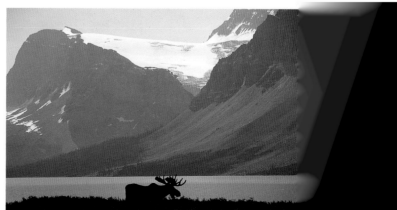

wolves (according to the cook) came right into camp, and gyrfalcons perched on the shingled roof of the sauna. So we began staying a little closer to base. The bluff surrounding the lodge was honeycombed with sik-siks, or Arctic ground squirrels. Unlikely as it may seem, these busy rodents, which weigh only a few ounces, are as challenging and fascinating to "shoot" as half-ton polar bears.

In the beginning, the sik-siks were wary of camera people looming over the entrances to their homes and they sulked underground. But summer is only a few fleeting weeks long here, and they must mate, rear young, and store enough body fat to endure eight months of hibernation when the temperature might plunge to −50°F. outside. So they became used to us, in fact so accustomed that we used shorter and shorter telephoto lenses. One afternoon, while climbing to photograph hoary marmots, a grizzly bear visited camp and excavated (for its own nourishment) at least half of the sik-sik settlement. The survivors never trusted us very much after that.

There are countless other places that a peripatetic cameraman might explore in Canada. Among those we know firsthand and recommend are Riding Mountain National Park, Manitoba, especially when this sanctuary is aflame with fall color. Banff and Jasper national parks, adjoining in the Alberta Rockies, have moose, elk, mule deer, white goats, and bighorn sheep. Many of these animals are visible from the main highways, especially in winter, but it doesn't hurt to hit the well-marked hiking trails into the higher country. Or take a pack trip on horseback. Kluane National Park, Yukon, has Dall sheep; to reach them requires steep hiking through matchless mountain real estate.

There are many seabird colonies in eastern maritime Canada, along the Arctic coasts, and on many Arctic islands. Camps created especially for naturalist-photographers are located on Banks Island and at Bathhurst Inlet, N.W.T. We only hope that there is time to get around to all of these places while they still exist.

IX

Central and South America

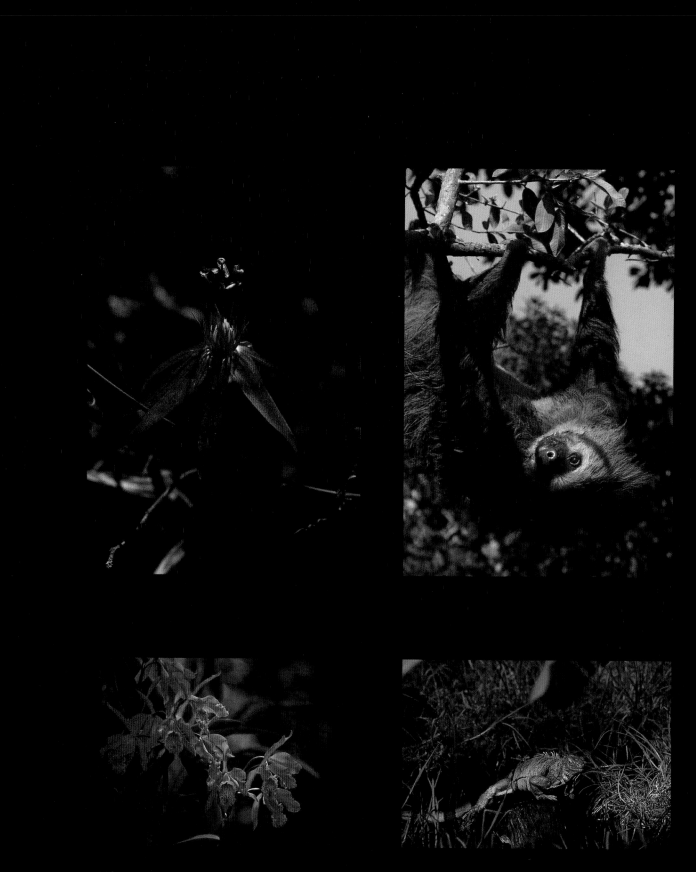

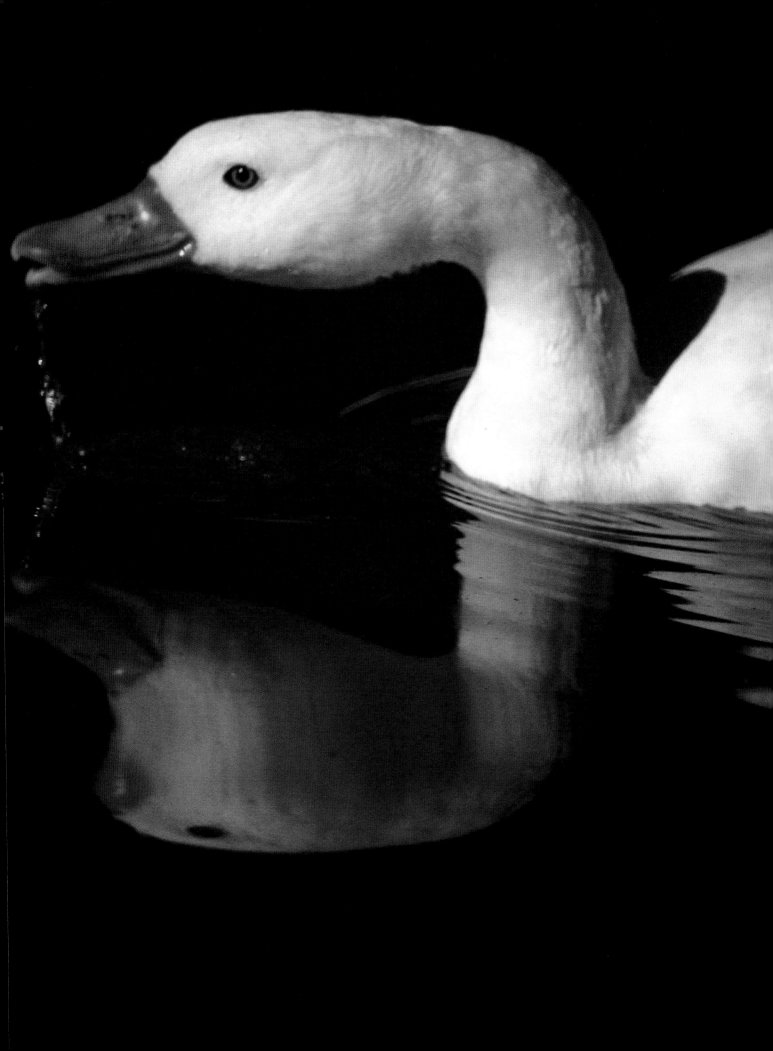

PAGE 118 TOP LEFT
The passion flower is as spectacular as the exquisite hummingbirds that seek nectar from it. The vine grows in dark undergrowth, so we watched for individual flowers that had found temporary shafts of sunlight piercing Corcovado National Park.

PAGE 118 TOP RIGHT
We photographed this sloth, living its inverted existence, during a river journey by dugout canoe into Panama's Darien Jungle. It is tragic that Panama has not set aside some of its jungle lowlands (and its cool highlands, as well) as national parklands or nature reserves.

PAGE 118 BOTTOM LEFT
Lavender orchids cascade downward in the highland forest of Trinidad. The Spring Hill Estate (sanctuary) is a haunt of bird watchers and photographers.

PAGE 118 BOTTOM RIGHT
A wandering wildlife photographer is likely to meet the common iguana almost anywhere in wet, lowland habitat from coastal jungles to central city parks of northern South America. They are seldom shy where they are not hunted and eaten.

PAGE 119
Once during a stopover en route to Patagonia, we made a brief bird-finding foray to a marshy region just south of Buenos Aires. Among our pictures of waterfowl was this one of a Coscoroba swan.

PAGE 122 TOP
The Cuban crocodile was photographed at Lago Tesoro, a research station and captive breeding project site. The government scientists are trying to reestablish these reptiles into former natural habitats from which they were eliminated.

PAGE 122 BOTTOM
The golden toad, here copulating, was not discovered until 1965. It is known only from a restricted area of the Monteverde Cloud Forest. The brilliant gold-orange color of the male is believed to compensate for lack of voice in luring females. A photographer must grovel in soggy ground with a macro lens for such a picture.

PAGE 123
Of all the many primates of central and southern America, none are more strange and few more elusive than the red uakari of the Amazon basin. Its face resembles an enamel, oriental ceremonial mask, and it is a dweller of dark places where woodcutters have not invaded.

From a deserted washboard airstrip at Palmar Nord in southern Costa Rica, we had flown by light five-passenger plane over a nearly unbroken wilderness. Suddenly, as we approached the Pacific Ocean, the pilot banked the aircraft sharply and began a steady descent toward a narrow clearing that was our landing place. A moment after touching down, we stepped into the intense, almost overpowering heat of Corcovado National Park.

Corcovado, one of nineteen parks and natural reserves gazetted since 1969, is a jewel in a system of national parks that is unique in the world. Rather than run a gauntlet of hotels, curio shops, and filling stations through traffic, we walked (carrying camping gear and cameras) 200 meters to an unpainted, two-story wooden structure, which was the park headquarters at Sirena. Corcovado does not have a motorized vehicle or vehicle road of any kind within its 89,000 acres. In fact, there are few visitor facilities beyond campsites in most of the Costa Rican parks. At Corcovado, it was lucky that we had brought our own air mattresses and mosquito netting. We unrolled the mattresses on the floor of the open-sided, upper deck of headquarters, where a warm breeze sometimes penetrated. The netting proved to be worth its weight in uninterrupted sleep.

But despite the spartan, and sometimes crude, conditions we found at Corcovado, it is a remarkable place for a cameraman to wander over miles of tropical rain forest trails, through lukewarm rivers, and beside a primeval ocean beach, where the tracks we found were of peccaries and a jaguar. Costa Rica is a tiny republic, which is desperately trying to preserve its remaining wild lands and special wildlife. No country (except possibly Tanzania) has set aside such a large percentage of its territory for pure conservation purposes. That is especially commendable in Latin America, a large part of the globe where no conservation tradition exists and where there is the least empathy for the environment and wildlife.

We watched an astonishing display of wildlife from the porch of Sirena headquarters and without hiking far into the forests. Howler monkeys sat in the trees that bordered the airstrip. Scarlet macaws flew past without fail each morning. Scarlet-rumped tanagers were beginning to nest. Someone counted seven different species of hummingbirds in the immediate vicinity.

Before flying to Corcovado, we had visited two other Costa Rican parks. The first was Volcan Poas in the central highlands, where one can walk to the edge of a yawning volcanic crater. Active as recently as 1978, a steady blast of steam still issues from the volcanic pit. But most remarkable about this site is the halo of wildflowers we found growing around the crater rim. Brilliant hummingbirds constantly refuel at the blossoms.

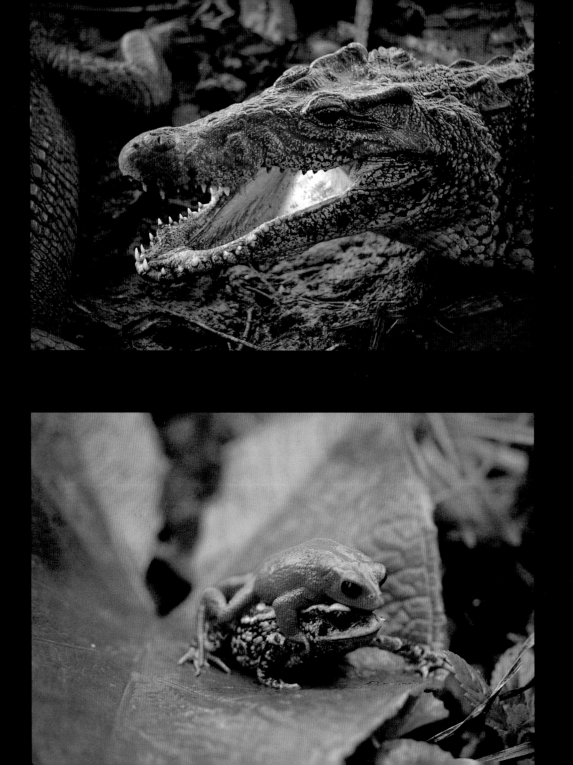

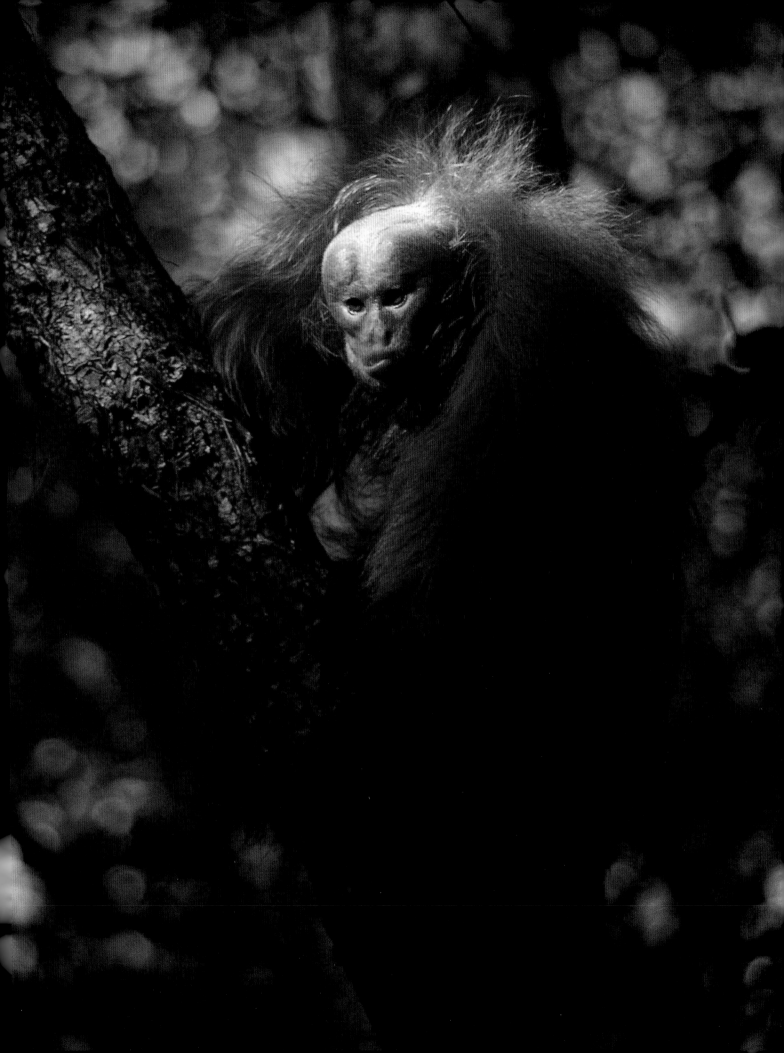

From Poas we motored to Monteverde Cloud Forest, which is as unique as the federal parks. Monteverde is a "private national park" owned and managed by a community of American Quakers, who arrived in the rain-drenched Cordillera de Tilarán in 1950. Often dank and darkly forbidding, the dripping fern and tree forests are the most lush and beautiful we have ever seen. And although wet and slippery, the trails are suitable for exploring on foot.

Most of the few visitors to date reach Monteverde in search of the colorful birds and forest amphibians, especially the resplendent quetzal and the golden toad. The now rare, long-tailed, emerald-hued quetzal is among the most strikingly beautiful birds on earth. The golden toad remained unknown to science until 1965, and only a few have ever been found in dark rainwater pools of the cloud forest and then only for a few weeks each year. We were fortunate to find both a quetzal and the toads.

The New World south of the United States is potentially a Promised Land for a wildlife or nature photographer. The tropical rain forests alone are the single largest repository of species on earth. Consider a few statistics: the forests of one country, Colombia, contain about 160,000 of the world's 250,000 vascular plants. Colombia is generally conceded to support the greatest number of bird species in the world (about 2,600), more kinds of mammals than Africa south of the Sahara, and an estimated 50,000 species of flowering plants. But less than one percent of Colombia's lowland tropical forests is now protected, and several natural habitats in that country are being eliminated. So wildlife photography opportunities are too few and decreasing. Any wildlife cameraman venturing into South America, particularly the northern two-thirds, should be armed with plenty of determination and equanimity as well as an oversupply of waterproof containers for all photographic equipment. National parks in which the resident wildlife is not terrified of an approaching human are rare indeed south of Costa Rica. Argentina and Chile offer a few exceptions.

The best and best-known parks in both of these countries are in the south. Atop the list is Nahuel Haupi National Park, a region of deep, pure lakes and stunning Andes scenery at San Carlos de Bariloche, Argentina, a tourist town not unlike Aspen or Chamonix. Even more spectacular is Los Glaciares National Park, farther south along the Andes range, where cameramen can focus on at least two superb sights. One is Moreno Glacier, an advancing, crumbling, turquoise wall of ice, which cuts Lago Argentino in two and produces floating icebergs. The other spectacle is of two famous mountains, Cerro Torre and Mount Fitzroy, which were once regarded as unclimbable and were

conquered only after Mount Everest. Hikers on the trails toward Fitzroy usually encounter guanacos, maras (hares), Darwin's rheas, ashy-headed geese, and Patagonian foxes. Equally grand glaciated panoramas exist in extreme southern Chile's Torres del Paine National Park, where a photographer can easily squander all his film on the scenery that compares to, or may even exceed, the grandeur of the Himalayas. But for shooting wildlife alone, the Valdés Peninsula and nearby Punto Tombo on the Atlantic Ocean in Argentina may be the finest opportunities in all of South America.

When Ferdinand Magellan waded ashore on or near the Valdés Peninsula about four and a half centuries ago, he was the first European to do so and apparently did not linger long. He found only a semiarid steppe, where a hot wind seldom stopped blowing. In his log of the voyage, he noted seeing only Indians with big feet (*patagones*, from which is derived Patagonia). Probably it is natural that a Portuguese explorer of the time, in single-minded search for gold, would not consider any wild creatures worthy of mention.

Sometime between December 6 and December 23, 1833, Charles Darwin sailed within a few miles of Valdés aboard the *Beagle* and perhaps even within sight of it. But the expedition did not pause, despite the excellent anchorages, and that is unfortunate. We are denied the naturalist's description of what would have been the largest marine wildlife community he would ever have seen, larger even than that in the Galapagos Islands. We visited Valdés nearly 150 years following Darwin's passage. Only a fraction of the birds and mammals he would have seen were there, but the spectacle was worth the long and difficult journey. Both the environment and the wild creatures were a startling contrast to what we had photographed in Costa Rica.

Isla de los Pájaros is a small island just north of the Valdés Peninsula, accessible only at low tide and by wading through a fairly protected surf. It is a traditional nesting site of gulls, terns, and night herons. Flamingos are occasionally seen here. Doubtless, the place suffers from too much unsupervised visitation by tourists during Argentina's Christmas and school holidays. It needs protection, just as the entire Valdés Peninsula deserves national park status.

We drove from Pájaros northeastward toward Punta Norte and stopped beside a busy, active, noisy elephant seal rookery. We parked where a pair of massive bulls were facing off. They fought, chest to chest, necks extended to the limit, in a duel over a community of females. The cows appeared totally disinterested, flipping sand, although blood was flowing. When the fighting and our filming finally stopped, it occurred to us that this might well be the only

TOP LEFT
An immortelle tree blossoms in the high forest of Trinidad, near Spring Hill Estate, where its flowers are a magnet for humming-birds.

TOP RIGHT
Species of heliconia, or lobster claws, will attract any photographer hiking the forest trails of Corcovado National Park in Costa Rica.

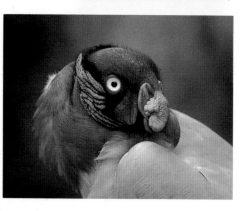

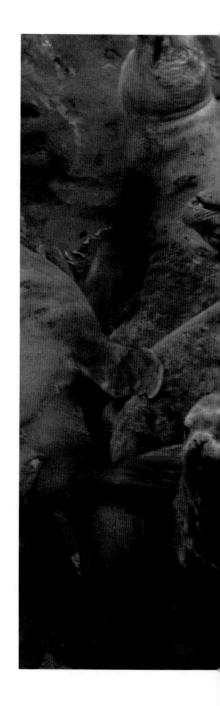

BOTTOM LEFT
Ferns, mosses, and geraniumlike flowers (*Impatiens, sp.*) are a visual botanical delight in the Monteverde Cloud Forest.

BOTTOM RIGHT
The portrait of an ornate South American king vulture is of an injured bird which orni-thologists were attempting to rehabilitate to the wild. The species' numbers seem to be decreasing.

The ocean shores of Argentina's Valdés Peninsula have several southern sea-lion rookeries, some very accessible to peninsula roads. From one we look down upon a pod of the mammals during the breeding season. The beachmaster bull is the one more than twice as large as the others, which are females.

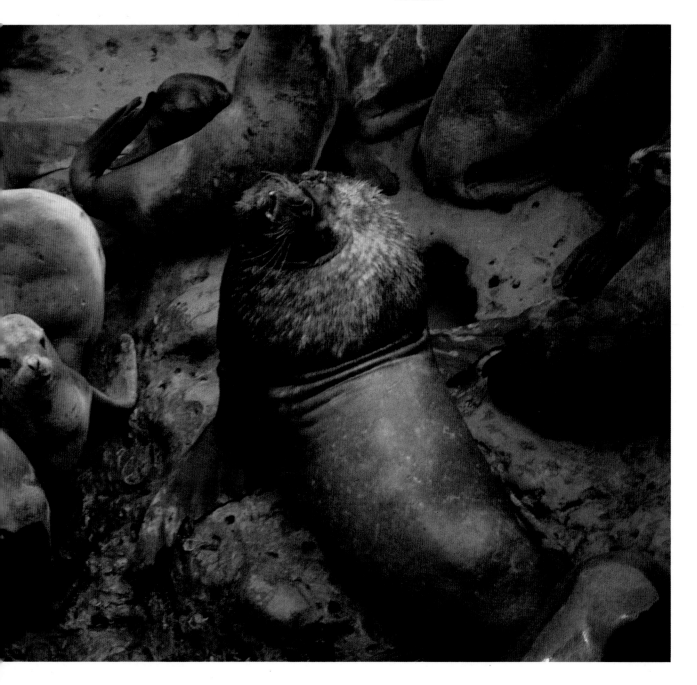

place on earth where it is possible to drive right beside an elephant seal (or any other kind of sea lion or seal colony) in a motor vehicle.

Actually, we had arrived just after the peak of the elephant seal's mating activity. Most were lying and basking in the sun as driftwood logs on the beach, half-rising to belch at us if we ventured or set up a camera tripod too near. But not so with the southern sea lions. Our visit coincided with the peak of breeding—in fact, with the most crucial time in the life cycle of the species. Males had already established territories but, unlike more separated elephant seal territories, these were jammed close together, causing constant turmoil and noisy struggle. Beachmaster bulls endeavored to increase their harems at the expense of their neighbors; troublesome younger bulls, frequently trying to invade the harems, had to be driven off. Each herd was a sleek mass of activity, of growling, grunting, and barking. Walking along a rocky shoreline, we could locate a sea lion colony by sound and by the pervasive stench long before we could see it. We ran rolls of film through our cameras and hoped that the always-blowing sand was not penetrating the mechanism. Later, sadly, from scratches on the film emulsion, we found that it had. Fine Patagonian sand proved to be a greater problem than the moisture of Costa Rica.

It is a short distance from Valdés Peninsula to Punto Tombo, a smaller and wilder peninsula poking out into the Atlantic Ocean. It is remarkable for the estimated one million Magellan penguins engaged in all stages of nesting, brooding, and feeding young, and it was impossible to walk in many places for fear of crushing an underground nesting burrow and the chicks inside. We kept well to the fringes and photographed the giant bird nursery from there.

Not only penguins, which brayed like jackasses, populated Punto Tombo. The steeper, rockier cap at land's end was a teeming rookery of kelp gulls, dolphin gulls, and four species of shag: rock, king, olivaceous, and blue-eyed. We also spotted a guanay cormorant, a species that had only recently appeared there; hitherto, its nearest known nesting site was 1,300 miles distant in the Pacific Ocean. We aimed cameras at oyster catchers and at skuas, which swooped down on and killed unattended penguin chicks as we watched. A few sea lions had hauled themselves out on isolated rocky beaches between sea cliffs below the nesting shags. Altogether it was a scene to thrill anyone who appreciates the wild world.

It is necessary to add an unhappy note here. A Japanese company has proposed to the Argentine government a plan to harvest large numbers of the penguins and sea lions each year for the oil and skins. At this writing, in 1983, the plan stands rejected, but it is far from dead. There is a terrible temptation

PAGE 130 AND 131 TOP LEFT

Black-browed albatrosses huddle together beside their earth and grass nest on West Point Island of the Falklands. Before the conflict between Argentina and Britain, astronomical numbers of seabirds nested annually in the Falkland Islands and hopefully they still do.

PAGE 131 TOP RIGHT

A rockhopper penguin, aptly named for its climbing ability, turns toward the cameraman kneeling nearby to make this picture. In our experience, rockhoppers are the noisiest and most quarrelsome of all penguins while on their nests.

PAGE 131 BOTTOM

Adult Magellan penguins gather on shore, near Punto Tombo, Patagonia, before beginning a daily commute out to sea. They will return to feed chicks left behind in underground burrows. Punto Tombo is one of Argentina's (and South America's) finest wildlife pageants.

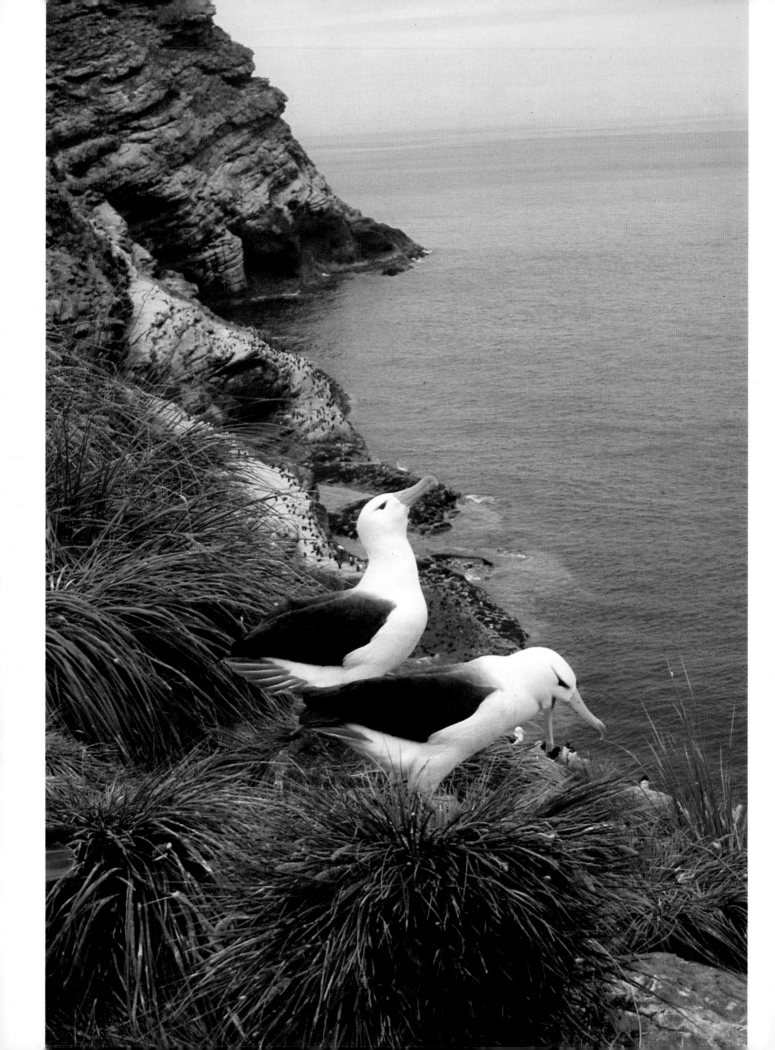

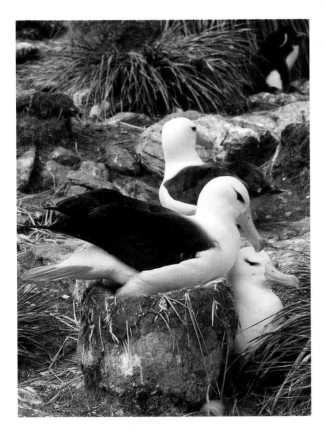

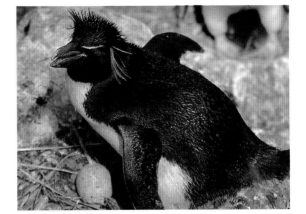

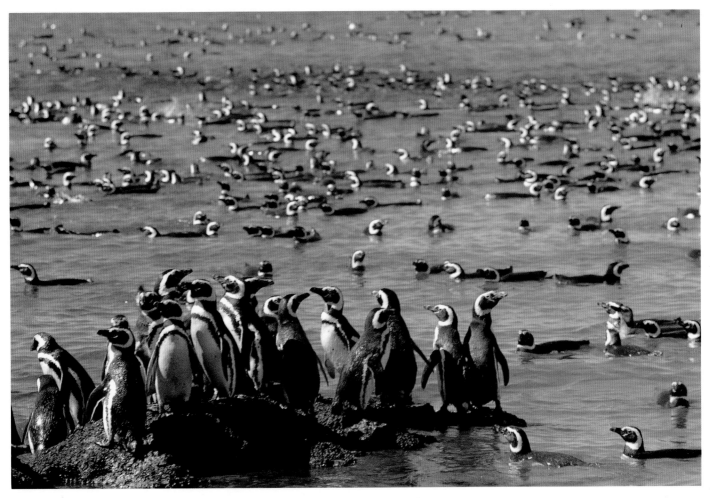

in a land with great monetary and social problems to take the short-term profit.

We have spent many happy days in the Falkland Islands, which lie in the cold, turbulent Atlantic just east of the tip of South America. During our visit on several islands in 1971, it was a most exciting place for a wildlife photographer. Gentoo, macaroni, and rockhopper penguins, black-browed albatrosses, flightless steamer ducks, kelp geese, sheathbills, and striated caracaras were among our willing subjects. We enjoyed tremendous filming between the rain squalls and brief snowstorms. But since that time, a tragic war and military occupation have probably changed the peaceful archipelago, and not for the better. We hope that the Falkland Islands do not suffer the same fate as so much of southern America.

X

Southern
Africa

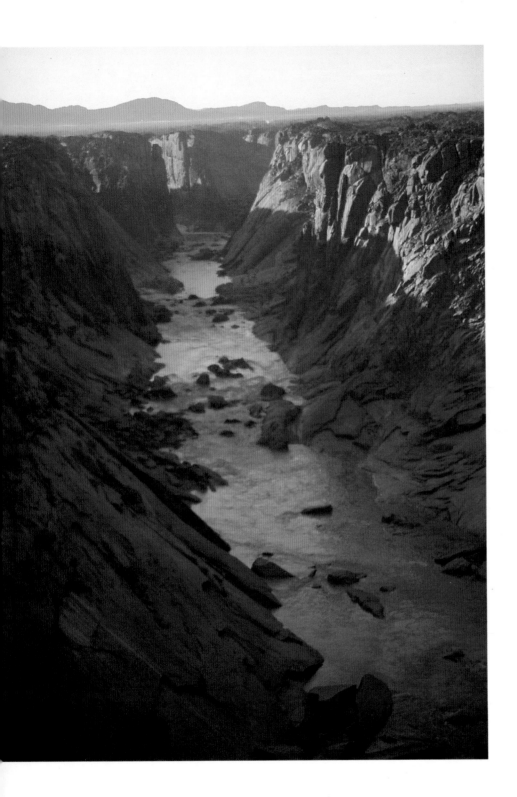

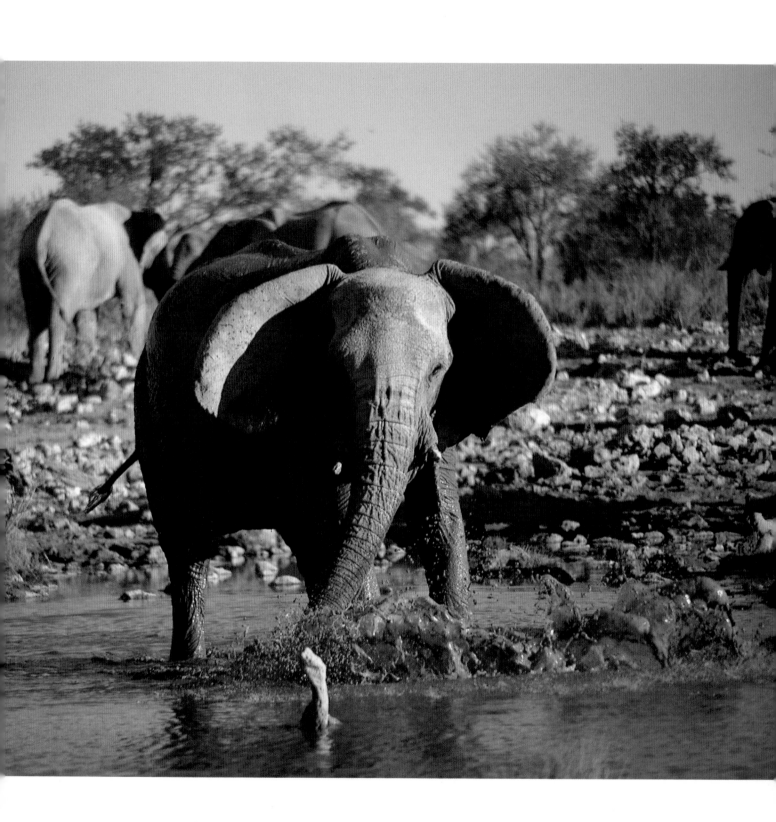

PAGE 138 TOP
Particularly during dry periods, which is most of the time, wildlife of Kalahari Gemsbok National Park is never far from the scattered water sources. Here a quartet of springboks files past a waterhole soon after sunrise.

PAGE 138 LEFT
One of our camps in Zambia was located beside this murky oxbow of the Luangwa River. Many elephants and a few bushbucks came to drink or bathe on the opposite bank.

PAGE 138 LEFT
Different species display different behavior as they approach waterholes. The wildebeests of Etosha come in a single noisy herd, but greater kudus, such as this splendid bull, approach slowly and do not mingle with other animals.

PAGE 138 RIGHT
The photograph could be titled "the odd couple" because the foreground animal is a greater kudu female while the other is a young impala buck. After the sunset drink, they will evaporate in the shadows and brittle brush of Kruger Park at night.

PAGE 139 TOP
During a dry season, Kalkheuwel is one of the busiest waterholes in Etosha National Park. The parade of zebras never seems to end. Except when lions are in the vicinity, most wade directly into the water, drink, and then leave to make room for new arrivals.

PAGE 139 BOTTOM
The photo of a natural delousing station, and a symbiotic relationship, was made at Umfolozi Nature Reserve, Kwazulu, South Africa. Red-billed oxpeckers (tickbirds) meet most arrivals at this tiny waterhole, such as the warthog, to pick the numerous ticks from its body.

PAGE 134
Aughrabies Falls National Park lies in dry western South Africa, where the Orange River plunges into a deep canyon at Aughrabies Falls; this is an evening photo of the first cascades.

PAGE 135
This elephant has just arrived at a waterhole where we have stationed ourselves for some time, photographing a steady procession of arrivals. The meaning of the swinging trunk behavior is not clear, but this tusker drank and made no aggressive moves toward us. Etosha Pan, Namibia.

All at once it dawned on us, probably for the first time at Kalkheuwel waterhole in Etosha National Park, that an elephant's intelligence is an eerie thing. Watch a coyote, or a jackal, or an otter, and you know immediately that it is bright and calculating. You can tell from its eyes and its body language what it will probably do next. But a dull-looking elephant with small watery eyes averted, standing knee-deep in the water, trunk swinging, reveals very little.

We were sitting at the edge of Kalkheuwel in our pickup truck long before the small herd of a dozen tuskers arrived. In single file, they approached along an old path, which had become a trench from years of elephant passage. One of the arrivals was a cow followed by a half-grown calf. With the camera and telephoto lens resting on a foam pad and poked through the open cab window, I focused on the calf, which hurried ahead toward the water in high spirits. It was having a good time. From old habit we also kept an eye on the mother.

Apparently the cow had no interest at all in us, and she barely glanced our way while drinking and giving herself a muddy shower bath. But she did keep shuffling ever so slightly to the right, feeling her way carefully along the muddy bottom of the waterhole, still not looking toward us. But suddenly, on solid ground again, she trumpeted once, flattened her ears, tucked her trunk under her body, and came lumbering in our direction. Mildly surprised, we backed away from the pond and lost a photo opportunity. Fortunately that was a very rare incident. It never happened before or since during hundreds of hours spent waterhole-watching. Other elephants have charged or threatened us, and we have seen other devious behavior, but that morning in Etosha Park was a lesson to be remembered. It was also an exciting way to begin our safari on the Dark Continent.

Southern Africa has a treasure of national parks and reserves, where elephant and other wildlife photography is as productive as anywhere on earth; maybe *more* productive for a first-time visitor. Furthermore, most of the best places are accessible and convenient to reach. Anyone arriving on a first trip at Johannesburg's Jan Smuts airport is astounded by how similar it is to landing somewhere at home. You can rent a car, for example, and drive right away to a game park, such as Kruger National Park on the Mozambique border, as easily as you could land in America and drive to Everglades, Yellowstone, or Yosemite national parks. There is no language barrier. Especially in the Republic of South Africa, the wildlife conservation ethic is as strong as anywhere else on earth, and it is nearly as vigorous if you proceed to Namibia or to Zimbabwe. In fact, the entire southern third of Africa is an extremely

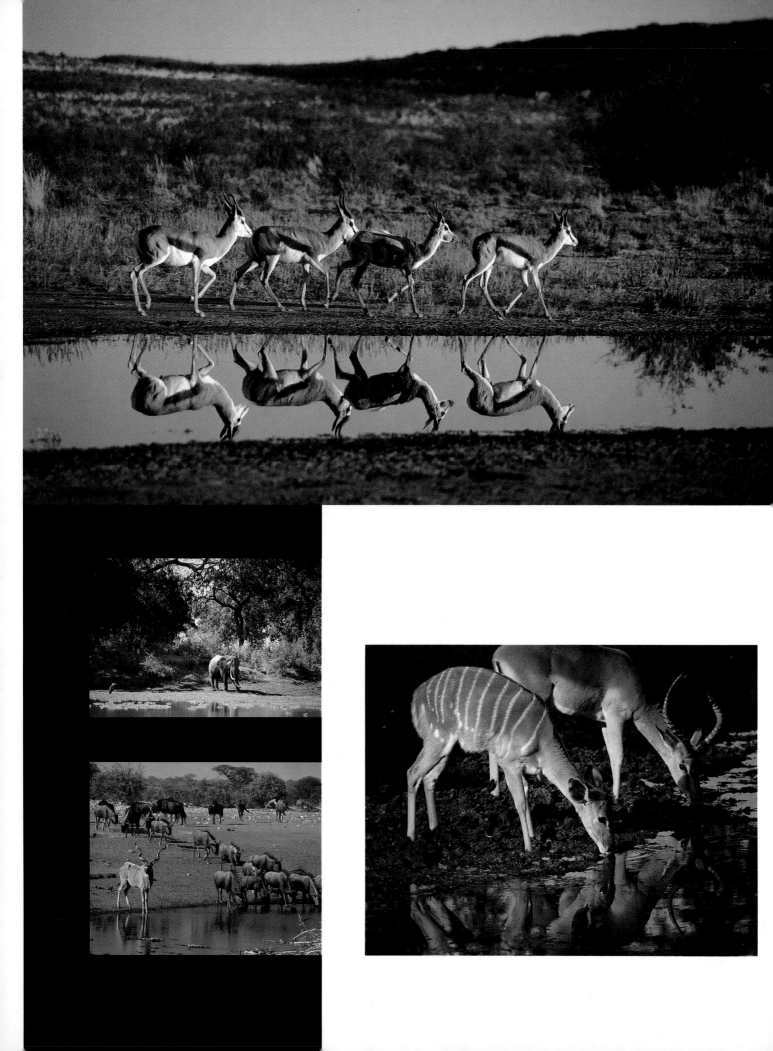

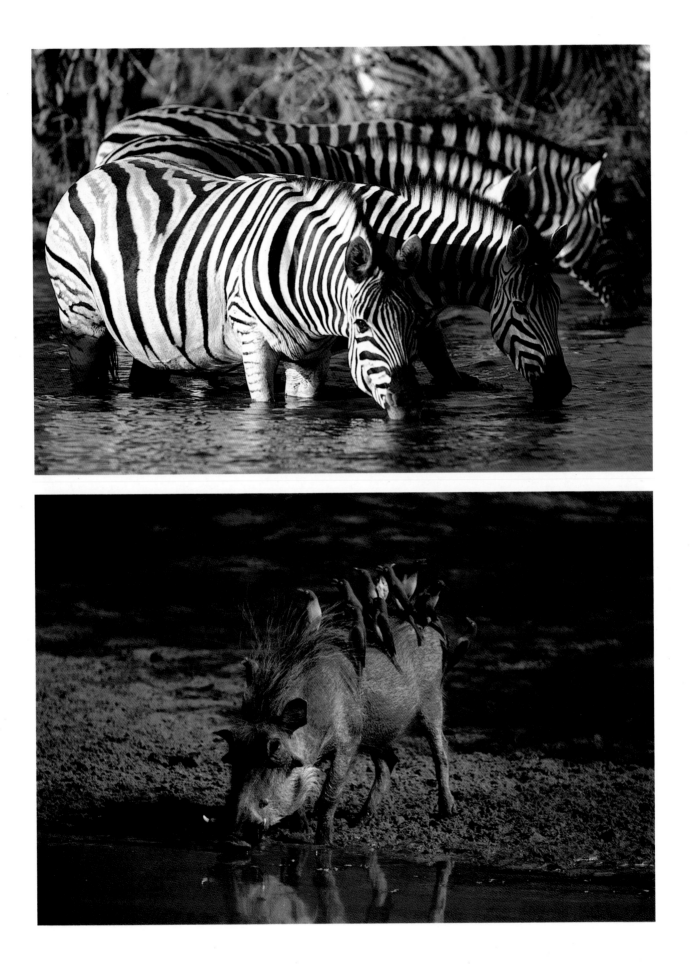

beautiful conglomerate of stark, sunburnt deserts and humid riverine swamps, of highveld and lowveld, of spectacular coastlines and mountain ranges.

Aside from the numerous natural areas never spoiled by human development, southern Africa has the only "instant" national park, reclaimed and created almost overnight. In Bophuthatswana, a tribal homeland enclave within the Republic of South Africa, a 100-square-mile area in the Pilanesberg Mountains was designated a national park to attract tourists to that area. Humans within the parksite were compensated and moved to other homes; many were hired as rangers. An elephant-proof fence of iron rails and bridge cables was erected around the new park. Then all of the original wildlife that had lived historically in the Pilanesberg region, including rhinos, was reintroduced from other parks. Today, unique Pilanesberg is an outstanding place for a wildlife photographer.

Because of a fairly predictable weather pattern, with definite wet and dry seasons in a generally dry part of the world, no technique pays off better than waterhole-watching. Dry seasons (which as a rule occur during the northern hemisphere summer) concentrate all forms of wildlife around existing sources of water. Etosha National Park in northern Namibia is an excellent illustration. Following the annual rains, which transform the central Etosha Pan into a vast, shallow lake, the game herds are scattered throughout the park, which is among the largest anywhere. But in June we found the pan totally dry, a dust bowl scoured by hot daytime winds. Virtually all creatures were located around the isolated waterholes marked on our park map.

Once we spent several days from daylight until dusk beside Kalkheuwel, and during that time an almost continuous stream of zebras came to drink— small bands and large herds, noisy and quarreling, kicking and cavorting. They paid no more attention to us than to the skeletons of dead trees, devastated by elephants, which ringed the waterhole. But they were nervous, and occasionally a vagrant breeze would bring a whiff of danger. Then the pond would empty in a second of panic; a few minutes later, reassured, all would return.

At dawn one morning, it was no false alarm that sent the zebras thundering away. Suddenly four lionesses were on the scene. They had not come to drink; instead, all crouched separately in ambush on our left and some distance back from the edge of the pond. Their lean, buff-colored bodies blended so well into the dry earth that had we not seen them arrive, we might never have noticed them concealed less than 100 feet from where we parked.

For the first time since we had staked out that waterhole, the atmosphere was entirely different—it was electric. We could still hear the zebras barking,

coming from a distance. For an hour, two hours, we sat in suspense, tense, cameras focused and eyes straining. We were waiting for one zebra to blunder near enough so that the predators would charge. But no zebra came all the way. It was almost a relief for our nerves when the lions gave up, stretched, and retreated to the shade. Minutes later, as if by magic, the waterhole was again a mass of striped zebras. Although most lion kills are made at night, no cameraman can resist any slight chance to film the drama in daylight

Giraffes also visited Kalkheuwel. With forelegs splayed far out to the sides, they lapped the water, which resembled thick pea soup. In that awkward position, giraffes are very vulnerable to lion attack. Greater kudu bulls with magnificent spiral horns came even more cautiously to the waterhole and drank quickly. At sundown, sandgrouse by the hundreds zoomed in, cackling, and for a time formed a living crust around the water's edge. Just before night-fall, the waterhole was empty at last. A single black rhino had been the last to leave. A lion roared in the distance as we drove away to our camp at Namu-toni.

Waterhole-watching is made easier in some South African parks by the presence of permanent blinds built over or near water. During the dry season, elephants are constantly performing in the pool beneath a platform in Zim-babwe's Hwange National Park, which is among the finest sanctuaries in southern Africa. At Bube viewing hide (blind), beside one of two permanent water sources in Mkuze National Park, Kwazulu, we once shot a record of thirty-six rolls of 35mm film during one day's time.

There are certain dividends to photographing from fixed blinds as opposed to shooting safari-style from a vehicle. First, it is possible to use a tripod with the long telephoto lenses for sharper images; and second, one is more delib-erate, since the urge to move on is diminished and one can more clearly observe what is taking place all around. One afternoon at Bube, for example, we noticed that many red-billed oxpeckers (tickbirds) had congregated in the vicinity of the waterhole. As various animals came in to drink, the oxpeckers would fly up to land on them—sometimes clustered all over their bodies—and methodically pick off and eat all the ticks. We were photographing a natural delousing station.

Kalahari Gemsbok National Park, located between Botswana and Nami-bia, is another little-known (because of its remoteness) reserve in which most wildlife is nearly always within the vicinity of the chain of water sources con-nected by just two park roads. In all of southern Africa, Kalahari Gemsbok may offer a photographer his greatest feeling of escape. During a June trip in an area the size of Long Island, we saw virtually no one, and we lived at the

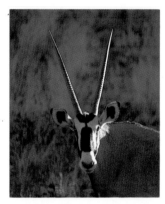

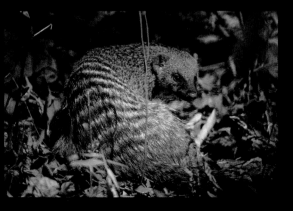

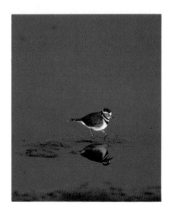

tidy, inexpensive Twee Rivieren Rest Camp almost alone. It would have been a ghostly experience except that the park abounded with big game and desert birds.

Botswana's Chobe National Park has far more visitors than Kalahari Gemsbok, plus a couple of places of special interest for photography. From Linyanti Camp on the Chobe River, it is possible to cruise by double-decker launch and shoot two species of elusive, rare antelope—red lechwe and sitatunga. Along a strip of the Savuti Channel, less than a mile from Allan's Camp, elephants, greater kudus, and buffaloes are almost continuously active in and along the river. After drinking, the elephants strolled into our compound and fed on the seed pods of the camelthorn acacia trees, which shaded our tents. This visit furnished one of those rare opportunities for a wildlife photographer to use a wide-angle lens on wildlife.

Aughrabies Falls National Park in far western South Africa reminded us somewhat of home. It gave us a chance to shoulder the same backpacks we tote on Rocky Mountain trails. For two days we trekked on a deep canyon course roughly paralleling the milky Orange River and had a look at a different southern Africa that resembles a moonscape and that few other travelers ever see. Along the way we saw klipspringers, sure-footed small goat-like antelope that live in the harshest badlands, a few springbok, baboons, and a leopard drinking in the deep purple shadow below our camp. We photographed strange kokerboom trees, broccoli-shaped, which live nowhere else and which attract neon-colored sunbirds to feed on the blossoms.

PAGE 142
Victoria Falls from the Zimbabwe side is an eerie, foaming spectacle at daybreak.

PAGE 143 TOP
The red lechwe is an uncommon antelope on scattered moist plains, usually along a few rivers of southern Africa. We photographed this buck from a high-decked photographic boat on the Linyanti River, Botswana. The riverine habitat is shared by sitatungas, hippos, and African fish eagles.

PAGE 143 LEFT
Look out across the red-brown landscape of Aughrabies Falls National Park and at first you may see no sign of life. But look a little more carefully and you may see klipspringers, small rock-jumping antelopes, which actually live on their toes.

PAGE 143 RIGHT
Dusk is descending on Kalahari Gemsbok National Park, South Africa. During daylight, the gemsbok was bedded unseen on a hillside near the waterhole. Now it rises, and we focus on the highlight of its long straight horns.

PAGE 143 LEFT
While walking in the damp forest beside Victoria Falls, Zimbabwe, we met the banded mongoose hunting along the hiking trail.

PAGE 143 RIGHT
Beside a waterhole of Etosha National Park, one visitor was the small three-banded plover, which waded in the elephant tracks next to our parked car. Shrikes, hornbills, doves, and sandgrouse by the hundreds also stopped here to refuel.

XI

East Africa

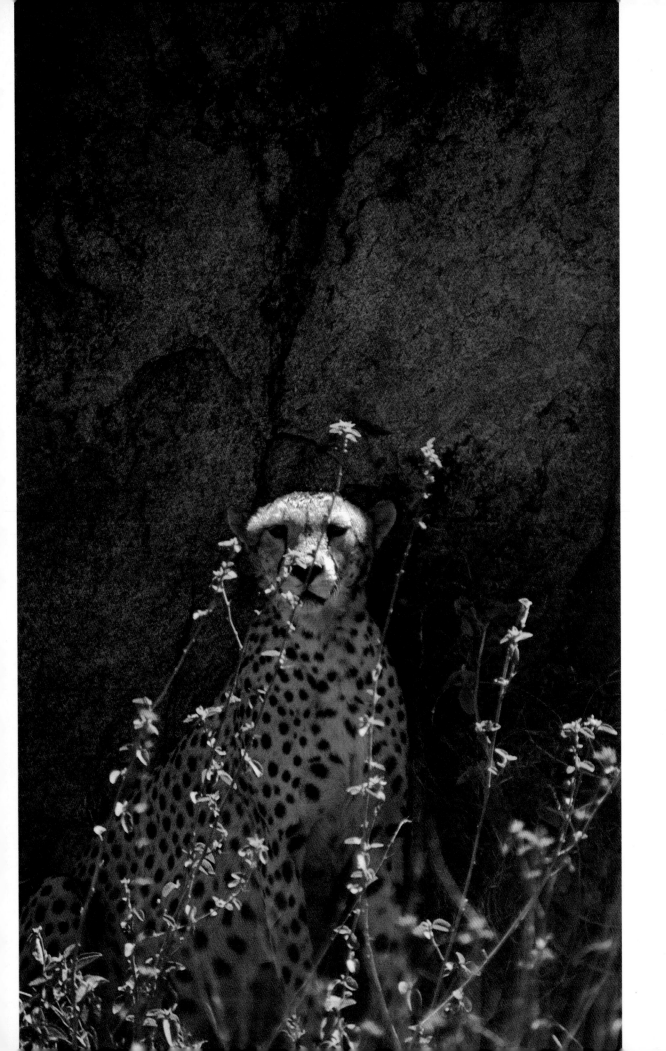

One year the end of February found us in Serengeti National Park, Tanzania. Shaped like the blade of a tomahawk, the edge facing eastward toward Kenya, it is the second largest (to Tsavo, Kenya) national park and contains more large mammals than any other sanctuary in East Africa. Two million wildebeests, zebras, gazelles, plus the predators that constantly stalk them, wander in an endless migration here in a lifelong search for the new green grass growing after the seasonal rains. Only the herds of bison, which once journeyed across North America's Great Plains, matched the trans-Serengeti trek for sheer biomass on the move.

Timing was a delicate matter on this expedition. We wanted to be present on the short grass prairies of the southern Serengeti plain when the wildebeests were passing through and calving along the way. The predators are also hyperactive because the bonanza of new wildebeest calves comes at a time when many lions, cheetahs, and hyenas have their own new families to feed. So here was a splendid time and place to see survival of the fittest taking place.

Our base headquarters was Ndutu, a cluster of reclaimed gray huts, once the camp of a professional white hunter. From the front porch, or the lukewarm shower, of our hut, we could watch passing wildebeests and elephants wallowing in a waterhole not far away. At Ndutu we rented a Land Rover, which was really a conglomerate of parts cannibalized from other dead Land Rovers. No tread was visible on its tires, the brakes did not respond, and there was too much "play" in the steering wheel. Several spare tanks full of gasoline were almost as expensive as liquid gold. Well before daybreak, we set out to find and follow the game herds. Driving across rolling roadless country, following old car tracks when we encountered them, we headed northeastward toward Gol and Barafu kopjes. These are rocky outcrops (technically known as inselbergs) of granite, which stand out in stark juxtaposition to the surrounding flat plain. Each kopje is an island in the sea of short grass, with its own plant and wildlife community. Lions and cheetahs commonly loiter around these isolated landmarks and we hoped to photograph them there.

At daybreak we came upon the first columns of wildebeests trailing northward and silhouetted against the lemon sunrise in the east. The farther we drove, the more wildebeests we met, moving in great masses. The herds opened up, leaving gaps wide enough for us to pass through, then closed ranks immediately behind us. All at once we noticed that among the dark figures of the adults were much smaller tan forms. These were calves, already able to join the migration a day or two after having been dropped into the world.

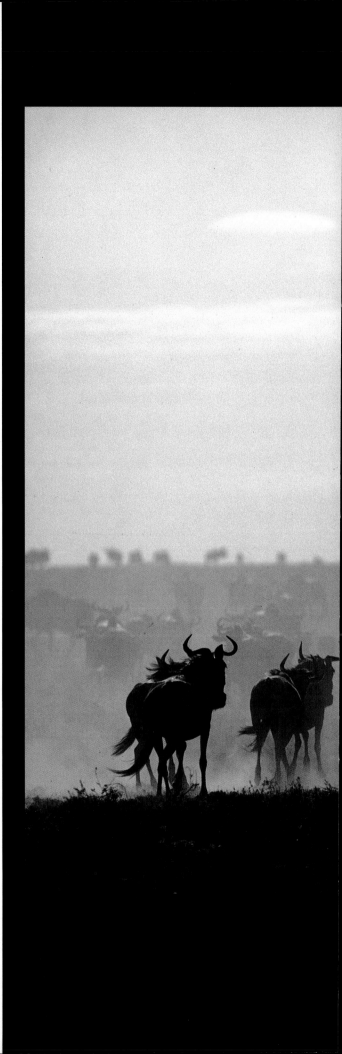

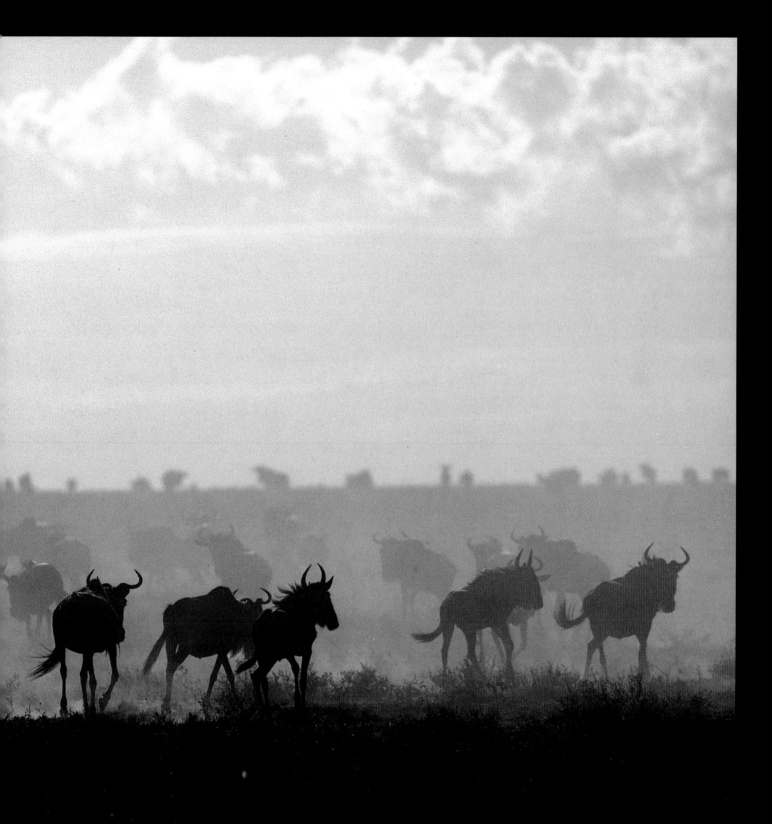

Two miles from camp, one great mass of wildebeests unaccountably split into two columns. They began to trot, sidestep, and move ahead more briskly. Suddenly we saw the reason for their uneasy behavior. Two male lions, their manes gleaming orange in the first low rays of the sun, stood motionless studying their prey. It was a memorable tableau. Fortunately the pair did not run, but seemed only slightly annoyed when we approached near enough to photograph them at a favorable distance. For several moments, through a long telephoto lens, we could see every detail in the amber eyes of those splendid cats. Almost certainly those lions were siblings, bachelors with no other family ties and without membership in any pride. They are among the many lions that spend a lifetime following the ungulates, living off the fat of the land.

There is no way to estimate accurately the numbers of animals we saw on this day's crossing of the southern Serengeti. Once we stopped to photograph a pair of Thomson's gazelle bucks fighting, heads lowered almost to the ground. From east to west, an unbroken line of wildebeests trekked in slow motion, suspended in heat waves, and at the same time a squadron of vultures funneled down to a point out of our sight. Zeroing in on the large birds, we drove to where several spotted hyenas were tearing apart the remains of a wildebeest carcass. Two jackals tried to share the kill, but were driven away. Moments after we arrived, only the horns, jawbone, and pedicle of the skull were left for the jackals and vultures to scavenge.

That night we camped beside Barafu Kopje. In the twilight, we cooked coffee over a sterno can while munching cold chicken, bananas, and peanut-buttered rolls—very plain fare, but here a veritable banquet. We unrolled air mattresses and sleeping bags in the back of the Land Rover, but, finding the space too confined, made our beds underneath the vehicle instead. There we slept fitfully because the night was alternately strangely quiet and startlingly noisy. Either way it was impossible not to listen.

Somewhere in the rocks behind us a bird—probably a capped wheatear—sang intermittently all night long. Hyenas whooped far away, and herds of hooved animals passed surprisingly close to where we were not sleeping. We knew that some were zebras by the barking and neighing; other animals, very nervous in the dark, stampeded and pounded away out of hearing.

Most of the passersby were wildebeests, easily identified by the grunting that a herd maintains when it feels secure. Lulled by this sound we dozed, when it stopped abruptly. Now we were totally alert, up on one elbow and listening, because when wildebeests suddenly become silent, it means that they are alarmed, sensing that a lion is nearby. Dawn did not come too soon.

PAGE 154 TOP LEFT
Dawn breaks over a waterhole of Aberdare National Park, Kenya, and a Cape buffalo arrives at water's edge to drink.

PAGE 154 BOTTOM LEFT
Late on a still afternoon, giraffes gather beside a Tanzania waterhole to drink. They are nervous and look around in all directions. A pride of lions also frequents the watering area and could be watching from ambush.

PAGES 154 AND 155
We found this nomad lion, apparently attached to no pride or family, following a herd of wildebeests over the Serengeti Plain. One morning we identified it about twenty miles from where it was the morning before.

PAGE 154
Hyenas have killed a wildebeest and we have marked the spot from far away by watching the descending vultures. Driving there as quickly as possible, we catch two hyenas in the midst of a meal.

PAGE 155 LEFT
It is ironic that some very rare animals can be photographed more easily than very common ones. In that category is the mountain gorilla of Kahuzi-Biega National Park of eastern Zaire. We found this large mature silverback male after a taxi ride and a short hot jungle walk.

PAGE 155 RIGHT
The splendid male lions, probably siblings, are among the itinerant predators that continually, relentlessly, follow the herds of ungulates over the Serengeti Plain.

As it happened, six lions did kill a wildebeest during that night less than a mile from where we listened. But by sunrise, minimum light for photography, the carcass was already eaten, and only the bloody muzzles of the cats identified the killers. Vultures began to arrive. Gorged and with stomachs almost too bulging to move, the lions strolled in single file toward our kopje. They spent the next two days sleeping within sight of where we had camped.

Serengeti is typical of the national parks that might be described as the true East Africa of wildlife watchers and photo safaris. Others in this category are Ngorongoro Crater, Tarangire, Manyara, and Ruaha, all also in Tanzania. Each except the last is easy to reach and is located on beaten tourist pathways. Masai Mara National Park, which borders Serengeti to the north, is Kenya's best wildlife refuge. But Samburu, Marsabit, Meru, Tsavo, and Masai Amboseli are also excellent destinations for photographers. In addition, Kenya boasts a number of good privately owned sanctuaries, such as Taita Hills owned by Hilton International. Three fine national parks exist (or once existed) in Uganda, but years of political turmoil leave their status uncertain: Kabalega (Murchison) Falls, Ruwenzori, and Kidepo.

Kagera National Park in Rwanda undeservedly is little known, but is lush and beautiful. Tsetse flies discourage visitation to some extent. Also a victim of its remote location and political instability in the region is Virunga National Park in eastern Zaire. Lions prey on hippos here as they do on zebras and antelopes elsewhere, and the mountainous portion has mountain gorillas. Ethiopia's national parks of Awash and Semien have great potential, but no government past or current has ever really cared for or protected them.

But there is another East Africa far above the dry plains and savannas. It is high on the cool, often soggy, and cloud-enveloped mountain masses that form an arc from Uganda's Mountains of the Moon southeastward past Mount Elgon, Kenya's Aberdare Mountains and Mount Kenya, to Mount Meru and Kilimanjaro, the highest point on the continent. These alpine regions, which are in immense contrast to the rest, are an Africa no one really knows.

We decided that late September would be a good time to explore Mount Kenya, the lovely roof of that country. We selected our companions much better than the time of year because the weather constantly threatened. Although directly on the equator, we encountered much more snow than we would at home in Wyoming's Tetons at that same time of year. One of our fellow trekkers was the Sherpa Tenzing Norgay, then sixty-five, who had climbed Mount Everest a little more than twenty-five years before. Leaders of the trip were Vince and Chris Fayad, husband and wife biologist-botanists of

Michigan, who have a Nairobi-based climbing-trekking company. Kikuyu porters carried the camping gear while we lugged too much photographic equipment in backpacks. Along the steep trails toward the twin crests of Mount Batian (17,058 feet) and Mount Nelion (17,020 feet) we saw a remarkable variety of wildlife, from elephants and Cape buffaloes in the moss-draped montane forests near the bottom to open moorlands and tussock grasslands where red-tufted malachite sunbirds darted too near and too rapidly to be captured on color film.

The Mount Kenya trails are neither as well maintained nor as well marked as most in the northern Rockies, the High Sierra, or the Austrian Alps, and the system of mountain huts is more primitive than the European system, from which it is copied. However, those are minor handicaps in the thin atmosphere where the forests of giant groundsels, the Dendrosenecios, and the furry rosettes of the lobelia are strange enough to have originated on some other planet. At 11,500 feet we discovered where elephants had bulldozed a stand of senecios to the ground; the hollowed trunks of some exposed the nests of groove-toothed rats, another resident of the highland. Beyond the elephant damage we had our only brief glimpses of Abbot's duiker, a spaniel-size antelope, as it evaporated into the landscape.

Our most memorable camp was at Two Tarn Lake, at about 14,500 feet, where it misted most of the time and a crust of wet snow tested our tent every morning. Rock hyraxes scurried everywhere giving life to the cold landscape. The presence of these little animals explains the leopard track we found when fetching water for tea one morning. A very rare resident of this elevation is Mackinder's eagle owl, and we saw three. One perched on a cliff near our camp, and we filmed it from just three feet away. We have never seen another photograph of this species taken in the wild.

After many long trips to photograph East Africa, it is easy for one venture to melt into the memory of another. Still, one stands out, and although we call it The Great Gorilla Hunt, we do not highly recommend it to all. The destination was Kahuzi-Biega National Park in extreme eastern Zaire.

The expedition began uneventfully in Kigali, the highland capital of Rwanda, which is as near to Kahuzi-Biega as one can go by scheduled commercial flight. From there it is a long rough dusty drive to Goma just inside Zaire's border. Even with passports and visas in order, red tape and insolent officials made passing this point harder than climbing Mount Kenya with a full load. Once in Goma, where the walls of a once fine post office were polka-dotted by machine-gun fire, things really got tough. The next step was proceeding to the opposite

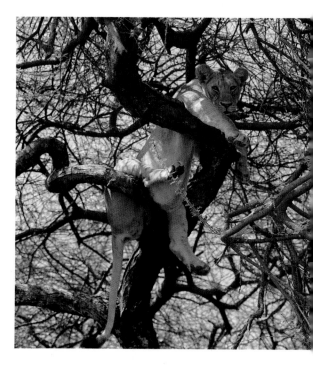

Flat-topped acacias are typical of the East African savanna and provide what little shade exists on the open plains.

For reasons not entirely clear, lions of Tanzania's Manyara National Park have learned to spend much of their lives, when not hunting, in trees. It may be to escape annoyance by insects, or to maintain a safe distance from the Cape buffaloes on which they regularly prey.

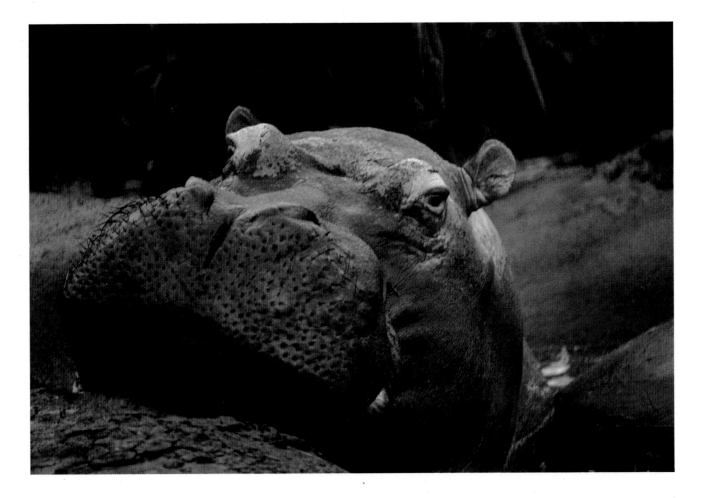

The hippo is one of many packed into a fetid muddy pool of Virunga National Park, Zaire. A long dry season has reduced the available water areas where hippopotamuses can submerge during hot days, crowding the animals into fewer places.

Most photo safaris to East Africa focus on the great numbers of large mammals, but the bird life is equally remarkable and many species are colorful camera subjects. This vulturine guinea fowl, filmed in Tanzania, is among the more striking larger birds.

In a sense elephants are glacial in that they really do affect and change the African landscape. By overbrowsing, they can transform forests into grasslands. Here at Masai Mara National Park in Kenya, two females (mother and aunt) are protecting a small calf by keeping it between them and safe from the photographers sitting in a vehicle.

side of Lake Kivu—once a chic Belgian resort area, but now in total depression—to Bukavu. In that town, the skirmishes and gunfire that went on in the streets all night were quiet in the morning. Luckily we found one taxi with enough black market gasoline in the tank to transport us to the steaming hills east of town. Two hours later and somewhat higher in elevation we came to a roadblock and a sign reading Kahuzi-Biega National Park. We stepped out of the taxi and told the driver to wait. A guard with a machine pistol led us to a shack where several rangers loitered. They grinned at the first visitors they had seen in a long, long time. This surely is the only place on earth where a rare and endangered species, such as the mountain gorilla, can be reached by taxi. We followed two rangers wearing raincoats (despite the heat and the fact that it was not raining) and carrying machetes. One continually grinned at us as if anxious to share some guilty or valuable secret.

On an overgrown trail barely ten minutes from our starting point, one ranger pointed to the crushed and broken vegetation, evidence that the great beasts had come this way. After hacking a tunnel with a machete for another hour into a nearly impenetrable green thicket, he stopped and pointed. The black face of a gorilla was staring directly at us from a distance of fifty feet. We could feel the rush of adrenaline. Standing rooted in place, weak in the knees, we saw other gorillas. One looked down from a tree not quite directly overhead. That's when our guide passed a warm bottle of Coca-Cola and a hard-boiled egg to each of us. As ridiculous as this seems, this incident is true, and we spent a few hours photographing the vanishing mountain gorilla.

Altogether it was an exhilarating experience with what seemed to be dull and gentle beasts; most surprising was their great size. For a while some slept, younger ones scuffled, and others appeared to be studying the camera people below with disinterest. Eventually all drifted away and that ended the gorilla safari. Almost.

On the way back to park headquarters, the ranger with the guilty secret revealed what was on his mind. He asked—and used the correct English words—if we had any rock-and-roll tape decks or any Levi's blue jeans for him. Since we didn't, a tip had to suffice.

XII

Islands

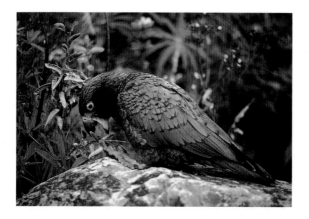

We first met the kea of New Zealand's South Island, as many hikers do, around the huts on mountain tracks. The noisy birds are more crowlike than parrotlike in behavior. One stole the ham sandwich from a pocket in our backpack.

By far the most colorful creatures a traveler meets in the Galapagos are Sally Lightfoot crabs. Lava shorelines are brightened by their presence. We photographed this one on Hood Island, scraping algae from barnacles with its claws.

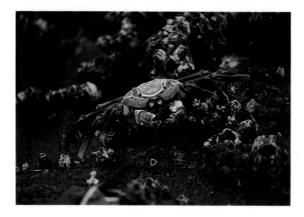

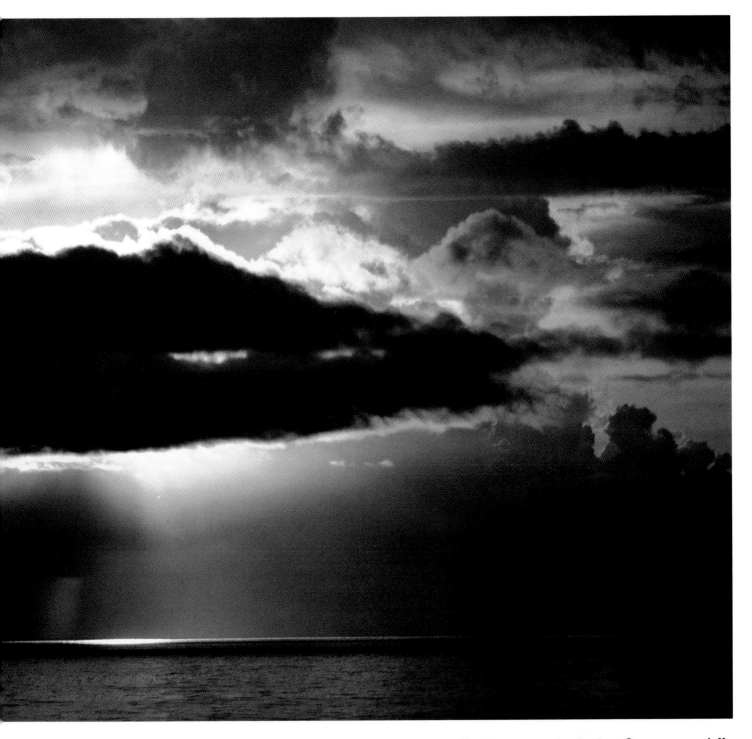

Cruising over the Indian Ocean, especially when the monsoon season is near, produces a spectacular sunrise each morning, here near the Seychelles Islands.

It is possible to identify the island of origin of a Galapagos tortoise or a marine iguana by the shape of the tortoise's carapace or the color of the iguana. This iguana's distinctive green and pink beaded skin reveals that this picture was made on Hood Island.

Seychelles islanders claim that Vallée de Mai Nature Preserve on Praslin Island is the original Garden of Eden. An endemic black parrot lives among giant double coconut palms, called coco-de-mer, which grow the world's largest nut.

Two conditions are necessary to "stop" birds in flight: first is to find a position where birds are likely to fly past; second is a fast (at least 1/1000 second) shutter speed. The brown-headed gull followed our ship, the *World Discoverer*, for miles as it cruised among the Andaman Islands.

Nature photography is not very rewarding in the Caribbean area, and a serious wildlife cameraman is wise to search elsewhere. We shot this Swainson's motmot at a bird feeding station on Tobago.

In Queensland, Australia, swarms of rainbow lorikeets and other birds are attracted daily to a well-known feeding station there.

It is not easy nowadays to find a koala in Australia's widespread eucalyptus forests; they are neither abundant nor very active. We photographed the female with cub at the Lone Pine Sanctuary in Queensland.

A very unwary bird we have met was the tawny frogmouth of Queensland, Australia, which sat nearly motionless for long periods during daylight. For this portrait, the camera was hand-held with a macro lens.

The world's birds seldom are easy subjects to photograph at close range, but there are such happy exceptions as the Victoria crowned pigeon in New Guinea, where many species of birds are all but impossible to approach.

It is midmorning when the bus finally stops on the edge of a sodden, gloomy, silver beech forest in New Zealand. The door opens and we debark reluctantly with a party of hikers. Since daybreak we have motored along a wilderness road past calendar landscapes, but have seen little through mud-splattered windows and the austral autumn rain pouring outside. We shiver and try to retreat deeper into our ponchos and woolen jackets. We tighten the laces on well-worn, well-siliconed hiking boots, but bending over allows cold trickles to explore down our necks.

"If we're all tidy now," a lissome girl guide announces with excessive cheer, "we'll start tramping."

The next four hours are very unpleasant tramping in single file over a rocky ascending trail. Gradually the ordeal lessens. By midafternoon we are still plodding up a steep slope, but the rain slackens and then ends. On the crest of a razor-thin ridge we emerge into blinding sunlight above clouds. We have entered a happier world and wallow in the warmth. Atop another even higher ridge, a band of red deer pause in their grazing to study the hikers removing their blue and yellow waterproof garments.

Perhaps as much as anywhere else on earth, New Zealand is walking— tramping—country. This is natural because particularly on South Island many good tracks cross soaring mountain ranges and traverse national parks of such enormous beauty that half the hikers you meet are visitors with foreign accents from around the world. For a long time Milford Track has been the most celebrated trail in New Zealand and is often described as "the finest walk in the world." Maybe it is. But this one, the Routeburn Track, goes higher, is more spectacular and more challenging. It is also better for finding wildlife.

Like the Milford Track, Routeburn begins in cool Fiordland National Park. At midpoint it crosses a high pass called Harris Saddle and concludes some sixty kilometers later in Mount Aspiring National Park. You can hike it easily on your own, or as a member of an organized party, which is not a bad idea when making the trip for the first time. We spent our first overnight in a dry wooden hut at Lake McKenzie. We were welcomed there by a pair of keas, which sat chuckling on the porch railing. Keas are the strange olive "parrots" that live only in a few alpine areas of New Zealand's South Island. We spent some time filming the uncommon birds before sharing the pot of powerful tea that someone had quickly brewed on arrival.

Early in New Zealand's history, settlers sorely missed the familiar sports of home in Great Britain, especially the hunting and fishing. Since no "game" birds, animals, or fishes had evolved on either North or South Island, a be-

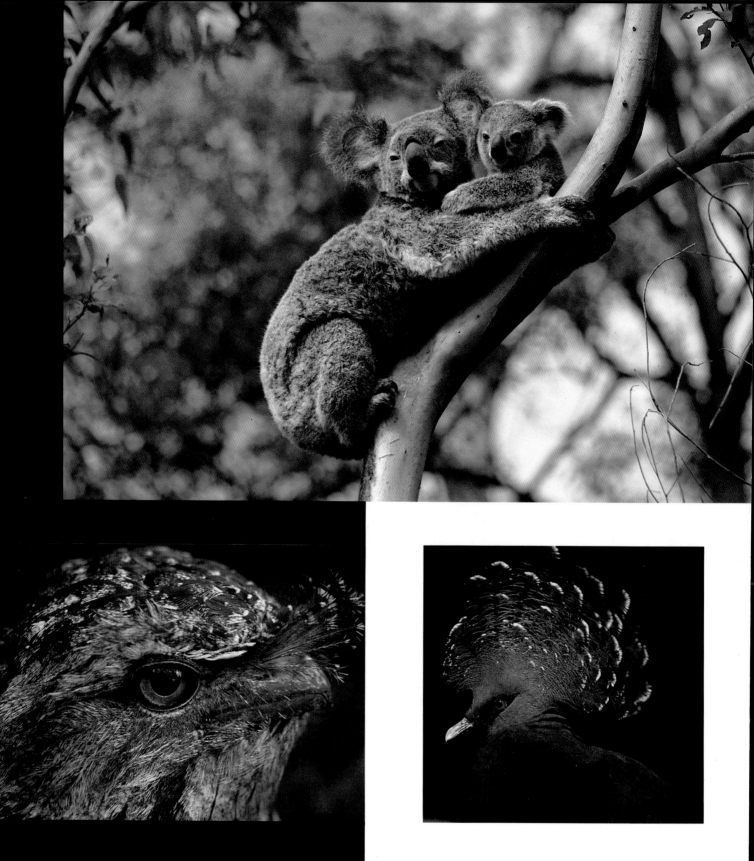

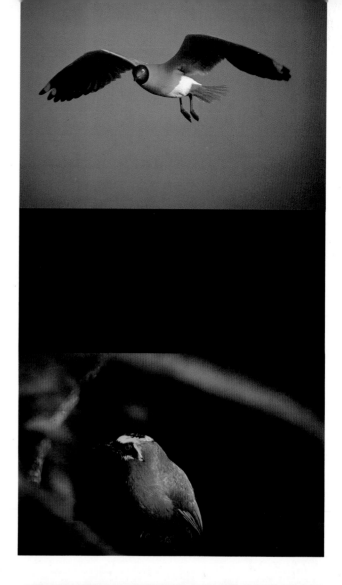

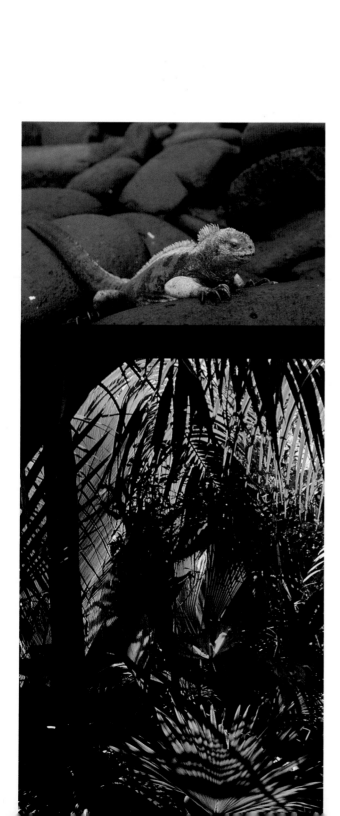

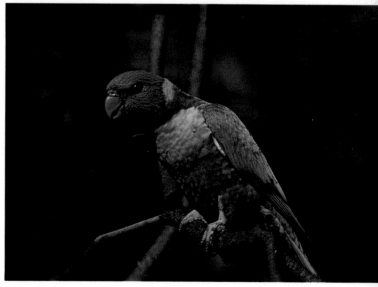

wildering variety of alien creatures were imported from around the world. A partial list would include red deer from Scotland, wapiti and geese from Canada, white-tailed deer from America, tahr from the Himalayas, chamois from Austria, brown trout from Germany, and quail and rainbow trout from California. In time the populations of some of these exploded with disastrous results, and vast areas of native vegetation were destroyed, in some instances forever. But the New Zealand government has corrected part of the grave problem by allowing, even encouraging, unlimited harvest by any means of the large mammals. You may hunt red deer and tahr anywhere, any time, even in national parks. Since it was the onset of autumn in the southern hemisphere, we left Routeburn Hut early one morning and also went hunting, but with cameras rather than guns.

Red stags are always impressive beasts, although never more than during the fall rutting season when they compete violently to possess and breed with harems of sleek fat cows. They are not monogamous. Carrying a rack of ivory-hard antlers, which may weigh fifty pounds, a stag will pose on a promontory with head tilted back and roar a challenge to any other males within hearing. It may also dig up turf, urinate on itself, and behave in other bizarre ways until a rival appears. If it does, and if the two stags are equally ardent, a dramatic duel for superiority may follow.

We heard roaring faintly in the distance after daybreak when we began climbing from the hut, and we followed a trail freshly carved by the sharp hooves of many red deer in transit to the breeding grounds. Big as they are, red deer tend to be supershy of hunters and so we traveled slowly, always studying the ridgelines ahead and above, trying to see before we were seen. A mile above camp we heard the shrill roaring again and this time much closer. An answer came from another direction. Continuing toward the first roar, we reached a defilade from which to watch an open alpine meadow. In another instant it became an arena as one stag strolled out majestically and challenged. After gasping for breath in the thin air and pawing deep furrows in the ground, the stag roared a second time. It was an absolutely primeval spectacle in the yellow light of early morning.

Unfortunately, the rival bull never appeared. Probably it was intimidated by the enthusiasm and volume of the first bull. But that incident remains a highlight of our days spent photographing on top of South Island, one of the most beautiful islands on earth.

Islands, which comprise about 5 percent of the world's land surfaces, have played an inordinately large role in the earth's evolution and biotic diversity.

PAGE 170 TOP

If a reptile can have a noble mien, this marine iguana on Fernandina Island certainly does. We sat down nearby, edged closer and closer with a short focal-length lens, but it did not blink an eye or retreat one inch.

PAGE 170 BOTTOM

Punta Espinosa on Fernandina Island, where we found these marine iguanas, is among the most fascinating of all places to spend many days in the Galapagos.

PAGE 171 BOTTOM RIGHT

The large male land iguanas feed on fallen opuntia cactus fruits and on the portulaca blossoms that carpet the ground in February. These iguanas have virtually no fear of photographers on South Plaza Island.

PAGE 171 TOP AND BOTTOM LEFT

We photographed the Komodo dragon, which is really a giant land monitor, after a hike toward the top of Komodo Island of eastern Indonesia. This encounter with dragons remains among our most unusual island adventures.

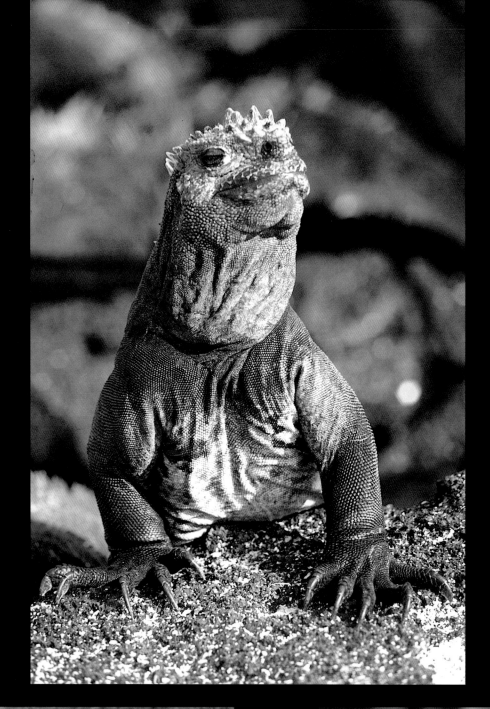

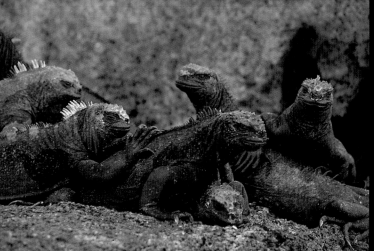

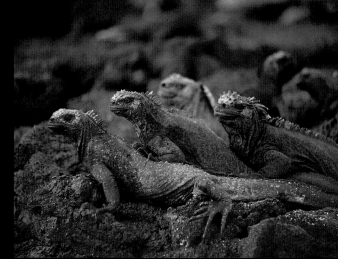

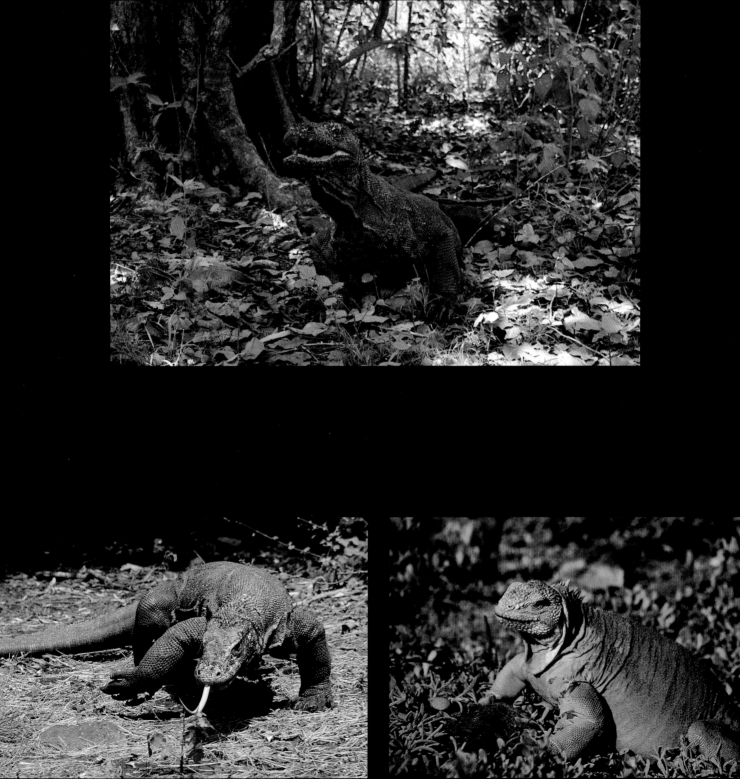

The planet's flora and fauna would be far fewer in variety if the oceans were not punctuated with these isolated tracts of land. Odd forms of life, which would have been eliminated elsewhere by predators, have been able to survive on islands because of their isolation. For example, about twenty-five different flightless rails (some now extinct) are known to live or have lived on remote oceanic islands. Flightless steamer ducks live in the Falkland Islands and flightless cormorants in the Galapagos Islands. The Hawaiian Islands, in addition to all the endemic honeycreepers, have a flightless moth, fly, and bug, as well as wasps, lacewings, crickets, and beetles.

On Aldabra, Mauritius, and the Seychelles islands in the Indian Ocean, endemic large land tortoises have, or once had, the role of the large grazing animals on the world's mainlands. Australia's insularity permitted all of its marsupial mammals to survive competition from the placental animals, which exist elsewhere. Therefore many islands are among the most fascinating destinations for wildlife watchers and photographers. The more remote and neglected by man, the better. We have been fortunate enough to visit, if not always to explore seriously, many of the most distant and forgotten of these islands. The most memorable were the Galapagos Islands, 600 miles due west of Ecuador, astride the equator.

The Galapagos are often described as beautiful, or as island paradises, which they certainly are not. They are hot, silent, sparse, brooding, if not downright desolate as compared to New Zealand. But the silence, if not the scenery, is beautiful and so is the desolation. Charles Darwin described the Galapagos as forbidding, even hostile, and if you do not relish raw wilderness, you will doubtless agree.

No two of the Galapagos Islands are exactly alike. We came ashore at Punta Espinosa on westernmost Fernandina Island late one afternoon because the combination of flood tide and ocean currents made an earlier beachhead inadvisable. Uninhabited, Fernandina is a single volcano rising almost a mile out of the sea, with another island deep inside its crater lake. We landed in bare feet, holding boots and backpacks high overhead to insure dry cameras and dry footgear for walking over the black lava ground. When we sat down to lace up the boots, a black marine iguana walked directly over, rather than around, one boot on its way to the water. It seemed not to realize we were there.

That late afternoon at Punta Espinosa was an extraordinary experience. It was the breeding season, and female iguanas disputed the rights to nest-digging in the limited areas of black sand. On all aa lava points and over driftwood logs, hundreds of other iguanas were draped, dozing, one on top of the other. They resembled sluggish miniature dragons.

Equally primitive or reptilian in appearance were the dozen or so cormorants. The birds sat upright, with jade-green liquid eyes and outstretched useless wings. The only bright color was the orange feet of ruddy turnstones, which scampered where the surf washed a black rock ledge. A few sea lions also were on hand. None of these creatures exhibited any fear whatsoever of two persons poking cameras toward them. Dusk came far too early and we had to retreat to our boat anchored in deep water off the island.

The next morning we returned to Punta Espinosa but it was not quite the same. It was cloudy with approaching rain squalls on the horizon. Many marine iguanas were apparently out to sea feeding on algae, and even the turnstones with the orange feet were gone. In their place was a drab wandering tattler, which had flown here from Alaska or the Yukon. This was a good chance for us to put the cameras aside and go swimming with the sea lions. They seemed genuinely to enjoy our company.

It was raining again when we waded ashore on Hood Island during our most recent Galapagos expedition. As on Fernandina, the first residents a visitor meets are marine iguanas. Although these of Hood are the same species, they are green and gray and pink instead of nearly all black. The island of origin of the iguanas can be ascertained by the color of the skin, as can that of the giant Galapagos tortoises by the shape of the carapace.

We found a sheltered cove at the base of a cliff and sat under an overhanging rock until the rain eventually passed. There was life and continuous movement all around us. In a steady procession, marine iguanas emerged from the sea and climbed up onto rocks already occupied by scarlet Sally Lightfoot crabs, which chipped away at barnacles on the rocks. After we had remained motionless for a while, both the crabs and the reptiles became used to us, walking over and around our feet. Several masked boobies landed to preen on a pinnacle rock nearby, and at a higher level they were joined by swallow-tailed gulls. An endemic Galapagos ground dove, with pale blue rings around its eyes, alighted but flew away when a motion toward a camera was made. All the while at regular intervals, incoming Pacific Ocean swells drove shafts of water up through a tiny blowhole with a roar like a jet engine. We were alone on an island lost in time.

Few islands of the world offer as many unique photo opportunities as the Galapagos archipelago, but some other islands we have visited are certainly worth mentioning. The South Shetland and South Georgia islands and many others of Antarctica and the south Atlantic are nesting grounds of penguins and other oceanic birds. Today, these remote landfalls are accessible each

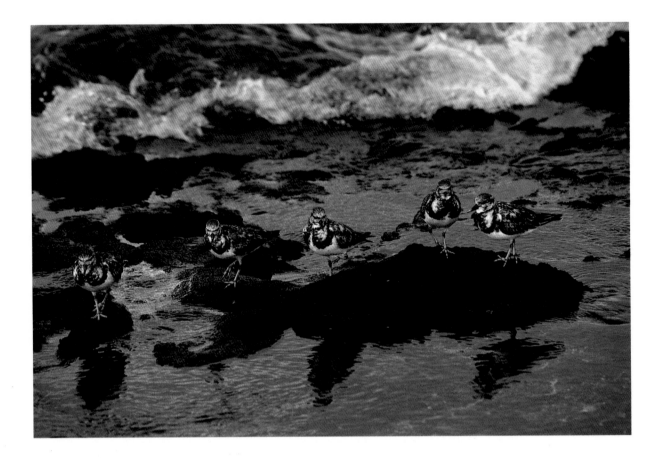

Late in the afternoon on Punta Espinosa, a flight of ruddy turnstones blew in to land on black lava almost at our feet. They may have arrived from far northern Canada or only from the nearest Galapagos island.

Masked boobies take a break from parental chores on Hood Island. The pair have a fuzzy gray chick begging for food in a nest nearby. We composed the photo so that the white birds would be posed against the black island background rather than against the lighter-colored sea.

Some remote islands have large wildlife populations, others little at all. Landing on one of the small Maldive Islands (Indian Ocean), the first and only birds we found were these crab or ghost plovers stalking the water's edge. The nearest one is an immature.

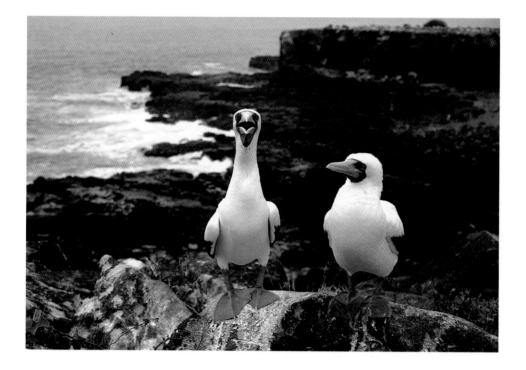

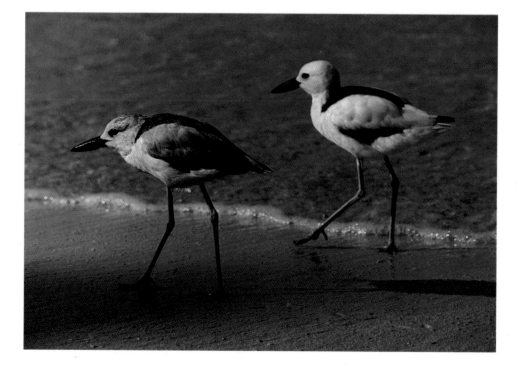

winter (summer in the southern hemisphere) via two adventure cruise ships, the *Lindblad Explorer* and *World Discoverer*.

Brutally hot Komodo Island east of Bali, Indonesia, is not a comfortable place to go ashore, but it is the home of the Komodo dragon, the earth's largest monitor lizard. During a one-day hike inland, we lost five pounds of weight apiece from dehydration, but photographed at least one monitor exceeding ten feet in length; it had been baited to a photo site with a live goat. We couldn't quite dismiss from our minds the tales of shipwrecked sailors and others who simply vanished in the past on Komodo Island.

The Seychelles and Aldabra Island in the Indian Ocean are exciting wildlife islands; Aride, Cousin, and Bird are the islands of most interest to bird photographers in the Seychelles. Vallée de Mai, a sanctuary on Praslin Island, is a remarkable botanical reserve, where the coco-de-mer grows in a lush palm forest. The fruit of the coco is the world's largest nut. Islanders believe that eating its meat assures long life and virility, both of which are very useful to wildlife photographers.

XIII

The Indian Subcontinent

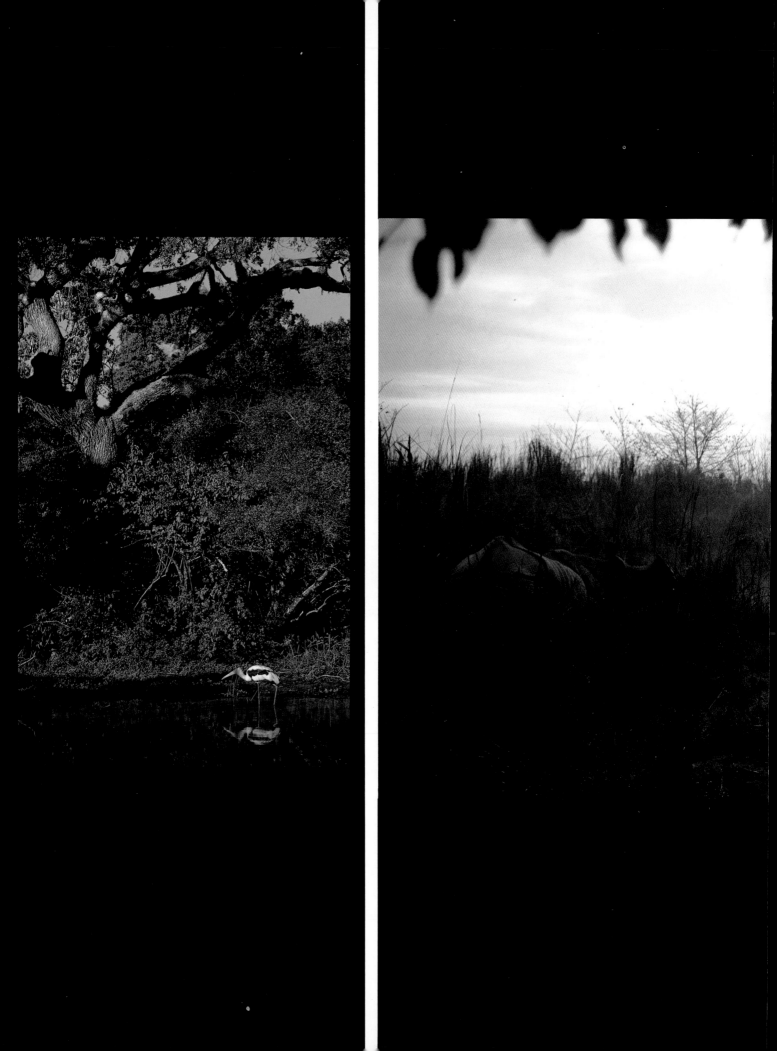

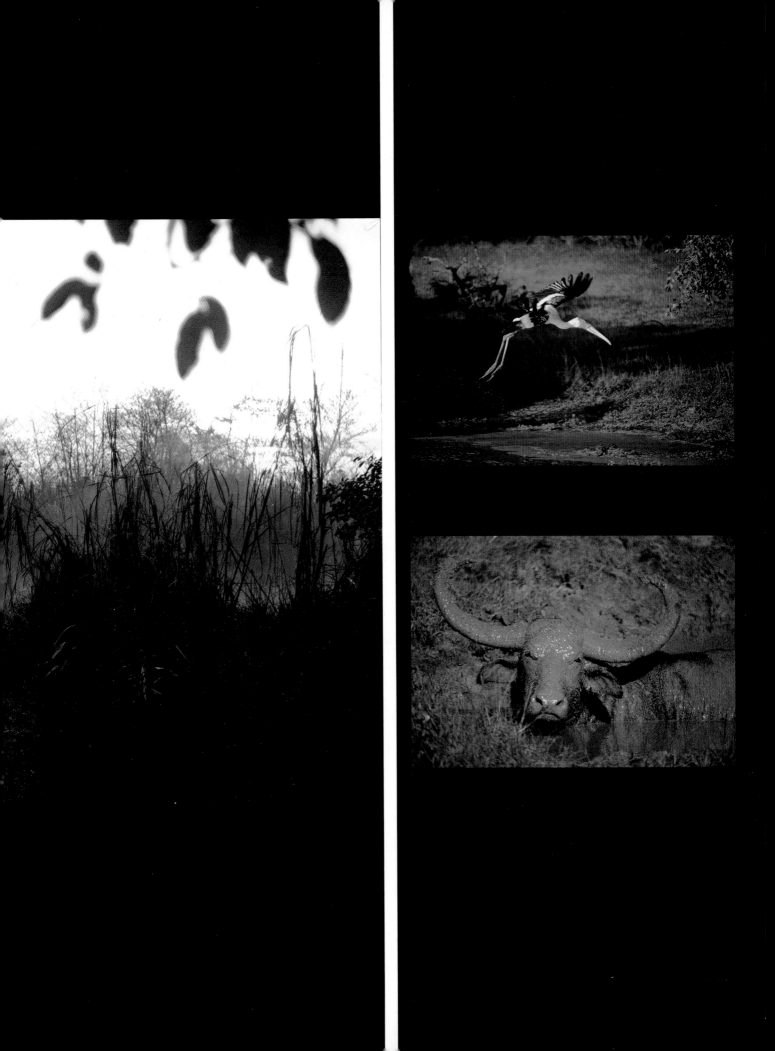

PAGE 178 AND 179 TOP
The painted stork is a familiar fisherman in
the national parks in Sri Lanka.

PAGE 179
For convenience and because of the tall vege-
tation, all wildlife watching in Nepal's
Chitwan National Park is done from riding
elephants. But at dawn one morning we left
Tiger Tops camp on foot to photograph the
old Indian one-horned rhinoceros, which fre-
quented the camp vicinity. We wanted to
shoot the animal from ground level and this
is the result.

PAGE 179 BOTTOM
In Ruhunu National Park, Sri Lanka, an
Asian buffalo wallows in a pond, which is
evaporating with the dry season. A large,
probably *too* large, buffalo population lives in
the park. Leopards help control numbers by
preying on the calves.

Restless Blossom seems somehow uneasy this still steamy morning in late February. We notice that her eyes are watering. She shifts her weight from one wrinkled foreleg to the other and her trunk swings nervously. But the mahout raps her sharply on the head, speaks sternly, and the old elephant kneels and waits for us to climb aboard. We do so by grasping her tail and pulling ourselves up over her rump. Ajai Kumar makes it a foursome on the wooden deck where we will ride. A moment later we leave the elephant camp at Bandavgarh National Park and follow a wide cleared track into a sal forest.

Although it is India's dry season, dew covers the vegetation and soon we are wet from brushing the overcanopy of trees. The morning is warm even at this early hour. Urged by prodding from the mahout, Restless Blossom soon is moving at a steady swinging pace. We are filled with excitement because we are searching for a tiger that is known to be at our destination; it has killed a buffalo and probably will not leave the vicinity of the kill until the buffalo is completely devoured.

Riding elephantback isn't an especially pleasant pastime once the novelty has worn off. Even with padding, it becomes hard on the behind; your feet hang down heavily over the edge of the platform, and you must brace to avoid sliding off. But Blossom had a better, quicker gait than most domesticated tuskers, and we were not uncomfortable.

Ours was a curious group riding through Bandavgarh. Not long ago this national park was a hunting preserve for princes in the state of Rewa. We had spent the previous night in the maharaja's hunting lodge, where huge stuffed tigers and leopards in glass showcases stalked through the dining room. Now we were riding where as many as thirty-six tigers had been shot during a single season within recent memory. Our companion, Ajai Kumar, had been a hunting guide during many a royal hunt in the past. As we rode, Kumar described how the first "white" tiger (a perfectly normal tiger, but with an ashen, instead of a yellowish, coat) was captured alive here. Apparently all of the "white" tigers in world zoos today descend from this one at Rewa. A jungle game scout had reported another white tiger recently, but Kumar doubted its truth.

A mile from the starting point we left the main elephant trail and turned off to parallel an overgrown stream course. Here and there Blossom splashed through shallow pools of rum-colored water. Hornbills, orioles, and blossom-headed parakeets flushed as small bright flames in the forest. Suddenly Blossom hesitated and seemed uncertain about her footing. The mahout tapped her on the skull and she went forward several more steps. Then he turned to

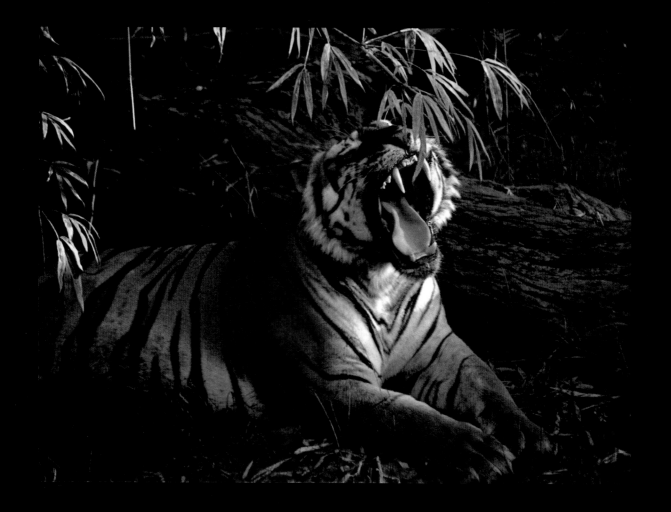

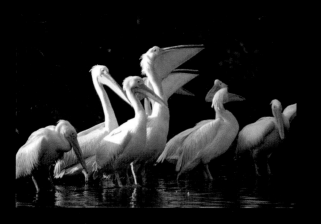

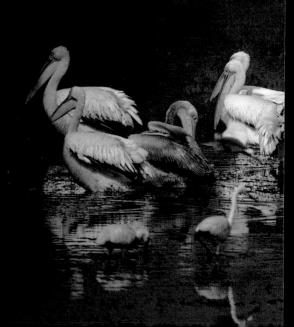

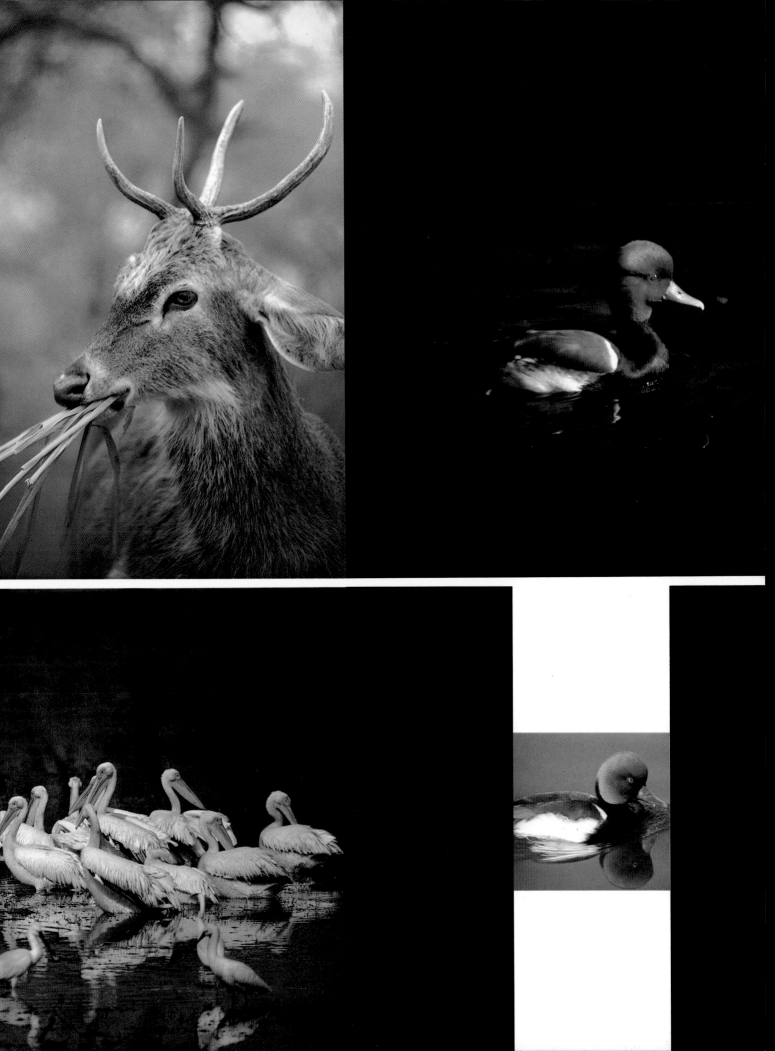

PAGE 182 TOP
This male tiger is yawning on the edge of an Indian forest early in the morning. It has gorged on meat from a buffalo kill nearby and soon fell asleep. We shot the picture from elephantback not far away because the tigers of Bandavgarh are accustomed to photographers atop elephants.

PAGE 182 BOTTOM
Gray pelicans stretch and welcome morning on a shallow reservoir of northern India.

PAGE 183 TOP
Generally the animals of India's national parks and sanctuaries are not as tolerant of photographers as are similar species in most African and North American national parks. But the now rare brow-antlered deer with a mouthful of marsh grass was unusually obliging.

PAGE 183 BOTTOM
A flock of gray pelicans rests at Bharatpur Sanctuary, India's most important waterfowl refuge. These birds feed cooperatively by closing in on a circle of small fishes trapped in the center.

PAGE 183 RIGHT TOP AND BOTTOM
By sitting in a blind during the north Indian winter, it is possible to focus on a great variety of waterbirds and waterfowl. Among the most colorful, but least common, migrants is the red-crested pochard, which nests in northern Eurasia.

PAGE 186
Another shot of the one-horned rhino on page 179.

PAGE 187
The game scouts of Kanha National Park have an almost mystical ability to locate resident tigers. And within the past decade or two, tigers have learned that humans riding on elephants are no longer dangerous. So good photos, as of this tiger drinking in a jungle pool, are often possible.

Kumar and mumbled in Hindi, pointing to a patch of black hair and red meat almost hidden by green bush. It was the carcass of the buffalo kill.

The elephant stood in place, her heavy breathing slightly raising and lowering the riding platform as we searched the forest floor all around. Then all at once the tiger was right there, barely 100 feet away, staring at us from the base of a bamboo clump. Once we distinguished the exquisite cat from its background, it was perfectly visible. But in a career spent outdoors, we have rarely found a large animal so perfectly camouflaged into its background. The tiger's stripes seemed to melt into the vertical bamboo stalks. No wonder the species is such an efficient predator.

In the best of circumstances, it is not easy to photograph from a heaving elephant back, but the problem was compounded by the difficulty of focusing sharply on such a camouflaged subject in the dim light of forest understory. Fortunately the cat only yawned at us, and the mahout coaxed Blossom to within fifty feet. What we saw in the camera viewfinder remains among our finest photographic experiences. Then trouble! Trying to change film too quickly with five thumbs on each hand, we dropped an exposed roll overboard and it was lost in the knee-high grass. With no more cue than a guttural command, Blossom backed up one step, probed the grass with her trunk, and then passed the film back to us.

In time, the tiger stood up, stretched by humping its back, and walked through a sunlit glade to drink at the stream. That seemed to annoy Blossom because she huffed and backed away, and we missed the picture. But no matter, for during the next few days we saw that same tiger (still near its kill) three more times and three other tigers as well.

Our photo shoot at Bandavgarh was as significant as it was rewarding. Here it is possible for anyone to see (with reasonable certainty) and photograph one of the world's rarest, most endangered creatures. It is doubtful if more than 5,000 tigers survive on the entire Indian subcontinent of Asia—or on earth. But we found many of them in two other places: Kanha National Park in central India and Royal Chitwan National Park, Nepal. The latter could be a most reliable region to watch tigers if not managed as ineptly as it was in 1982. Kanha is another park where the elephant handlers have developed tiger-finding into a fine art. Once they showed us six different cats during one week in only a few hours per day of searching the forests and edges of the grassy meadows.

The color and opulence of India's long past may distract any visitor from another Indian heritage—its wildlife. As recently as a century ago, the game

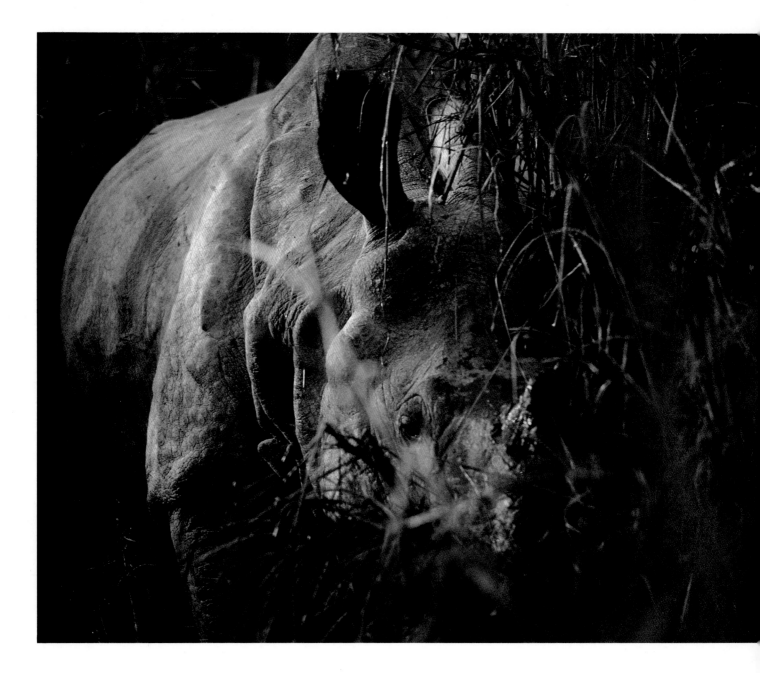

186 **XIII** THE INDIAN SUBCONTINENT

herds of India were comparable to those of Africa today. Now only a pitifully small remnant survives. There may be more Indian black bucks and chital on exotic game ranches in Texas today than living wild on Indian plains. Still, the national park system is a good one and several of the parks, although small by African and North American measurement, are extremely beautiful and rich in native fauna.

There are two camps at Kanha. Ride out on elephantback, or even by open jeep, soon after daybreak and you pass herds of chital, black bucks, and barasingas grazing in the first golden light. The barasingas, rare relatives of the Wyoming wapiti and the European red stag, carry their high massive antlers through the February dry season. Time and again we watched bulls fighting.

Ranthambhor National Park in Rajasthan has a matchless wooded setting around shallow lakes, where sambar deer wade at dusk. The wildlife is unaccountably shy, as if illegal poaching still persists.

Kaziranga and Manas national parks in troubled Assam would be outstanding nature reserves anywhere in the world. At Manas, on elephantback, we followed the tracks of a tiger in soft sand to the Manas River. After crossing the wide shallow current to Bhutan, we found the same tiger tracks emerging on the opposite shore. Although we never actually glimpsed that cat, we did eventually find and photograph a troop of golden langur monkeys, a race of the species that exists only here.

We have traveled to Kaziranga twice because it is one of the best places (where the species survives) to hunt the Indian one-horned rhinoceros. A short ride from camp on a park elephant will usually bring a photographer to point-blank range of several animals. But Kaziranga has always produced a few surprises, such as being rushed by a wild bull elephant in musth, the male breeding period. Halfway through the charge it stopped and decided to overturn a large tree instead. We used the diversion to hurry away.

With the snowy Himalayas looming in the background on clear mornings, Kaziranga may be the final refuge of the pure wild Indian buffalo. Elsewhere the wild species is all but eliminated by interbreeding with domestic stock. Swamp deer are another species photographable only at Kaziranga.

We have never been able to spend enough time at Bharatpur, a vast marsh and until recent times a shooting preserve of the maharaja who owned it. Carefully kept records reveal that in the past viceroys of India, nabobs and their entourages often shot more than 1,000 ducks and geese a day from the royal blinds. The guns are silent now and Bharatpur is the single most important waterfowl refuge and wintering area on the subcontinent.

Our life has demanded through the years that we sleep in a wide variety of accommodations, from a blanket bed on bare frozen ground or in expedition tents, to tidy rest camps, or in the bed of our own pickup truck. We have also found ourselves ensconced in strange or luxurious facilities. Somewhere between the strange and luxury was Golbagh Palace, the maharaja's former residence where we berthed at Bharatpur. Our suite was of faded grandeur atop two flights of a spiral staircase straight out of early Hollywood. Vast is the only way to describe the bedroom, the dressing room, and the bathroom. Unfortunately maintenance had long ago been discontinued and the plumbing dripped its life away onto a marble floor, but the knob on the toilet was cut crystal.

It is possible to count an astonishing variety of birds at Bharatpur. Migrants from as far away as Siberia (the rare Siberian cranes) and Arctic Europe are on hand during the winter dry season. But the nesting of the natives (the painted storks) takes place after the monsoons begin in late spring. A boat with boatman-guide is necessary to explore this vast wetland.

Sri Lanka is another small impoverished country with a dedication to conserving its wildlife heritage, specifically in two national parks, Wilpattu and Ruhunu. Although leopards have managed to survive the cancer of spreading civilization better than is generally suspected, and although the animals still exist in good numbers widely over Asia and Africa, they simply are not easy to find and photograph anywhere. The Sri Lanka parks are the exception.

During a trip in 1969 we saw many of the spotted cats, including four together at one time, three males following a female. But it had been a rainy visit plagued with other problems, and the determination to return under better circumstances always existed. Ten years later we made it. Along with the late Percy deAlwis, who was then director of Sri Lanka's national park system, we rented a cottage beside a secluded *wilu* (a jungle pond), around which a leopard had recently prowled. For several days we photographed everything from jungle fowl and water monitors to spotted deer and elephants without ever seeing a spotted feline.

One morning near dawn we drove to another *wilu* where leopard prints were everywhere in the muck surrounding the water. A game guard had seen a leopard catch and eat a monitor here just the day before. So we parked at the edge of timber and sat silently, watching the pond. But all we saw were the resident herd of spotted deer, a family of wild boars, and black-necked stilts. We sipped hot coffee from a thermos and pondered driving elsewhere. Then somebody happened to glance aside and there was our leopard. It was sitting,

The chital, or spotted deer, may be the most striking deer on earth. The twin stags with velvet antlers pause from grazing in Kanha National Park as we photograph from the rear seat of a jeep.

This leopard licking its loins in Wilpattu National Park, Sri Lanka, was barely fifteen feet away from us before we spotted it. The exposure was made in very poor light at 1/15 second.

also watching the *wilu* (probably for a meal), not twenty feet from where we had stopped. We might never have seen it at all, except that the splendid cat had begun to lick its paws with a wet pink tongue. Unfortunately it soon moved away into the jungle, where we could not follow. Over dry leaves and through heavy brush it vanished in absolute silence, but it left the lasting impression that here was a predator even more splendid and elusive than the tiger.

XIV

The
Last Word

A wildlife photographer must possess a number of qualifications: a restless spirit, a passion for travel, a genuine fascination with wild creatures, physical stamina, a greater than normal tolerance for discomfort, plus determination and equanimity. A wildlife cameraman also needs a good bit of equipment, not all of it photographic. We have always considered a good pair of hiking shoes as absolutely essential. So is a lightweight backpack. But let's begin with the camera.

Any camera for outdoor use should be sturdy, reliable, fast to use, not too heavy, not too bulky, and able to withstand rough handling and abuse. It should function in extreme cold, in great dampness, and in heat; and it certainly should feel good held in the hands. In short, for wildlife photography the ideal is a 35mm single lens reflex, or 35SLR, of which there are a bewildering number and variety on the market today. To photograph such static subjects as scenes and plants, many professional cameramen carry cameras larger than 35mm.

Selecting the best 35SLR may appear impossible because today all are technologically excellent and some nearly foolproof. New and better cameras and lenses appear almost weekly. For the record, but not necessarily as a recommendation, the cameras we have used for most of the photographs in this book are Nikons; the lenses are Nikkors and Vivitars.

The best advice to offer, no matter what the camera system, is to become thoroughly familiar with it. First study the manual, and then practice shooting the camera around home or anywhere you go. Use it on your family and friends doing things, on pets playing. Shoot any new camera empty at first and in time load it with black-and-white film, which is a little cheaper than color to develop. Concentrate always on rapid handling, on fast but sharp focus. This drill, which may seem useless at first, is guaranteed to pay off in better wildlife pictures.

There are as many opinions on "correct" lenses for wildlife, or nature, photography as there are photographers. We can only pass along a list of lenses we normally carry. We rarely use a 50mm or shorter lens, but do find much application for a 55mm macro lens, even beyond its macro capability. We depend mostly on two zoom lenses (35–85mm and 70–210mm) and on two long telephotos (400mm f/3.5 and 300mm f/2.8). We also carry a 1½ X extender, which at times has been of considerable value. All of the lenses are interchangeable on the three or four identical cameras we carry.

It is purely a personal matter, but we do not have any use for cameras mounted on rifle stocks or similar devices, although these are very popular.

But it is sound advice to use a monopod with any telephoto lens and a sturdy tripod with lenses of 300mm and longer. Admittedly, finding a tripod that is both sturdy and lightweight enough to carry long distances is difficult.

Getting better and better wildlife pictures comes from dedication plus experience, and from being able to predict what any creature will do next. With only occasional exceptions, we do not try to stalk wildlife unseen as a hunter would. On the contrary, we make it a point to stay within view of our target so that it can always see what we are doing, where we are, and not be surprised. We almost never approach an animal directly or quickly, even a national park animal, which is as familiar with tourists as with its own species. Animals are rarely unduly alarmed by human voices speaking calmly or by normal sounds. But we always avoid making sudden movements or unnatural sounds.

There is potential peril in photographing any of the larger animals. We once saw an inexperienced person seriously injured by a park bison. But we have never been threatened by any animals, simply because we always maintain a safe distance. Since we live in and work a great deal in grizzly bear country and meet grizzlies from time to time, we have made a special effort to understand bear behavior. The following points are worth making to anyone who ever hikes in bear territory.

Most bruins do not want trouble or to be near people. If a grizzly (or brown or polar) bear stands on hind legs with ears forward, it is curious and trying to determine what and just where you are, even though it may move in your direction. The best reaction is to speak calmly to the bear while taking inventory of climbable trees in the vicinity. If you are a member of a group, we believe it is wise for all to stand close together and present a large "front." It is a bad sign if a grizzly lowers its head with ears back and makes a huffing noise or works its jaws. It is getting ready to come after you. Now is the time to get in a tree if one is near, or to drop whatever you are carrying while retreating ever so slowly. But never, positively never, run. The bear will probably give chase and if it does, it will win. But the plain truth is that mosquitoes and tsetse flies have been far more terrible than all the bears in Alaska put together. In fact, a supply of effective insect repellent is what made some photography bearable and possible.

Without question the best places to photograph wildlife anywhere in the world are in national parks. Some are very well known, while others are awaiting discovery. Of course it is possible to go almost anywhere on your own nowadays and have a successful shoot. But when visiting any destination outside North America for the first time, we strongly recommend joining a group.

Today there are many reliable adventure-travel agencies that organize expeditions to the most remote and best game sanctuaries on all continents. One advantage is that they are less expensive than shifting for yourself. They can also spare you much red tape, uncertainty, and valuable lost time. Some areas, such as Antarctica, are impossible to see except with group sponsorship.

One major disadvantage of a group trip is the rigid schedule. You can stay in a particular national park only so long, and then you move on although the photo opportunities seem unlimited. In addition, all animals are less confiding with a greater number of people in their area. A single photographer can spend hours filming a moose, for example, but if more people appear, the moose is likely to depart. So the ideal arrangement is to join a tour to see exactly what there is; then, on the next trip, go on your own and plan to be flexible.

No matter where in the world we've wandered, we have learned the absolute truth that the best times to be afield are very early and very late in the day. That causes discomfort, inconvenience, and often the necessity for camping at a given spot when another would be preferable. Being on the spot early has molded our way of life. On many trips, camping equipment has been as vital as our telephoto lenses. We have so often had to rouse reluctant guides from bed in the middle of the night that we have learned more and more to rely entirely on ourselves. The independence is a good feeling and a distinct advantage.

Obviously self-reliance is not possible when you are going after tigers and the only means is by elephantback. And there is no way to go ashore on an Antarctic island to film penguins before the boat and boatmen are ready. But we have learned to cope with stubborn Rocky Mountain horses and to navigate a raft down a whitewater river on our own. We are fair rock climbers and better than average on cross-country skis or snowshoes. We have also become fairly efficient at different kinds of subterfuge—at baiting, using artificial calls, decoys, scents, and sounds. Animal behavior is more predictable to us now, but never so certain that the challenge is gone.

All of it has added up to an extraordinary life with very few dull moments, but there is never enough time to do everything on earth we would like to do.

Maps

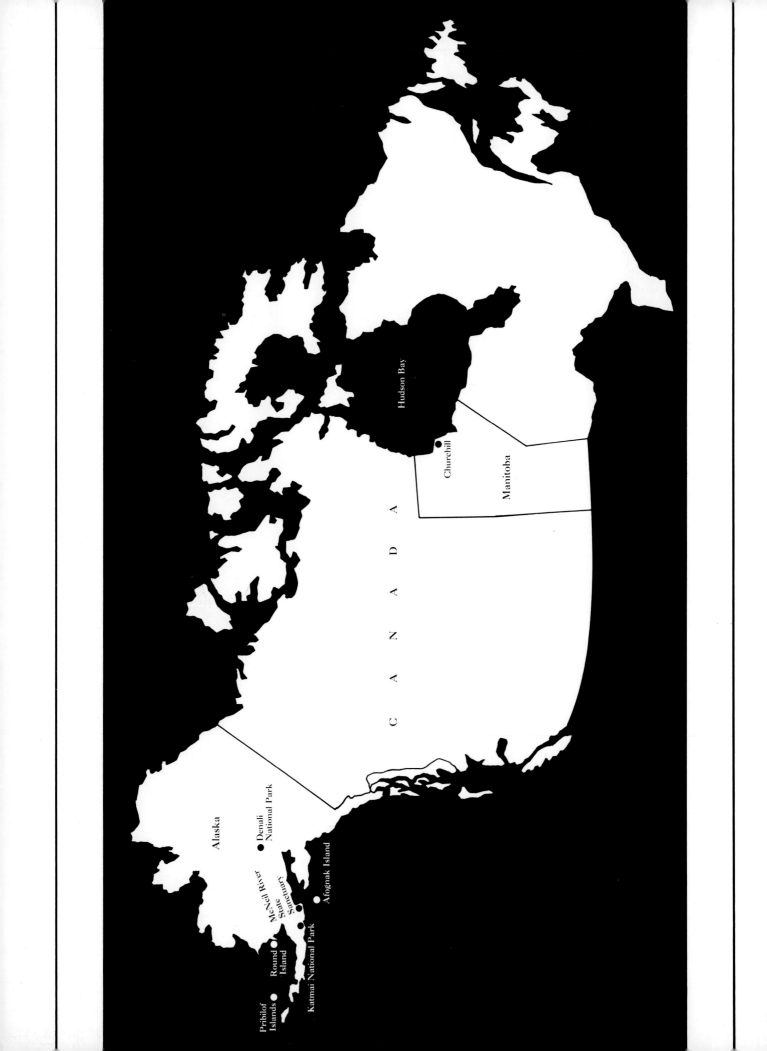

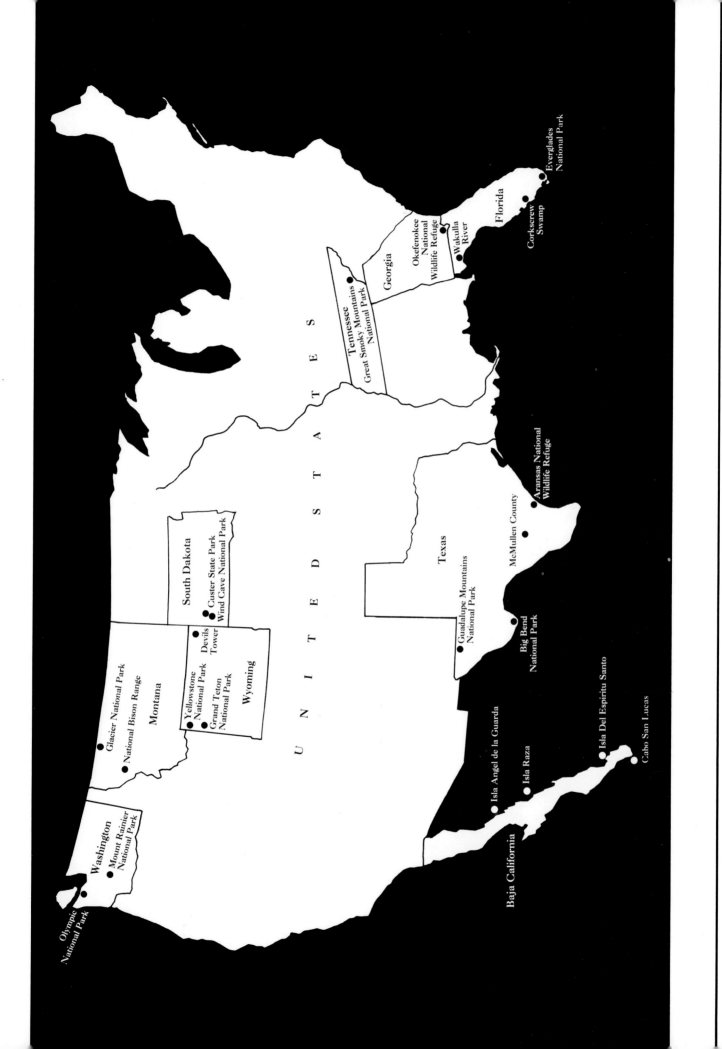

SOUTH SHETLAND
ISLANDS ●

● SOUTH GEORGIA
ISLANDS

ANTARCTICA

GALAPAGOS ISLANDS

NEW ZEALAND

North
Island

South Island

Mount Aspiring
National Park

Routeburn Track

Fiordland
National Park

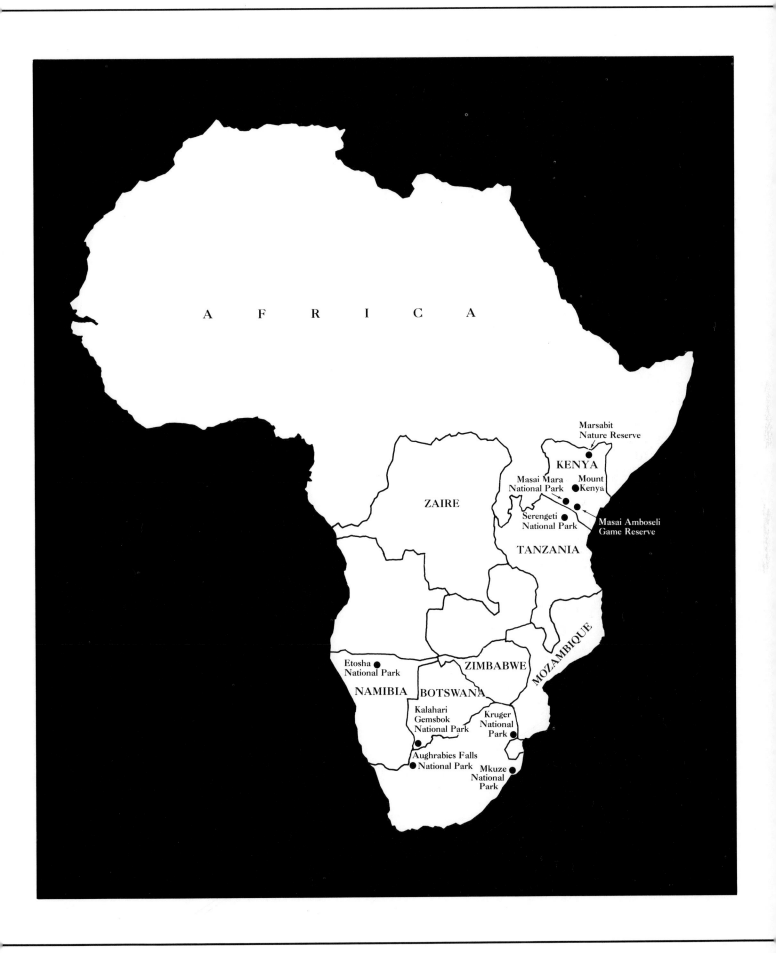

A F R I C A

Marsabit
Nature Reserve

KENYA

Masai Mara Mount
National Park Kenya

ZAIRE

Serengeti Masai Amboseli
National Park Game Reserve

TANZANIA

MOZAMBIQUE

Etosha
National Park ZIMBABWE

NAMIBIA BOTSWANA

Kalahari
Gemsbok Kruger
National Park National
 Park

Aughrabies Falls
National Park Mkuze
 National
 Park

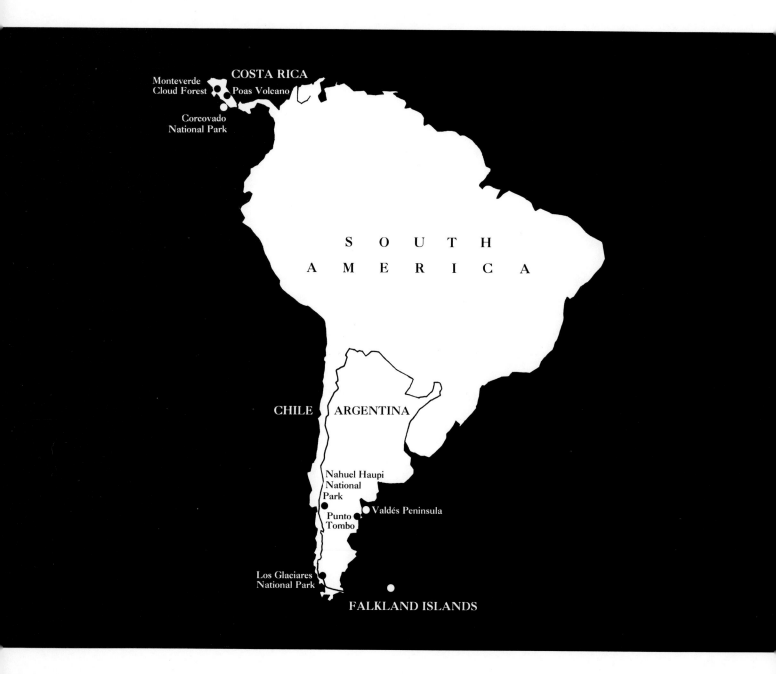

COSTA RICA

Monteverde
Cloud Forest · Poas Volcano

Corcovado
National Park

S O U T H
A M E R I C A

CHILE ARGENTINA

Nahuel Haupi
National
Park
· Valdés Peninsula

Punto
Tombo

Los Glaciares
National Park

FALKLAND ISLANDS

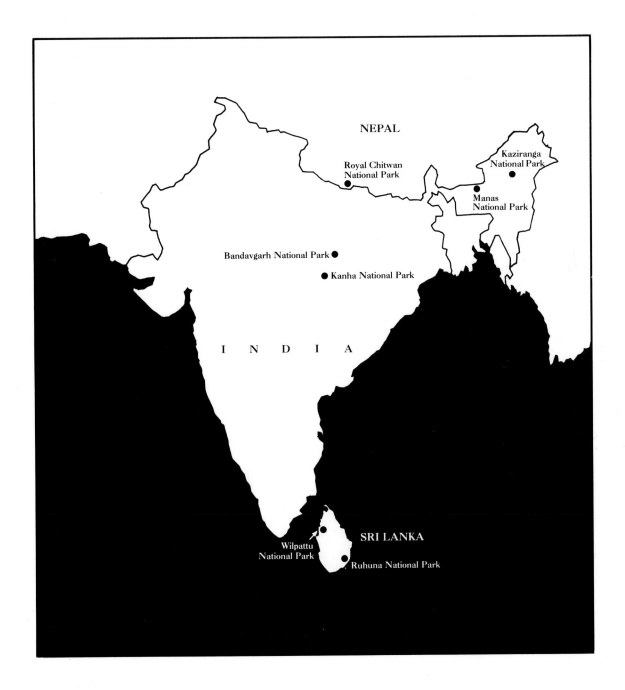

INDEX

Illustrations are on pages in *italics*